ROGER FENTON
Photographer of the 1850s

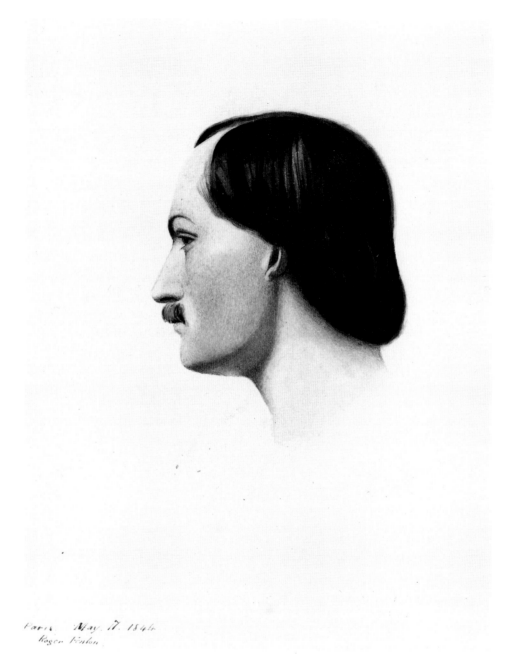

Paris May 17 1844
Roger Fenton

Anon., *Roger Fenton, Paris, May 17, 1844*, watercolour, 167 × 132 mm, private collection.

ROGER FENTON

Photographer of the 1850s

HAYWARD GALLERY, LONDON
4 FEBRUARY TO 17 APRIL 1988

SOUTH BANK BOARD

Exhibition organised by Lynne Green and Muriel Walker

Catalogue produced by Yale University Press, London
for the South Bank Board
Printed in Italy by Amilcare Pizzi s.p.a., Milan

Copyright © 1988 South Bank Board and author

ISBN 1 85332 016 1

The South Bank Centre is administered by the South Bank Board, a
constituent part of the Arts Council of Great Britain.

COVER ILLUSTRATIONS
Front: Down the Ribble near Ribchester (1858/9). Cat. 83.
Back: Girl in Eastern Costume (1858). Cat. 147.

Contents

Lenders to the Exhibition

Austin
The Gernsheim Collection, University of Texas

Bath
The Royal Photographic Society

Exeter
Exeter Camera Club

London
The Trustees of the British Museum
The Trustees of the National Portrait Gallery
The Board of Trustees of the Victoria and
 Albert Museum

Malibu, California
The J. Paul Getty Museum

Montreal
Centre Canadien d'Architecture/Canadian
 Centre for Architecture

New York
Gilman Paper Company Collection
The Museum of Modern Art

San Francisco
The Rubel Collection, Courtesy Thackrey &
 Robertson

Stonyhurst
Stonyhurst College

Windsor
The Royal Archives, Windsor Castle

Jeremy Fry

Robert Hershkowitz

Kenneth and Jenny Jacobson

and other private collections

Acknowledgements

This exhibition was proposed to us by the photographic historian Valerie Lloyd. Some might consider it an unlikely project for the Hayward, but we accepted with enthusiasm since Roger Fenton's ambitious picture-making and his immensely important role in the early development of the medium make such an exhibition and publication long overdue. We are greatly indebted to Ms Lloyd for undertaking the research, selection and cataloguing, and would also like to make special mention of the following who have advised and assisted in innumerable ways: Mrs Pamela Roberts of the Royal Photographic Society, Bath; Mark Haworth-Booth, Curator of Photography at the Victoria & Albert Museum; John Nicoll and Gillian Malpass of Yale University Press.

<div align="right">

Joanna Drew
Director, Hayward and Regional Exhibitions

</div>

Author's Acknowledgements

This catalogue has been produced during the course of my preparation of a catalogue raisonné of Roger Fenton's photographs on which work is still progressing. Many people have been of great assistance in discussing the project with me, and I would like to thank them for their help and advice. First of all grateful thanks go to Ian Burton who was extremely generous in sharing his ideas at a particularly difficult time, and to Jeremy Fry and Roger Davies for their practical help and enthusiasm. Others have given both advice and encouragement, especially Maria Morris Hambourg, Joel Snyder, Sarah Greenough, Robert Sennish, Albert Boime, John House, John Styles, Michael Podro, Derek Southall, Neil Hamilton, Andrew Forge, John Nicoll, Gillian Malpass, David Dawson, Bruce Bernard, Carolyn Bloore, Jenny Stringer, André Jammes, Harry and Miriam Lunn and Sam Wagstaff, who is sorely missed.

Many people have helped answer my queries and among them I would like to thank Barbara Kehoe, Keith Vignoles, Oliver Le Neve Foster, Jonathan Evetts, Henry Banning Fenton, Margaret Greenall, Margaret Peecock, Peter Peecock, Virginia Surtees, Mary Bennett, Jeremy Maas, Rupert Maas, Lord Raglan, Mrs E. C. Muir, Mr Dutson, Ray Watson, David Brook, Roger Rolls, Joan Hayes, Sylvester Williams, Michael Gray, O. H. Wicksteed, Stephen Joseph, Harry Wills; Pamela Roberts and Hope Kingsley, The Royal Photographic Society; Frances Dimond, Royal Archives, Windsor Castle; Marion Harding, National Army Museum; Janet Wallace, British Museum Archives, Terence Mitchell, Keeper, Department of Western and Asiatic Antiquities, Antony Griffiths, Deputy Keeper, Department of Prints and Drawings, Ian Jenkins, Department of Greek and Roman Antiquities, Alan Donnithorne, Department of Conservation, and Brian Tremaine, all at the British Museum; Mark Haworth-Booth and Christopher Titterington, Victoria and Albert Museum; W. W. S. Breen, Honourable Society of the Inner Temple; Diane Raper, The Law Society; Patricia Methven, Kings College, London; C. R. Bowen, University College, London; Dr G. D. C. Allan, Society of Arts; Reverend Butchard; Robert Lassam, Fox Talbot Museum, Lacock; R. H. Taylor, Exeter Camera Club; Noel Chanan; Reverend O'Halloran, Stonyhurst College; Geneviève Bonté, Musée des Arts Décoratifs; Bernard Marbeau, Bibliothèque

Roger Fenton

Nationale; Gerard Levy, Paris; Peter Bunnell, Princeton Art Gallery; Jerrald Maddox, Library of Congress; Eugene Ostroff, Smithsonian Institution; John Szarkowski and Peter Galassi, Museum of Modern Art, New York; Pierre Appraxine, Gilman Paper Company; Roy Flukinger, Humanities Research Centre, Austin; Weston Naef and Victoria Blasco, Getty Museum; Richard Pare, Canadian Centre for Architecture; Joanne Lukitsh, George Eastman House; Sean Thackrey; Robert Koch; Maggie Weston; Hans Kraus; Robert Hershkowitz and Ken Jacobson. Finally, thanks to Helmut Gernsheim and John Hannavy, who have each recognised Fenton in the past and who wrote the first books on his photographs.

Photographic Acknowledgements

The publishers would like to thank the following for providing photographs:

The Trustees of The British Museum
Collection Centre Canadien d'Architecture/Canadian Centre for Architecture, Montreal
The J. Paul Getty Museum
The Gilman Paper Company, New York
Michael Gray
The Harry Ransom Humanities Research Center, Gernsheim Collection, Photography Department, the
 University of Texas at Austin
The Museum of Modern Art, New York
The Trustees of The National Portrait Gallery, London
The Royal Archives, Windsor Castle
The Royal Photographic Society, Bath
Rubel Collection, courtesy Thackrey & Robertson, San Francisco
The Board of Trustees of The Victoria & Albert Museum

Introduction

T. S. Eliot described Tennyson as a great poet, 'for reasons that are perfectly clear. He has three qualities which are seldom found together except in the greatest poets: abundance, variety and complete technical competence.' The same terms can be applied to Roger Fenton.

Fenton was probably the greatest British photographer of the nineteenth century. The scope and quality of his work distinguishes him from his contemporaries, and the images—close to two thousand which are traceable, all done in a ten-year period between 1852 and 1862—cover most categories of subject matter popular at the time. Known to many for his photographs of the Crimean War, his landscape, architectural, still-life and other subjects have been little seen or reproduced. He was the main instigator in the founding of the Photographic Society (now the Royal Photographic Society) in 1853 and its Secretary for the first few years. The example set by him, through his few early speeches to the Society and through the professionalism of his work and dealings with his colleagues, was consciously designed to put photography on a par with other visual media and raise it from the uneasy status it occupied in the first decade of its existence—that of being a reproductive medium and a threat to artists—to being a fine-art medium in its own right.

Fenton became the first artist in his family at a time when the arts were in a transitional and rather inward-looking period and revivalist theories prevailed. The part he played in the foundation of the photographic establishment in the early 1850s was rooted in his experiences in the art world of the forties, in Paris and London. Photography, technically a 'revolutionary' possibility, was an expanding medium at a time when originality in the visual arts seemed subordinate to the academic; but it also provided endless potential for exploiting the prevalent theories of historicism, and for injecting new life into the by then somewhat degenerate notions of the picturesque.

As a child in Lancashire, Fenton watched while his grandfather built, from almost nothing, a banking and cotton business which made him a millionaire in twenty years (although he remained a devout Independent and liberal employer). His father, John, became the first (Whig) Member of Parliament for Rochdale, and when Fenton arrived in London to attend University College in 1836, he would have had all the contacts and influences of his father's circle available to him and would have found himself in a capital city which was undergoing considerable change. He studied mathematics, logic, English with literature, Greek and Latin, and opted to pursue a career in the law. He became a member of the Honourable Society of the Inner Temple, as did his half-brother, James, and a cousin, Joseph Kay. Kay was doing important research on the Continent and in Britain into the social conditions of the poorer classes, and was to become a

notable Q.C. Kay's brother, James Kay-Shuttleworth, was working on conditions in the cotton industry and was to found the national system of education in England. John Bright, an early champion of the working classes and a prominent member of the Anti-Corn Law League, was close to Fenton's father and grandfather in Lancashire, and it is worth noting that both William Henry Fox Talbot, inventor of the negative/positive photographic process on paper, and Horatio Ross, later founder of the Scottish Photographic Society and friend of Roger Fenton, were Members of Parliament at the same time as John Fenton.

What led Fenton to study painting as well as law is a matter for conjecture, as is when and where he began. There is no record of his attending the drawing classes started at University College in 1841 and given by G. B. Moore. He married Grace Elizabeth Maynard in Yorkshire in the summer of 1843, and was in Paris the following spring, where it is likely that he stayed for two or more years, continuously or not. It is probable that his first daughter was born there in 1844 or 1845, and certainly his second daughter was, in 1846. A small watercolour of Fenton in Paris is dated May 1844, and if he was studying painting in either a formal or informal capacity at that time, it would be interesting to speculate who might be responsible for the portrait. Paul Delaroche, with whom he allegedly studied, was not in Paris at that time, having closed his studio at the end of 1843 to go to Italy, where he remained until the end of 1845. Of the several students of Delaroche later to become well-known photographers, neither Gustave Le Gray nor Henri Le Secq were there, although Charles Nègre was, and perhaps Louis Robert. It is possible that Fenton made an earlier trip to Paris between the summer of 1841 and his marriage in 1843, but if he did, there is no record of his registration either as a student of Delaroche or as a drawing student in the Louvre. However, the connection with Delaroche is a likely one, through Fenton's painting tutor in London, Charles Lucy, a history painter who had himself studied under Delaroche in Paris. In any event, there is no doubt of Fenton's involvement in the fine arts at this time, and the system and attitudes prevailing in Paris unquestionably had a great influence on him, as well as on Lucy.

In London, Fenton studied painting with Lucy at his studio at Tudor Lodge, Camden Town, near to Fenton's home in Albert Terrace, Regent's Park. For each of three years, between 1849 and 1851, he exhibited a painting at the Royal Academy. The whereabouts of these pictures is not known, but the titles, *From Tennyson's ballad of the May Queen. 'You must wake and call me early, etc'*, *The Letter to Mama: What shall we write?* and *There's music in his very steps as he comes up the stairs*, all indicate genre subjects of a typical domestic, Victorian nature.

Fenton was clearly close to Lucy, and through him, in 1847 or early 1848, met Ford Madox Brown, another artist who had close links with Paris. Some time after this meeting, these three, with E. G. Bailey, S. C. Hall, Thomas Seddon and George Truefitt, formed a committee to found the North London School of Drawing and Modelling in Mary's Terrace, Camden Town, which opened under the patronage of Prince Albert in May 1850.[1] The purpose of the school was to instruct 'the operative classes, in practical drawing and modelling, to enable workmen to execute the designs supplied to them with artistic feeling and intelligence'.[2] The ultimate aim was to encourage the production of work of a consistently higher quality, regardless of the relative importance of the products themselves. Schools such as this existed in every arrondissement in Paris and had informed the work of Continental artisans for many years. The School was, however, ahead of its time in Britain, and when the Society of Arts sought itself to promote

similar schools in every provincial town in the early fifties, it was criticised for not paying enough heed to the original instigators of the North London School.[3] The broad objectives of the School were in keeping with the spirit of the Great Exhibition and with the desire of the Prince Consort to improve British industrial design, and it is not surprising that Fenton, with his liberal, northern background, his legal training and his time spent in Paris, was drawn to such a cause. His experience with the School would have stood him in good stead and was in some senses precursory to his future role in founding the Photographic Society. The School also set a precedent for Royal patronage. This was Fenton's first encounter with Prince Albert, who was later to become photography's most prominent advocate.

It has been claimed that Fenton was one of the members of the small, informal group of amateur photographers who began to meet together in and around London in 1847. The group was at first referred to as the Calotype Club and later, the Photographic Club, but there are no references to, or photographs extant by Fenton that early, and in a list of the principal members of the Club published in 1851, Fenton is not mentioned.[4] The earliest dated photographs by him known so far were taken in February 1852, and are quite plausible as very early, if not first works. They include a group of rather amateurishly arranged portraits, including what is presumably a self-portrait, and some views taken around his Regent's Park home, of the local church, the road and the park. Scenes taken in the West of England, around Cheltenham, in April of the same year, are different in colour and surface, and are clearly the work of an operator who is not yet master of his technique. Some of the Cheltenham views were published, rather prematurely, during the autumn of 1852 in the first two parts of *The Photographic Album*,[5] and were in fact criticised for their poor technical quality in the *Art Journal*: 'the specimens published are by no means equal to a great number which are now being produced by Photographic amateurs. . . , although the operator has an artist's education, it does not appear that he has the facility of . . . adjusting the camera to meet the difficulties with which he has to contend. . .'.[6] The journal noted that the pictures had not been taken with a view to publication and, at the same time, praised the 'remarkable examples of photographic printing' by Maxime du Camp to be seen in the French publication *Egypte, Nubie, Palestine et Syrie*, (Paris, 1852), then being distributed in London.

The publication of instructions by Fenton for the making of waxed-paper negatives in W. H. Thornthwaite's fifth edition of his manual in August 1852 shows that Fenton had thorough practical experience of the process before this date. The passage is based on Le Gray's French publication of December 1851, and Fenton is critical of Le Gray on points of chemistry. Essentially, however, the article details reworkings of the process with respect to the weaker sunlight and different papers available in Britain.[7] Le Gray's process was first communicated to the Académie des Sciences in February 1851, and by the time Fenton visited Paris in the October, many practising photographers were familiar with it, probably through Le Gray's photographic training school and laboratory in Paris, which existed by 1850. In January of 1851, Le Gray, Le Secq and Nègre, with others, had founded the first photographic society, the Société Héliographique, and in June Le Gray and Le Secq had exhibited paper prints in the Great Exhibition in London. If, as Fenton was to suggest later, the exhibition had provided the impetus for greater communication between photographers on both sides of the channel, leading to rapid improvements in photography at all levels, he himself presumably experienced something of this exchange of ideas and techniques while in Paris. Le Gray showed Fenton several hundreds of the

waxed-paper negatives taken for the Government by himself and Mestral in Touraine and Aquitaine. It seems, however, that Fenton did not attend Le Gray's lessons, since in Thornthwaite's manual he refers to advice obtained personally about the waxed-paper process from both M. Puech, who operated a laboratory producing photographic papers below the headquarters of the Société Héliographique, and vicomte Vigier, also a founder member of the Société, who used both Le Gray's and Talbot's methods; but there is no such reference to Le Gray. However, the evidence of the earliest photographs confirms that Fenton was practising both the waxed-paper and collodion negative processes by February 1852, if not before. It is also likely that he followed the French lead in using slightly albumenised printing papers, since none of his prints appears to be a plain salt print after Talbot's method. A further indication of Fenton's experience of the waxed-paper process, which allowed sensitised papers to be carried around for several weeks before exposure or development, was the commission offered to him by the civil engineer, Charles Blacker Vignoles, to accompany him to Russia in September 1852 in order to record the progress of the building of his suspension bridge over the river Dneiper in Kiev. None of this, however, implies Fenton's involvement in photography before 1851.

The decidedly greenish-yellow cast of the prints of Cheltenham and the first prints from the Russian negatives, all apparently on albumenised paper, is very similar to certain prints by Le Secq of that time, a similarity that extends even to the style of the occasional signature in a corner. In his report of activities in Paris, Fenton referred to the advantages of practising the art in France: not only had there been 'liberal encouragement given by the late government, to the eminent in photographic skill' (a reference to the photographic survey work commissioned for the Commission des Monuments Historiques), but there was the 'absence of any patent interfering with the independence of individuals'.[8] Fenton's last comment pointed the contrast with the situation in England, where Talbot had patented his methods and claimed that all successive paper processes derived from his. As a lawyer, Fenton is unlikely to have ignored this, unless he disagreed strongly with Talbot's position, particularly since his great respect for Talbot's achievements is recorded. There is no evidence of his applying for a licence to practise Talbot's calotype process.

Considering Fenton's relatively short experience of photography, compared to that of many other photographers, the publication of his own version of Le Gray's process by August and of the early prints of Cheltenham and Tewkesbury by September 1852 may seem precocious and premature. Alternatively, it could be seen as the first sign of Fenton's strong belief that organisation and publication were the methods by which to advance the new medium, taking it into the public arena, where communication between practitioners might become the norm. Once again, as with the North London School, the pattern was based on the French model.

In the early spring of 1852, Fenton was behind the 'Proposal for the Formation of a Photographical Society' which appeared in the *Chemist*.[9] At this time, Robert Hunt, Director of the Geological Museum, probably the best-known photographer of the day (apart from Talbot), and photography critic for the *Art Journal*, was already in correspondence with Talbot, on behalf of the members of the Calotype Club, over the matter of his relinquishing his patent rights. On 24 March, Talbot wrote to Hunt, indicating that he would be prepared to meet a committee of five elected representatives to discuss their proposals and come to some arrangement over his patent rights.[10] On the reverse of this letter, six names are listed in Hunt's writing: Berger, Foster,

Fry, Fenton, Newton and Hunt himself. These names were to form the basis for what became known as the Organising or Provisional Committee for the proposed photographic society.

In June 1852, Fenton was elected Honorary Secretary to the Organising Committee, and from that time on there is no doubt that he was the principal force in the planning of the structure and administration of the Society, in spite of his absence in Russia for almost three months, from the beginning of September to the end of November 1852. During this time, the first public exhibition devoted entirely to photographs was organized, and it opened on 20 December at the Society of Arts to a great deal of public interest. Fenton exhibited thirty-eight photographs, including three of Russia, and gave the opening address. In it, his first consideration was to give Talbot the credit for inventing photography on paper, and his second, to dispel 'distrust and apprehension' on the part of the artistic community. Betraying his origins, he dismissed the view that 'the camera had been looked upon as a kind of power-loom, which was to do away with hand labour' as 'a most narrow view,' and declared that 'the camera will present [artists] with the most faithful transcript of nature, with detail and breadth in equal perfection, while it will leave to them the exercise of judgement, the play of fancy, and the power of invention.'

In the rest of his speech he attributed the great advances in photography in both Britain and France during the previous eighteen months to the impetus derived on both sides of the channel from the Great Exhibition. He outlined the present state of the art, with particular attention to British and French work, in terms of technique, and it is interesting to note that at that time, before the Society was formed, all the principal techniques of the next twenty years were available: the daguerreotype and Talbot's original negative and positive salted-paper processes, together with the various (mainly French) improvements, albumen on glass negatives and positives, waxed-paper negatives, albumenised printing papers and the new collodion on glass negatives and positives. Within this framework was a multiplicity of variations in technique, constantly being applied and experimented with at the emulsion, developing and printing stages. The reports in the journals of the following years show the technical emphasis to have been on the obtaining of a good negative, with the fading of positives becoming a constant preoccupation during the mid- to later fifties.

At the Inaugural Meeting of the Photographic Society on 20 January 1853, Fenton read the major papers, which reported on the findings of the Provisional Committee and ended with the Rules of the new Society. At the first Ordinary Meeting on 3 February, he outlined the way in which the Society should conduct its affairs and declared its intent to forward the art of photography. During this whole period, Fenton retained his rooms in the Inner Temple, served on the Management Committee of the North London School of Drawing and Modelling, and had by no means been ignoring the actual practice of photography. Before leaving for Russia, he had photographed in various places, including Windsor Forest, Cheltenham, Tewkesbury and South Wales, and during the spring of 1853 he collaborated with Charles Wheatstone to make views for his reflecting stereoscope, which were exhibited, with others, at the Society meeting of 5 May.[11]

It is probable that Fenton's experience of coming from a self-made family of merchants-turned-managers was the basis for his quite conscious desire to do everything 'professionally', in terms of his work being done well and having a value. From his early insistence on setting up a formal body for photography through which to communicate the latest discoveries, to the

presentation of his work on fine-art mounts, his message was that photography stood beside other media as an equal. From the beginning, he submitted his work for publication; it had appeared first in *The Photographic Album*, and from sometime in 1853 he started to issue his own prints on fine-art mounts with printed credits and impressions of plate marks—leaving his audience in no doubt as to the intended status of, or market for his work. Prints sold through the print dealers P. & D. Colnaghi or Thomas Agnew and Sons, whether commissioned or not, were given the dealers' imprint, but the mounts in each case were similar, implying that every aspect of the final production was overseen by Fenton. The fine, biscuit coloured, matt prints of the Russian views, on large mounts, generally thought of as part of the first cohesive group of images by Fenton, would have been issued during this time, the earlier prints from the same negatives being quite different in quality.

Fenton's level of production and his many other commitments would suggest that he employed assistants from an early stage. Undoubtedly, when he entered into employment with the British Museum in March 1854, he would have done so, and since Marcus Sparling, who was to be one of Fenton's assistants on the Crimean expedition in 1855, was listed as being resident at Fenton's house in Albert Terrace in 1854, it is likely that he was working with him from early on. He certainly accompanied Fenton and his horse-drawn van, converted to a darkroom, north to Yorkshire in the late summer of 1854. Sparling had had experience in camera design, and he would no doubt have been an able technical assistant to Fenton in the initial period. He was later to write on photographic methods himself.

Fenton or his assistants sometimes appear in his landscape and architectural studies, not as the top-hatted, amateur gentlemen usually seen in photographs of the time, but as casually dressed operators in otherwise unpopulated scenes, leaning over bridges, often with their backs to the camera, inviting identification with the viewer. Fenton's mode of dress appears sometimes to have been in marked contrast to that of other members of the Photographic Society, as, when on the Society outing to Hampton Court in 1856, he is seen in the picture, set up by himself, in shirtsleeves and a cap (probably a souvenir from a French uniform in the Crimea). It is as though he is adopting a kind of anonymity, the lawyer and the organiser of the Society needing to wear a different hat to practice his art.

At the opening of the first Photographic Society Exhibition of Photographs and Daguerreotypes in January 1854, of the group who escorted the Queen and the Prince Consort around the exhibition, it was Fenton who described and explained it to them. Presumably known to Prince Albert from the early days of the North London School, Fenton was invited on a number of occasions that spring to photograph the Queen, the Prince Consort, the Royal children and various visitors at Buckingham Palace, and he was to maintain a relationship with the Royal Family throughout his photographic career. They commissioned and/or purchased a number of photographs by him, apart from the early portraits, including views at Spithead of the Fleet leaving for the Crimea in 1854, views of and around Balmoral in 1856, of the Rifle Volunteers at Hythe Barracks and of the Shooting Competition on Wimbledon Common in 1860. Fenton joined the 9th (West Middlesex) Rifle Volunteers in April 1860, as a captain, and portraits of him wearing a long beard and a Volunteer's uniform, together with earlier ones of him in Zouave costume from the Crimean series, compare with the many images of explorers and travellers of the period and with popular imagery of the Volunteers. Indeed, the Rifle

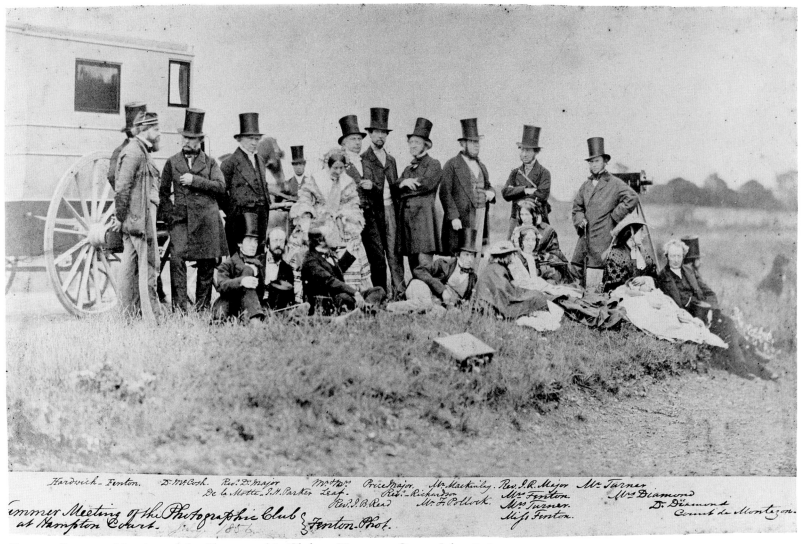

Cat. 17. Summer Meeting of the Photographic Club at Hampton Court, July 1856.

Volunteers' training sessions at Hythe seemed to have been a meeting place for a number of amateur photographers, including Horatio Ross, whom Fenton may have visited during his visit to Edinburgh *en route* for Balmoral in 1856 (the year Ross founded the Scottish Photographic Society), and whose son won the Queen's Prize at Wimbledon that year. Group photographs taken on the steps of 2 Albert Terrace after the competition include Ross senior and junior, Charles Lucy and Grace and Annie Fenton.

During the ten years Fenton practiced photography, his work included landscape, architectural studies, portraiture, copies of works of fine art or historical artifacts, war photography, oriental costume studies and still life. The few pictorial modes which he did not exploit, mainly narrative, imaginative or historical reconstructions, he almost certainly considered unsuited to the medium. In almost systematically prescribing the range of possibilities open to photographers, Fenton was photography's greatest advocate. Although Talbot had outlined in *The Pencil of Nature* the main uses to which the medium might be put, there is

7

throughout the work of Talbot and many of his contemporaries in the 1840s, a mood of amateurism, of private scholarship and a lack of any feeling of communication with the educated or professional public. In shaping the main channel of communication for the medium (the Society) and in leaving such a complete and remarkably fine body of work, Fenton has no rival.

After the meetings in the first year of the Society, there is a marked lack of fine speech-making by Fenton and virtually no comment on the aesthetic aspects of photography. Although he made occasional contributions of a technical nature, which appear in the journals, on the whole one is left to conclude that he intended his work to speak for itself.

The reasons why Fenton renounced photography after ten years, at the age of forty-three, remain a partial mystery. His achievements during that time were considerable; the directions left to pursue must have seemed limited, and those, populist and less dependent on the individual skills of the photographer. During the last few years of his career, Fenton made a number of groups of stereo-photographs, of North Wales, Lancashire, objects in the British Museum and still lifes of fruit and flowers. It is clear that he considered this smaller, portable and popular form a legitimate progression, with the obvious scientific or visual advantages of seeing a subject 'in the round'; indeed, he had originally suggested the possible use of stereo-photography in his letter of advice to the British Museum in 1853,[12] referring at that time to Wheatstone's more cumbersome method. However, the other directions which photography had begun to follow in the late 1850s, the rage for cartes-de-visites, and the mass production of tourist views for the traveller, obviously did not appeal to Fenton as a serious practitioner. Reviews of the Photographic Society exhibitions during these years could have done nothing to encourage him to continue. In 1858, when many of his exceptionally fine series of views in North Wales were exhibited, the *Art Journal* responded in jaded fashion: 'Mr. Roger Fenton, as usual, gives us many well selected scenes, treated with his artistic feeling, and full of those marvelous details which have ever been the prominent charm of a photograph.' But it found the Society failing in its aim of promoting the art and science of photography: 'Even regarding photography as an art, with a few exceptions, we find no better pictures now, than were produced ere yet the society had existence; and, as a science, photography has not advanced in the slightest degree, during the past four or five years, in any direction which can be traced to the society.'[13] By 1860, although the journal declared Fenton's photographs of Oxford and Lancashire 'fine specimens of photography, and many of them exceedingly beautiful', it found 'the society has failed in every way to fulfil the hopes, upon the strength of which it was started. We believe the cause of this lies somewhat below the surface. . . .' It complained of many things, including the exhibition of photographs already seen elsewhere, and the inclusion of prices in the catalogue, or pictures by commercial studios:

> The profession is a most honourable one, and one which calls upon the mind of the artist for the exercise of some of its best functions. . . . We have never seen the selling price of a picture in the Royal Academy catalogue. But there is no parallel between the sale privately of a picture, which has been the labour of months, or it may be of years, and the sale of photographs, which can be multiplied at will, and of which the finest specimens by Mr. Roger Fenton are ticketed at 12s.

In 1861, when Fenton's series of still-life studies of fruit and flowers was exhibited, together

with views in the Lake District and perhaps his most successful group of images of a country house—Harewood—the *Art Journal* failed to comment specifically on any of them:

> When we ask ourselves if there is any distinguishable advance in the art, we are compelled to pause. For several years we have seen photographs which possessed all the qualities that mark the best of these chemical pictures, in an eminent degree. Minuteness of details, sharpness of outline, aerial perspective, freedom from the convergence of perpendicular lines, are merits with which we are familiar. The pictures which Mr. Roger Fenton exhibits this year—many of them very beautiful—are in no respect superior to photographs exhibited by that gentleman four or five years since.

Although the reviews in the *Journal of the Photographic Society* were more appreciative, and indeed others elsewhere, the opinion of the *Art Journal* may have been crucial. Having played host to the early meetings of the Organising Committee, and reported regularly and frequently on photography from an early date, its support had always been valuable. Also, even as late as 1859, on his son's birth certificate, Fenton signed his profession as 'artist', and there is no doubt that his perception of his profession changed little with his adoption of the 'black art'. In 1861, Sir Frederick Pollock, President of the Society, found it necessary to write to Her Majesty's Commissioners for the International Exhibition of 1862 in the strongest terms, to complain that they had placed photography amongst carpenters' tools and agricultural implements, and to appeal for it to be rescued from this 'comparative degradation'.[14] This degradation was all the more pronounced, since in the Great Exhibition of 1851 photography had at least been placed in the class for Philosophical Instruments and Processes depending upon their Use. It must have seemed to Fenton, already retired from the Council of the Society, that, ten years later, all his efforts had been very much in vain. With no obvious aspects of the medium left for him to explore, the cumulative weight of general opinion reflected in these ways must have contributed to Fenton's decision to cease work. The finality of the sale of his negatives and his extensive collection of apparatus in November 1862 was absolute. It would appear that he made a clean break also with the Photographic Society, although it was with regret that it announced his retirement from photography in 1862: 'To the exertions of Mr Fenton the Photographic Society owes its existence.' It hoped that he would 'still occasionally attend the meetings of the Society, which owes so much to him, and where his presence is always so welcome and agreeable.'[15] But it seems that Fenton did not return; from then on he lived exclusively at Mount Grace, his second home in Potters Bar. He died there on 9 August 1869, the sum of his contributions to photography hardly recognised then, as now.

1. *Almanack of the Fine Arts for 1851*, London, 1850.
2. 'Suburban Artisan Schools', *Art Journal*, 1852, p. 103.
3. *Ibid.*
4. *Almanack of the Fine Arts for 1852*, London, 1851, p. 155.
5. David Bogue for Joseph Cundall, London, 1852.
6. *Art Journal*, 1852, p. 374.
7. W. H. Thornthwaite, *A Guide to Photography . . .*, London, 1852.
8. *Chemist*, February 1852, pp. 221–2.
9. *Chemist*, March 1852, p. 265.
10. Royal Photographic Society.
11. Royal Photographic Society. Minutes of the Council of the Photographic Society.
12. British Museum, Letter 1751, 14 July 1853.
13. *Art Journal*, 1858, pp. 120–1.
14. *Art Journal*, 1861, p. 223.
15. 'The Retirement of Mr. Fenton from Photographic Pursuits', *Journal of the Photographic Society*, 15 October 1862, p. 157.

The British Museum

The interest in the artifacts and achievements of past civilisations so strongly felt in the mid-nineteenth century was part of an increasing awareness and belief throughout Europe that they embodied spiritual and historical values which could be of use in a number of ways to a society undergoing great social, intellectual and religious change. In Britain, the emphasis on the expanding Empire and on increased overseas trade was paralleled by a growing interest in antiquarianism, anthropology and natural history. As more and more expeditions by scientists and naturalists returned from all over the globe, learned amateur societies recorded, documented and disseminated the results. The British Museum, aware of the increasing demand for copies of items in its various departmental collections from the scholars, artists, students and amateurs who constituted a substantial market for such visual emblems and records, turned to photography as the single means of providing accurate and accessible records.

In June 1853, the Trustees of the museum, who included Sir Charles Eastlake, President of the Royal Academy of Art and President of the Photographic Society, met to discuss the possibility of creating a photographic studio within the museum itself. The construction of a temporary chamber was approved, and Fenton, then Honorary Secretary to the Photographic Society, and Philip Henry Delamotte, likewise a founder member of the Society and the proprietor of the Photographic Institution in Bond Street, were consulted for advice about apparatus. To this request the two photographers replied, in July 1853, with characteristic differences.

Fenton, with his industrial background and his familiarity both with the teaching methods of art schools and universities, and with the restoration and documentation of buildings being carried out in France by the Commission des Monuments Historiques, was particularly well qualified to respond. He wrote a lengthy letter to E. Hawkins, Keeper of the Department of Antiquities, which dealt with every possible aspect of the museum's request.[1] He recommended the erection of a glasshouse on the roof and detailed both its size and the methods of controlling the light by blinds. He outlined the equipment necessary for photographing objects of very different size and texture, and specified cameras and lenses for specialised work, including stereoscopic. Darkroom apparatus and chemicals were described at length and he suggested various possible arrangements which might be made with a photographer, depending on the type of contract and the amount of work. In contrast to this, Delamotte replied with a scanty note enclosing a 'list' of necessary equipment which comprised '3 cameras at £180 plus chemicals £1 per week.'[2] During the same month, Sydney Smirke, Superintendent of Museum Buildings and successor to his brother Robert (designer of the new museum building in Bloomsbury) at the

Office of Commissioners of Works, sought Fenton's advice as to the positioning of the chamber on the roof of the museum.

During the summer of 1853, estimates for apparatus were approved and the Trustees advanced their plans cautiously. Delamotte had written again in August to offer himself as a candidate for the post of photographer,[3] but the Trustees had replied that they had no intention of making a permanent appointment.[4] On 4 October, Fenton wrote, probably in response to a request from the museum, offering his services as photographer. His application was supported by Sir Charles Wheatstone, Professor of Experimental Philosophy at Kings College and Vice President of the Photographic Society. Wheatstone recommended Fenton highly: 'I do not know any person better qualified to superintend the proposed photographic arrangements at the British Museum than Mr. Fenton. . . . He has had much varied experience in photography, is a good artist, very skillful in the manipulations, persevering and painstaking, and at the same time expeditious in his operations. He has, moreover, greater experience than anyone I know in taking stereoscopic pictures.'[5]

The Trustees formally recommended Fenton's appointment as photographer on 8 October 1853, but it was not until 11 March 1854 that the terms of his engagement for two months were approved. During this time he photographed specimens of zoology, obviously to the museum's satisfaction, since on 13 May his employment was extended for a further two months. But after 15 July, when his contract was terminated, work was suspended and a statement of expenses on photography was ordered by the Trustees, there is a large gap in the museum's records when there is no mention of Fenton. It seems there was disapproval of the considerable expenses involved with photography. Whether this was due to Fenton's high fees, lavish attention to quality and detail in both equipment and materials, or the assistance he may have hired, is a matter for speculation. It did not cause his permanent removal from the museum, but inquiries into expenses and the terms of his employment seemed to dog his relationship with the museum into the late 1850s, when in-house photography ceased until about 1920.

From June 1854 to February 1856, no photography of items in the collections was authorised. Fenton was for much of that time busy, first with the preparations for his expedition to the Crimea and then with the expedition itself. In his absence the Trustees discussed the usefulness of photographic books and the copying of prints and drawings. They also commissioned William Lake Price to photograph the work in progress on the Reading Room which was under construction at this time. In the spring of 1856, Fenton was back at work for the museum, presumably having completed the issue of his series of Crimean views for Agnew's, the last of which were published in March. The Principal Librarian was given control of photographic work and its expenditure, and copies of the Assyrian Clay Tablets and the Epistles of Clement of Rome from the Codex Alexandrinus were made. The former were mounted on card and collected in portfolios, and the latter published that year by the museum in book form—the actual prints being bound—in an edition of fifty.

In May 1856, the London print dealers, P. & D. Colnaghi, negotiated terms for selling the museum's photographs. During the next eighteen months a great many items were photographed by Fenton, including prints and drawings, specimens of natural history, and busts and standing figures in the Department of Antiquities. A collection of these photographs was presented to Prince Albert in November 1857 and a copy of the facsimiles of the Assyrian

inscriptions sent to Talbot, who, as an expert in translating ancient scripts and the earliest advocate, in *The Pencil of Nature*, of photography as a means of disseminating copies of such works, would have both deserved and appreciated them.

The objects chosen to be photographed were not all ancient or historic. Many of the sculptures copied were from the Townley, Payne Knight and Temple collections recently bequeathed to the museum, and although classical Greek works were included, many were Italian marbles, which had remained popular with the public long after the arrival at the museum of the Elgin Marbles. Images of muses, gods and goddesses, relieved by the occasional laughing child or satyr —or perhaps a reference to music or literature—were more congenial to the average Victorian connoisseur than the wet-fold drapery and raw power of classical Greek sculpture. Fenton would have been familiar with the studio lighting tradition in the graphic arts and clearly paid great attention to this when photographing sculpture. Objects are subtly lit, perhaps dusted with powder, and photographed with a long lens to avoid distortion. Shadows play a large part in some compositions, casting areas of dark across the form or background, the grain of the plaster or stone and the wood of the stands being clearly recorded, with no attempt to adorn or decorate what is clearly a functional arrangement. Up to three versions of many casts or carvings were taken, some in strong sunlight, others in subdued daylight, and the printing processes vary, as in the rest of his work, between lightly albumenised salt and glossy albumen.

The prints and drawings that were copied again reflect the taste of the period: works by Raphael, Mantegna, Leonardo, Veronese, Bellini, Titian, Dürer, Memling, Holbein and Rembrandt were predictably predominant. Reflecting the recent discoveries in science, objects of natural history that were photographed included fossils, corals and skeletons. Two different views of a human skeleton hanging next to that of a gorilla, graphically illustrate Darwin's recent theories. Placed next to a photograph of a Raphael Madonna, they would reflect both the range of ideas represented under one roof, and the current moral and theological controversies.

Towards the end of 1857, Fenton was once again in conflict with the museum, this time over the terms of his contract. He offered several courses of action to the Trustees, one of which was that he made the negatives at his own expense on condition that he retained the right to print from them after the museum had been furnished with the number of prints it required. But on 10 July 1858 the Trustees decreed that no further subjects, even though ordered, should be photographed.

It appears that the financial liabilities of the photographic studio were more than the museum was willing to assume, and certainly more than the income likely to be made from the sale of prints to the public through Colnaghi's or at the museum itself, where a booth in the foyer had been set up for this purpose. No blame seems to have been attached to Fenton, who had negotiated with the Trustees in a thoroughly professional way. He was not replaced and, in July 1859, following negotiations in which Henry Cole took part, Fenton was awarded a fee in compensation for his interest in the negatives, upon which he delivered them to the museum. In August, his outstanding bills were paid, but no decisions for the future were made. Many of the negatives were sent to the South Kensington Museum and prints remained on sale there until 1863. In March of that year, the Department of Science and Art discontinued the sale of the positives and returned all unsold prints and negatives in their possession to the British Museum.[6] Although a number of other photographers obtained permission to photograph in the British

Museum in isolated cases, the experiment of having an in-house photographer was clearly seen as commercially unsuccessful. In December 1888, a special sub-committee ordered the disposal of all the remaining stock of photographs, 'taken many years ago and now in a deteriorated condition'. Photographs of objects in the natural history collection were sent to the Natural History Museum and the rest were distributed to Schools of Art and to Free Libraries.[7]

1. British Museum, Letter 1751, 14 July 1853.
2. British Museum, Original Papers, Delamotte to Vaux, 25 July 1853.
3. British Museum, Original Papers, 22 August 1853.
4. British Museum, Minutes of the Committee of Trustees, 8604, 10 September 1853.
5. British Museum, Original Papers, 6 October 1853.
6. British Museum, Minutes of the Committee of Trustees, 10305, 28 March 1863.
7. British Museum, Minutes of the Committee of Trustees, 18107, 8 December 1888.

The Crimean War

In September 1854, Fenton, with his assistant Marcus Sparling, ventured forth for the first time in the photographic van which was later to become known to most of the British public. A former wine merchant's van, it had been converted by Fenton into a travelling dark room, capable of carrying all the apparatus for photographing and developing, on the spot, glass negatives of an unusually large size, more common in France. The trip led to magnificent views of the abbeys at Rievaulx, Fountains and Bolton, and the experience gained led to the most unusual commission in British photography for many years.

The Crimean War, the first major conflict involving Britain since the Battle of Waterloo in 1815, had aroused a great deal of public attention. Throughout 1854, mounting criticism of the conduct of the war, mainly engendered by the reports of William Howard Russell in *The Times*, had given rise to feelings of frustration and brought about a crisis of confidence in the government. This was the first time that official war artists were commissioned, and William Simpson's lithographs were later published by P. & D. Colnaghi, the London print dealers. There had been some speculation during 1854 as to the part photography might play in the war, both in the *Journal of the Photographic Society* and in the *Literary Gazette*, but it was Prince Albert who took an interest in the proposal, and another print dealer, William Agnew of Thomas Agnew & Sons of Manchester, who was to commission the first independent photographic reporter. Fenton had photographed the departure of the Baltic Fleet from Spithead for the Queen and Prince Albert earlier that year, and with his extensive experience of the collodion negative technique, he was the obvious choice. In December 1854, the Council of the Photographic Society announced Fenton's imminent departure for the Crimea, and expressed fear for his safety, since 'two eminent Photographers have already fallen victim to the war'—these being Major Halkett, who had died in the Charge of the Light Brigade, and Mr Nicklin, who had been lost at sea in a transport ship. In the meantime, the crisis over the war worsened and resulted in the resignation of Lord Aberdeen's coalition government on 1 February 1855.

On 20 February, Fenton sailed for the Crimea in H.M.S. *Hecla* with his photographic van and two assistants, Sparling and Williams. He went armed with letters of introduction from Prince Albert to the commanding officers, and it is likely that the Duke of Newcastle also had a hand in the arrangements, since he and Sir Morton Peto granted Fenton passage in the *Hecla*. Newcastle had already had experience of photography, for, in 1849, a surgeon, C. G. Wheelhouse, had made a number of paper negative views from the Duke's ship as it had cruised the shores of the Mediterranean. The *Hecla* sailed via Gibraltar, where Fenton went ashore and onto mainland Spain to purchase horses, and arrived in Balaclava on 8 March. The chaos that

greeted him was substantial, and it was days before he was unloaded and billeted. On 15 March he started to photograph in the neighbourhood of Balaclava and, by the end of the month, around Kadikoi. Initially, he was there at a particularly inactive period of the war: the long siege of Sebastopol was not to break until 7 June with the storming of the Mamelon, and by then the heat of the sun was intense enough to melt Fenton's gutta percha developing trays. Additionally, the van itself was an obvious target, and the whole process of coating a glass negative and exposing it before it dried was too long to be able to capture moving subjects successfully, or to make excursions into the field of battle practicable.

Fenton worked unceasingly, however, and often was the target of enemy fire, once losing the roof of his van. The pictures may not show corpses and the other results of battle, as the photographs of the American Civil War were to do in the following decade, but they do tell a powerful story for those with eyes to read them. The portraits of the officers and men do not reverberate with drama or rhetoric: they are not posed carefully or photographed from a heroic viewpoint. The groups are clearly directed, many to illustrate 'Scenes of Camp Life', but, within the traditional mode, the shabbiness of the soldiers, the barrenness of the surrounding countryside and the humble accoutrements and miscellaneous dress of the men tell their own story. There is something very ordinary about these people, and even the portraits of the officers are distinguished for their individuality and directness of approach.

Fenton left Balaclava on 26 June 1855, suffering from the cholera that had killed Lord Raglan, Commander of the British troops in the Crimea, and many others. The photographs—according to various reports up to 360 in all (Fenton took over 700 glass plates to the Crimea)—were exhibited very shortly after his return. Because of his illness, Fenton probably only supervised the printing of his negatives. On 11 and 12 September, he and William Agnew were summoned to an audience with Napoleon III to show the Emperor a selection of the prints, and on 20 September, some 312 prints went on view at the Gallery of the Water Colour Society in Pall Mall East. Published under the patronage of Napoleon III, Queen Victoria and Prince Albert, the prints were mounted by Agnew & Sons on stiff paper with printed titles and credits.

Before the exhibition of Fenton's Crimean work, most people had never seen a photograph of Lord Raglan, or any other British or French commanding officer, but had to rely instead on written descriptions or artists' interpretations to convey their characters. Fenton's simple, direct and unassuming portraits were revelations to many. Over thirty journals reviewed the exhibition within a few days of its opening, and *The Leader*'s description of a portrait of Lord Raglan, about whom many political doubts had been expressed, shows that the photograph had influenced the reviewer: 'There is no spectacle more affecting than the countenance of Lord Raglan. . . . It not only reconciles us to the man, but to our own estimation; teaching us that after all there was no mistake in the respect paid to the character of Raglan. The mistake lay in permitting a noble ambition to indulge itself, where a gentle force ought to have been used in making the aged man accept the repose which his patriotism spurned.'[1] The one photograph that might be seen as a recognisable 'moment in history'—*The Council of War*, taken when Raglan, General Pelissier and Omar Pasha met the morning of the capture of the Mamelon—was discussed at great length. Fenton's eleven-part panorama of the Plateau of Sebastopol was technically less than perfect, owing to the continual variation in the atmosphere caused by the intense heat and changing humidity, which affected the horizon from negative to negative, but it was much appreciated for

its delineation of the terrain, the neighbouring heights and, as one critic wrote, 'the entire ground occupied by the allied troops.'[2]

Like the great nineteenth-century realist novels, the photographs demand to be 'read' for the detailed observations they provide. The *Literary Gazette*, virtually alone, read the evidence most accurately:

> The views of Balaclava Harbour and the adjacent plain, with the unloading of the transports and the arrival of the materials for the railway, the quays everywhere covered with cattle for sustaining life, and piles of shot and shell for annihilating it, illustrate in a variety of scenes the stirring and deadly business of the period. . . . It is obvious that photographs command a belief in the exactness of their details which no production of the pencil can do. . . .[3]

The photographs of the Crimea have the same context as the portraits and views, but the meaning is transformed by the gravity of the situation. Many lesser critics failed to comprehend Fenton's grave message and commented endlessly on the quaintness of the uniforms of the *cantinier* and the foreign troops, and the perfection of the prints: the *Art Journal* even found *The Valley of the Shadow of Death*—strewn with cannonballs—'a most exquisite photograph.'[4] However, perhaps more than anything else, the photographs convey the tedious sameness of the soldiers' existence.

1. 'History's Telescope', *The Leader*, 2 September 1855.
2. 'Mr. Roger Fenton's Photographs of the Seat of War', *Manchester Guardian*, 25 September 1855.
3. *Literary Gazette*, 22 September 1855.
4. 'Photographs from Sebastopol', *Art Journal*, 1 October 1855, p. 285.

Landscape

Landscape and architectural subjects provide the continuous thread running throughout Fenton's ten-year photographic career, sometimes dominant, sometimes curving away, like the serpentine line, in favour of other, more temporary, interests or preoccupations. These two main themes are in many respects interdependent, but for the purpose of these essays all views will be placed into the landscape category which are not clearly studies of particular buildings. Fenton's landscapes often include buildings, people or other objects of interest, but for the most part these are not given particular focus. His figures do not dominate the scene, or hold the attention of the viewer; they are creatures of the landscape, as the various houses, bridges or ruins are part of their particular locality.

The two themes of landscape and architecture also divide naturally into regional areas, which are likewise interdependent, some of the landscapes clearly having been taken on expeditions to architectural sites, and vice versa. Some areas Fenton clearly visited only once, as with Scotland in 1856, when presumably Balmoral was his destination, but the views of Braemar, the valley of the Dee and Dunkeld, are ultimately the more important pictures from that journey. Similarly, the pictures of Lindisfarne, Newcastle, Berwick, Melrose and Roslin Abbeys and Edinburgh, all exhibited in the same year, would presumably have been taken on the journey north from Yorkshire. Fenton's role as self-appointed 'professional', in which he worked as would an artist, turning out mounted, saleable work of the highest quality, undoubtedly was made easier by a modest financial independence. His progress from site to site and his considered, thorough approach to his subjects are in the tradition of the great British romantic poets and artists, rather than the commercial tourist photographers of the latter part of the century.

Tourism, however, was an established phenomenon by the time Fenton began photographing. Certain places had been claimed in the eighteenth century or earlier by artists and writers as ideal subject matter and were focal points for travellers. These inevitably were sites which were found to have characteristics associated with the vogue for the romantic and the picturesque: humble cottages, gothic ruins, rambling ivy or other vegetation, winding rivers, streams or paths and the distant mountains of the eighteenth-century sublime. Fenton made photographs at many such sites: the major abbeys, country houses, the Lake District, North Wales and Scotland, and it is possible that he had sketched from them at an earlier date, or perhaps at the same time. His tutor, Charles Lucy, certainly worked in the Lake District during the time Fenton knew him, in spite of being known for his historical subject matter and portraits, and Fenton is known to have made watercolour sketches in the Crimea. However, no known title of a painting by Fenton would support the view that he produced finished landscapes.

The homes of his own and his wife's families in Lancashire and Yorkshire were excellently placed as bases for a great number of Fenton's most successful pictures, and the appearance of his wife and daughters in a number of them supports a theory of Fenton as a photographic entrepreneur, practising and promoting the art of photography within his own lifestyle, and returning to London to make the most of his expeditions, both by communicating his experiences and techniques to his colleagues through the Photographic Society, and by publishing and exhibiting his work to a wider audience. His own family was scattered in the country north of Manchester, between Heywood and Ribchester, within relatively easy reach of the Lake District and Furness Abbey, the Ribble and Hodder river valleys, Bolton Abbey and the Lancashire/Yorkshire border. His wife, Grace, came from East Harlsey, next to Mount Grace Priory in Yorkshire, and a close affection for the place might be assumed from the fact that the Fenton's house to the north of London was called 'Mount Grace'. Almost certainly, the studies of the major cathedrals of the eastern half of the country were made *en route* for Yorkshire, and once there, a number of major sites were within relatively easy reach: Fountains and Rievaulx Abbeys, Richmond, Harewood House, Ripon, York and Durham cathedrals.

The Lancashire countryside around Rochdale and Bury, although altering radically throughout Fenton's childhood, was even more scarred by industrialisation by the time most of his major pictures were taken in the latter half of the 1850s. Ruskin, in lectures only days apart in Manchester and Bradford in 1859, describes an extraordinary mixture of the picturesque surviving amongst the furnaces of future madness; of destruction of a kind against which he is not yet quite hardened. In Manchester, he described a romantic vision:

> The drive from Rochdale to Burnley is one of the grandest and most interesting things I ever did in my life . . . the cottages so old and various in form and position on the hills—the rocks so wild and dark—and the furnaces so wild and multitudinous, and foaming forth their black smoke like thunderclouds, mixed with the hill mist. . . .[1]

Later, at Bradford, though still engaged, he is more regretful:

> Naturally the valley has been one of the far-away solitudes, full of old shepherd ways of life. At this time there are not,—I speak deliberately, and I believe quite literally,—there are not, I think, more than a thousand yards of road to be traversed anywhere, without passing a furnace or mill.[2]

With the exception of very few pictures, notably *Bobbin Mill at Hurst Green*, this is not the subject matter of Fenton's photographs. Ruskin, on the journey described, was on his way to one of Fenton's major sites, Bolton Abbey, and Fenton must have known that road well. By his own confession, when departing for Rievaulx in 1854, he was 'in search of the picturesque'.[3] But, that said, this was to the members of the Photographic Society, and could have been in part an easy means of expression.

Fenton's approach to landscape certainly started with typically picturesque subjects, incorporating the line of beauty and contemporary notions of breadth of effect and aerial perspective—effects he gained and was sometimes praised for by the critics. Fenton's figures, like those in J. M. W. Turner's landscapes, never have particular identities or character, they are never

in close-up and are always subordinate to the overall subject. There is a strong feeling of the few figures in his pictures being in the hands of destiny, especially in the pictures of Hurst Green. In *Bobbin Mill at Hurst Green* the people stand, in the middle ground, dotted along the winding line of the road, some by the pile of chopped wood; farther along, a couple gaze over the bank to the unseen stream below. The stream, at once an emblem of the picturesque, pastoral past, and now also the force which drives the mill, is pictorially usurped by the serpentine road. In another picture, *Cottages at Hurst Green*, an afternoon haze lingers over the village, entirely surrounded by woodland. A small group of villagers stands, again in the middle ground, among piles of sawn-up tree trunks, gazing at some unseen activity in the woods to the right, probably woodchoppers. The past, present and future enfold the figures in both pictures; the trees become felled trunks—symbols of the destruction necessary to make bobbins for thousands of looms—in a process into which these people are inevitably bound. In both pictures the gazes are directed to the unseen, the future that Ruskin already warned of: 'but what is it to come to? How many mills do we want? or do we indeed want no end of mills?'[4] Within a few years, the cotton famine would hasten the decline of the cotton industry in Lancashire.

A mile or so away from Hurst Green is the convergence of two rivers, the Ribble and the Hodder, the latter of which divides Lancashire and Yorkshire. On the banks which mark deep seated divisions between Englishmen, Fenton made a group of highly successful views which range from the classical through the picturesque to a new, more abstract vision of that green and pleasant land. In *The Keeper's Rest at Ribbleside*, the overall detail is a source of lingering delight, and binds together the horizontal bands of the composition. The picture is taken from a position almost directly opposite the bank, which forms an almost vertical plane, parallel with the picture surface, or the camera-back. The river, temporarily at rest, is a shiny strip across the bottom, but in the winter months its furious pace created the tangle of jetsam, small trees and branches delineated on the bank below the figures. There is a temporal satisfaction in the arrested detail which is almost visionary.

In *Down the Ribble, the Through's Ferry*, the dramatic curve of the bank unfurls, leading down to the fishermen silhouetted against the light vista of the distant countryside. To the careful eye, the dark sweep on the right divulges the minute detail of the natural cycle of the river bank: the men, small in the hand of God, indulge in the age-old act of fishing for food. The river, reflecting the light of the sky, is the life-force, and fields in the distance reveal the ordered, man-made existence so recently disordered by industry. Close by, the Reed Deep on the Ribble is one of several places of which Fenton made a number of alternative views. Together they show the curve and path of the river deep into the landscape, one an eighteenth-century, classical composition, the placid river conveying a profound peace; the very English still waters of the Psalmist, in country which was sharply divided by the current crisis of faith. In perhaps the greatest picture of the group, *Valley of the Ribble*, Fenton turned the camera directly across, at right angles to the foreground stretch of the river, creating his favourite, horizontal layering of the landscape, playing with the abstracted reflections of the round trees along the lower edge, the precision of the cornstacks in the field above drawing the eye across the divisions, over the autumn scene, to the distance and—through the lens—to infinity. These are the Pendle Hills, and Fenton is practising the black art in the heart of Lancashire witch country, the subject of the classic mid-Victorian romance, *The Lancashire Witches*. Gothic and romantic associations aside, these

pictures impress us by their innovative creation of space and distance by totally unprecedented photographic means.

The landscapes range from these essentially classical, pastoral images to the romantic, rushing waters on the rocky beds of the tributaries of the Dee in Scotland, or the streams, falls and mountains of the Lake District and North Wales, already fertile subject matter for the Pre-Raphaelites and others. In 1853, John Everett Millais painted Ruskin and Effie by a rocky river bed in Glenfinlas, a subject which corresponds closely with many of Fenton's in Scotland and North Wales. With the camera, however, colour and the expressive brush-stroke were unavailable, and the exposure time turned water into milk. Different resources had therefore to be found.

Each of the images in the group photographed in North Wales in 1857 is taken within a triangle bounded on one side by the Conway Valley. Whereas in Scotland Fenton kept mostly to the valley floors, with their stony and wooded banks, in North Wales he travelled the more barren heights of Llyn Ogwen and the Nant Francon Pass. These photographs are the nearest Fenton came to an intense expression of place. Confined to a relatively small area, but one with great geographical contrasts, Fenton exploited the possibilities of the camera as never before. In two river studies, formally ostensibly similar, *Fors Nevin on the Conway* and *Double Bridge on the Machno*, he demonstrated an unparalleled virtuosity with the camera. The former is the essence of the picturesque: the light filtering through the trees to the trickling water delineates detail in the foliage and leaves the water calm and the air palpable; it is an entirely credible and conceivable, but ideal view. In the view on the Machno, however, our senses are confused; it is impossible to tell what is air, reflection, water or stone. It is the reduction to monochrome which is the powerful element; the light or not light—shadow or stone, light or lichen. Fenton used the limitations of the medium as pure assets, the detail of the collodion negative and the glossiness of the albumen print compounding the confusion by their rendering of the scene with an almost mirror-like faithfulness—one which has in the end to be believed as real. Fenton was here able to address directly the simplest truths, the most radical properties of camera vision, and thus reveal its most sophisticated potential. Travelling higher, he made two views of the Nant Francon Pass from different heights; in one the pile of rocks in the foreground provides a focus, but in the higher one, the river winds away into the distance, glinting serpent-like with reflected light, over a barren, rocky landscape which seems to date from the formation of the earth's crust. Taken only a decade after Smith and Lyell founded the principles of modern geology, dating these very stones, one can only surmise the significance of photographic images such as these to the Victorian sensibility—not merely connotations of the romantic or the sublime, but actually 'tests of faith'.

1. Quoted in Tim Hilton, *John Ruskin, The Early Years. 1819–1859*, New Haven and London, 1985, p. 259.
2. *Ibid.*, pp. 259–60.
3. *Journal of the Photographic Society*, 21 January 1856, p. 286.
4. Quoted in Hilton, *op.cit.*, p. 259.

Architecture

Fenton's studies of British, mainly English, architecture were almost certainly influenced by his attitude to architecture and the arts in general, and perhaps most of all by his experiences in Paris in the 1840s. That he was genuinely concerned about the standards of contemporary building, decoration and craftsmanship is confirmed by his involvement, in 1850, in the founding of the North London School of Drawing and Modelling, based on French models he had seen in Paris, and by his service on its management committee. At the same time, he would have been aware, through, among other things, the work of Viollet Le Duc and the Commission des Monuments Historiques in France and the publications of Ruskin in England, of the revival of interest in both late medieval architecture and the preservation of ancient monuments. In Paris, in October 1851, he visited the headquarters of the Société Héliographique, where Gustave Le Gray showed him several hundred waxed-paper negatives taken by himself and Mestral in Touraine and Aquitaine for the Commission des Monuments Historiques. The recognition in France of the value of preserving historic buildings—many of which were in advanced states of deterioration—and of the role that photography could play in this, had led the French government to commission photographers to document important regional sites. Fenton must have been all too aware of the contrast between this and the attitude in Britain, where the documentation, preservation and conservation of ancient monuments remained for many years a predominantly antiquarian and amateur pursuit, and it was left to amateur societies, such as the Photographic Society or the Architectural Photographic Association, founded in the 1850s, to acknowledge the potential of photography for this kind of historical documentation.

In Britain, the Gothic Revival was at its height, and issues of style were bound up with spiritual and moral debates. Recent discoveries in science and natural history threatened Christian beliefs. Protestant and non-conformist churchmen fought to counter the mystical and alluring dogmatism of Cardinal Newman and the Oxford Movement, which sought to maintain the ultimate power of the Church and to reconcile Catholic and Anglican. The ethical and liberal views of Matthew Arnold, and the reasonable scepticism of J. A. Froude, were further facets of a range of attitudes current at a time when atheism seemed to be gaining support among intellectuals. The abbeys, evidence of a Catholic past in a Protestant country, and the great Gothic cathedrals were seen to embody spiritual values which could be reasserted in the current crisis.

The fascination with pre-Reformation architecture was a notable feature of the picturesque tradition in art and literature which looked back to the paintings of Claude Lorraine, Gaspard Poussin and Salvator Rosa, into whose idealised landscapes buildings, often exotic or ruined, had been introduced as a means of both creating mood and commenting on the complex relationship

between man, nature and time. Fenton's early architectural photographs are significantly indebted to this tradition. His response to the negatives shown to him by Le Gray and Mestral in Paris was that 'The subjects were mostly such as were equally interesting to the antiquarian and the lover of the picturesque',[1] an approach which seems to have coloured his own initial efforts. Some of the sites he photographed corresponded to those traditionally favoured by William Gilpin and other picturesque travellers: the Wye and South Wales, the Lake District and the Highlands. Although his architectural views do not amount to a complete survey and, as far as is known, are not the product of any official commission, his studies of certain sites are reasonably comprehensive—consisting of a number of views—and seek both to establish the relationship of the building to its locality and, in many cases, to document architectural details or interiors.

The pictures of Fountains and Tintern Abbeys, taken in 1854, conform to the picturesque tradition and show the partially ivy-clad ruins set in light, hazy, undulating landscape, with leisurely travellers of the Gilpin ilk strolling or seated in the middle distance. The group of images of Bolton Abbey, taken during the same year, concentrates more on the wooded river valley than on the actual structure, and through effects against the light (*contre-jour*), emphasises the abbey's brooding, Gothic quality. In this excursion he was following in Tennyson's footsteps, and in Wordsworth's before that. Tennyson had described the abbey in a letter of the mid-1840s:

> I am at present in the classic neighbourhood of Bolton Abbey whither I was lead the other day by some half remembrance of a note to one of Wordsworth's poems . . . Wordsworth having stated (as far as I recollect) that everything which the eyes of man could desire in a landscape was to be found at and about the Abbey aforesaid. I coming with an imagination influenced and inflamed, and working upon this passage, was at first disappointed but yesterday I took a walk of some . . . nine miles, to left and right of the Wharfe, and you may conjecture that no ordinary charms of nature could get nine miles out of legs (at present) more familiar with armchair and settle than rock and greensward, so that I suppose there is something in what Wordsworth asserts, and that something will probably keep me here some time. . .

The same buildings, monuments and statuary were also evidence of a historical past, and part of a practical search at a time when preservation and restoration were becoming major preoccupations. Some of Fenton's architectural images document the Gothic-style buildings of the period; among them were the new Houses of Parliament, the Natural History Museum at Oxford and Balmoral Castle. The Houses of Parliament were the subject of a series of views taken in 1857, when the building was almost complete but scaffolding still featured on the towers and Big Ben. Fenton started the series from across the river at Lambeth Palace, then moved downstream from Westminster Bridge before photographing in greater close-up; finally, in a view from the top of Whitehall, Big Ben is visible in the distance. The views from across the river show the now familiar outline of the building above a river which has almost turned to milk during the long exposure, only the ruffled edge of a wave around a solitary paddle steamer breaking the surface. The view from beyond the bridge is one of Fenton's most successful, and has enormous breadth and atmosphere, while the view of the entrance to the House of Lords shows the fine carving and decoration in the Gothic style, the surface of the matt print combining visually with the stone of the building. It is the fine, matt process used for these prints which is a part of their attraction, as with those of Kensington Gardens.

The many views of the great cathedrals, abbeys and country houses are consistently fine, and it is difficult to distinguish between them for comment. Those of Lichfield, which, from a restricted distance, move around the cathedral from the facade to the side, gradually including the full height, use the limitations of the rising front to great effect. In earlier views of Tewkesbury Abbey, Fenton angled the camera low to include the graveyard in the immediate foreground, usually empty in such views, with extraordinary technical virtuosity. The gravestones recede rapidly in almost horizontal space and long depth of field to the west front of the abbey. Some of the most impressive photographs are those of Lindisfarne, on Holy Island, taken on his way to Scotland, via Newcastle and Berwick, in 1856. The great empty ribbed vaults reveal their skeletons against the sky, and figures sit among the ruins, ordinary folk looking across the ages, out to sea. The detail of the dark stone work is contrasted against the light, as in a drawing, but photographic detail has its own rewards in the ordinary: the fall of a shirt sleeve, the cut of rough stone.

Of the major pictures of country houses, those of Hardwick and Harewood stand out as exceptional. Hardwick is photographed from a high viewpoint, level with the second floor, which has the effect of seeing the plan of the formal front garden as though it is in the same plane as the house. It is reminiscent of some of the paintings of the British School of the seventeenth century, a primitive view of the entire schema of the house and its land. At the same time, it is a bold statement: the frame is entirely filled by the house and the garden, the horizon is blotted out, and the slight angle at which the camera is set to the front of the house gives the picture its geometry and the photograph its vanishing lines. The distortion of the lens is felt even now, but how much more extraordinary it must have looked in the 1850s. At Harewood House, once more the geometry attracted Fenton. This series of studies centres around the formal garden terrace as a setting for social discourse: figures walk down the steps from the house or lean over the balustrade. In the climax to the series, the camera is turned away from the building and takes up the position of its occupant, looking down across the terrace where a group of men and women converse, to the park beyond. These are the nineteenth-century successors to a long British tradition of the country house in art; but in the last picture the tables are turned again. A gentleman on horseback is the focal point in a picture taken from the far side of the park, with the house in the distance. But this is not the lord of the house, the occupant—it is the visitor, the Victorian tourist; in fact, it is Grandfather Maynard, Fenton's father-in-law.

1. *Chemist*, February 1852, p. 222.

Cat. 16. Roger Fenton [possibly self-portrait] (*c*.1852).

PLATES

RUSSIA

Cat. 1. Moscow, Domes of the Cathedral of the Resurrection in the Kremlin (1852).

Cat. 2. Scaffolding for the Repair of a Church at Moscow (1852).

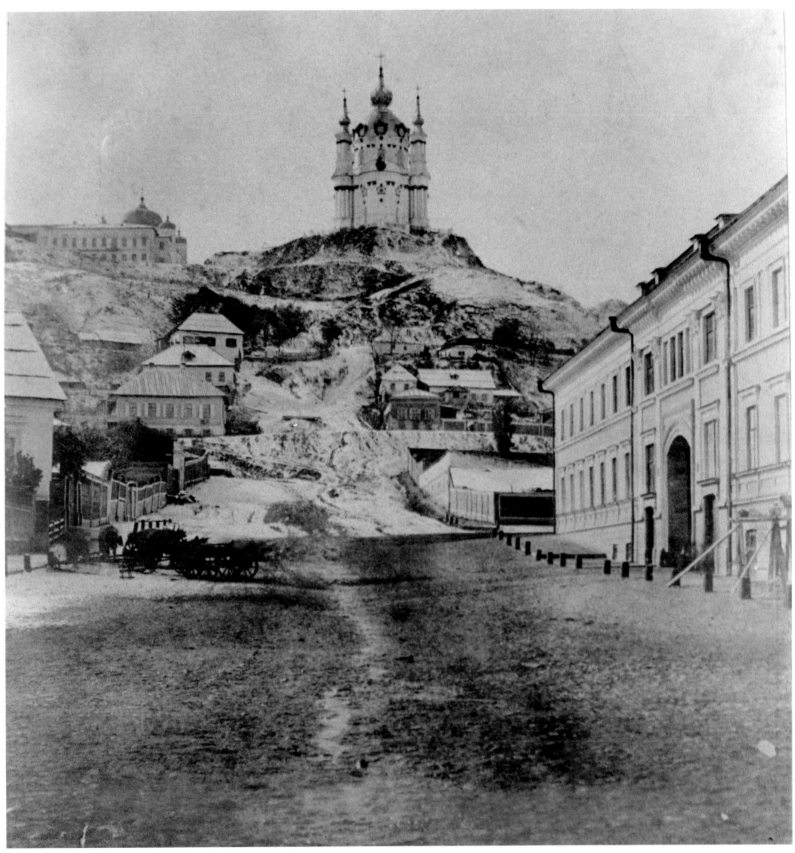

Cat. 3. Andreiski Church, Kiev (1852).

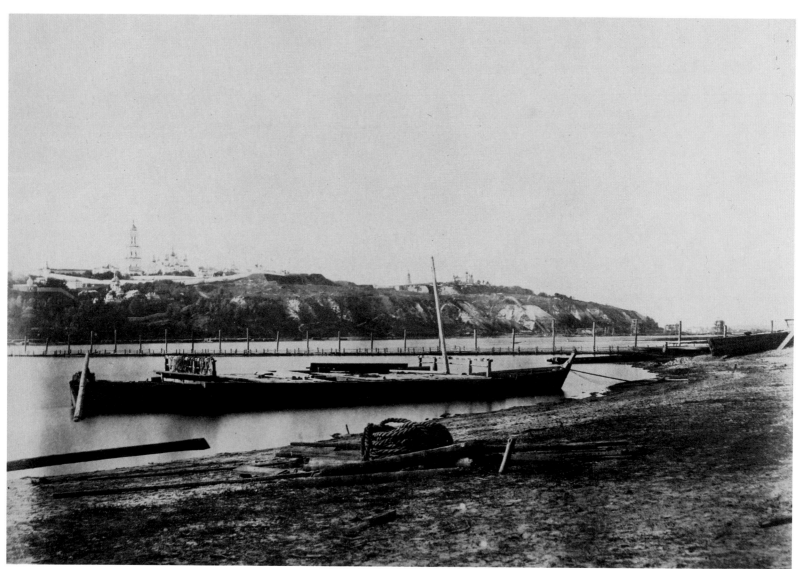

Cat. 4. The Floating Bridge across the Dneiper, Kiev (1852).

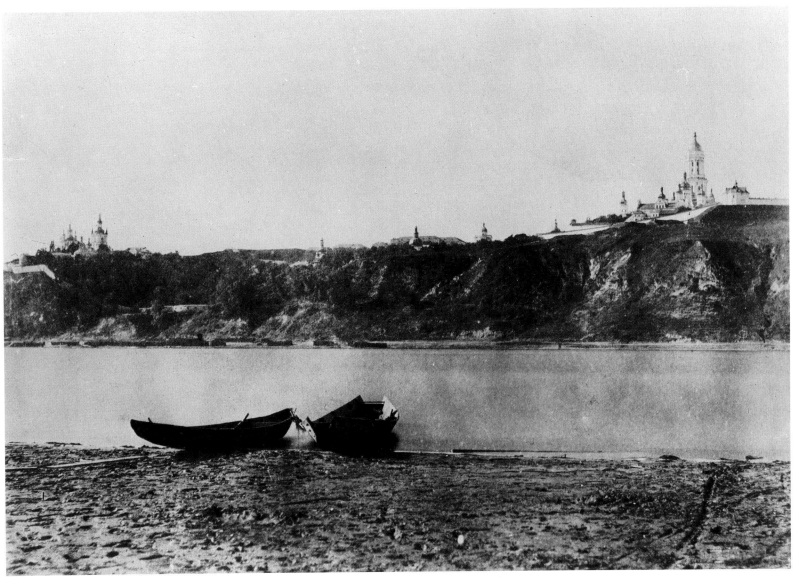

Cat. 5. The Great Lavra Monastery from the North Side of the Dneiper, Kiev (1852).

Cat. 6 (following page). The Post House, Kiev (1852).

PORTRAITS

Cat. 7. Prince Alfred, Duke of Edinburgh (1856).

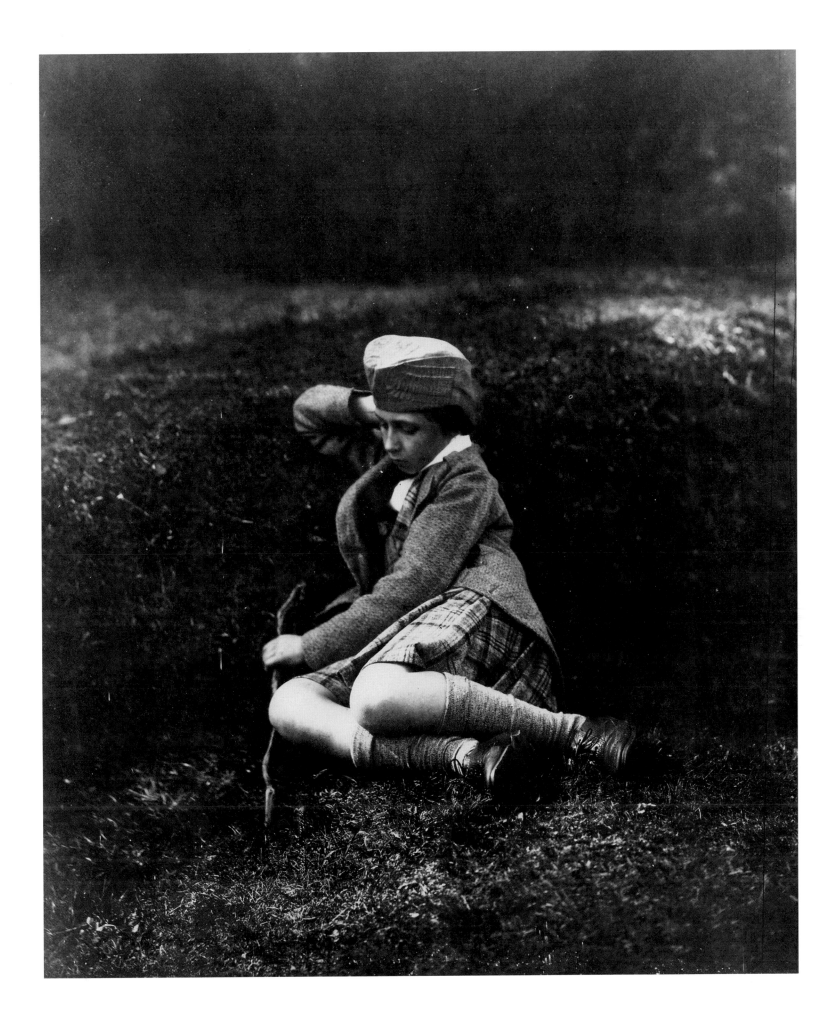

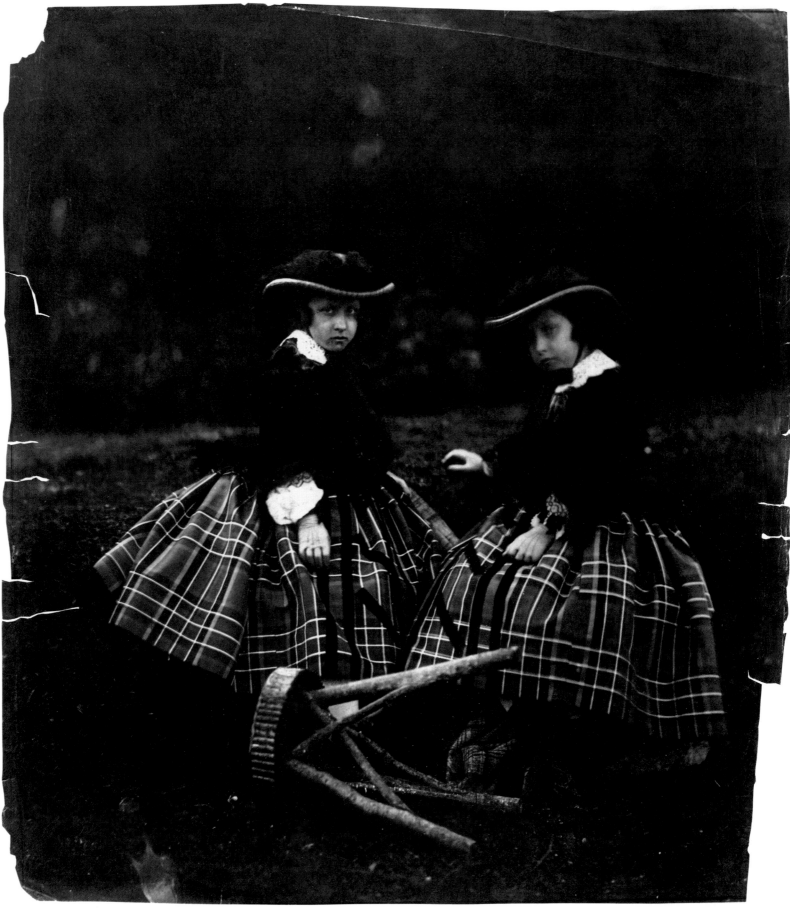

Cat. 8. Princesses Helena and Louise (1856).

Cat. 9. Princess Royal and Princess Alice (1856).

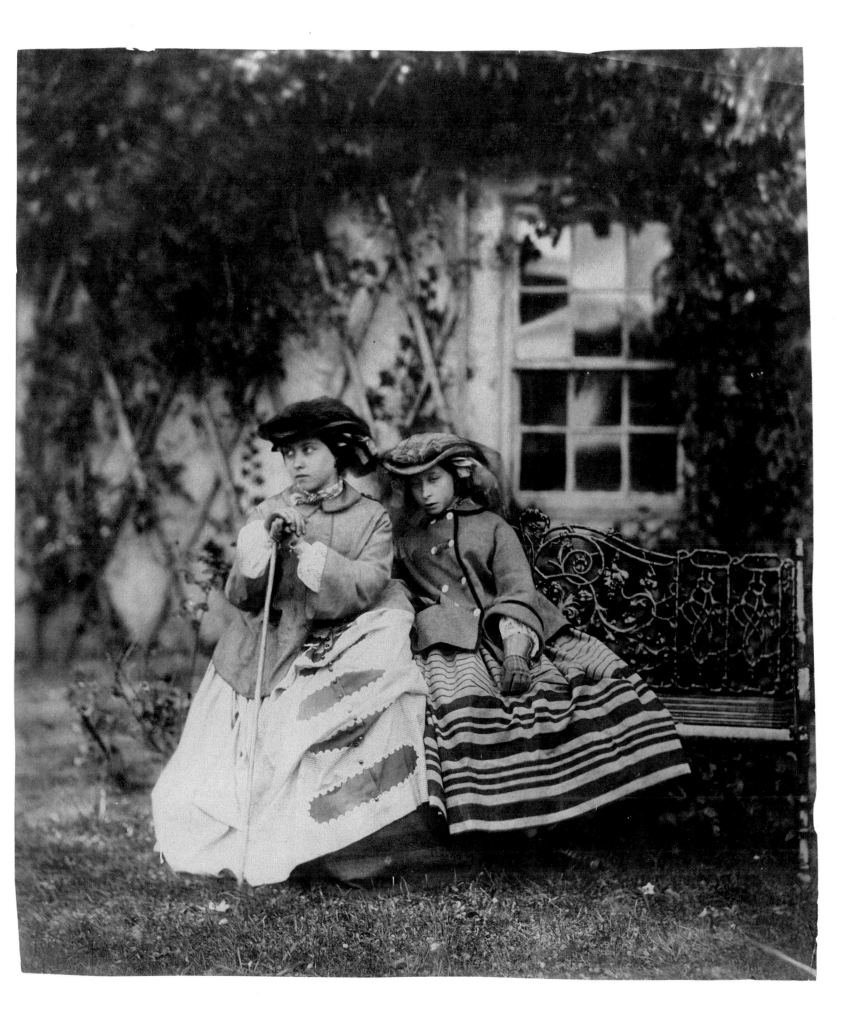

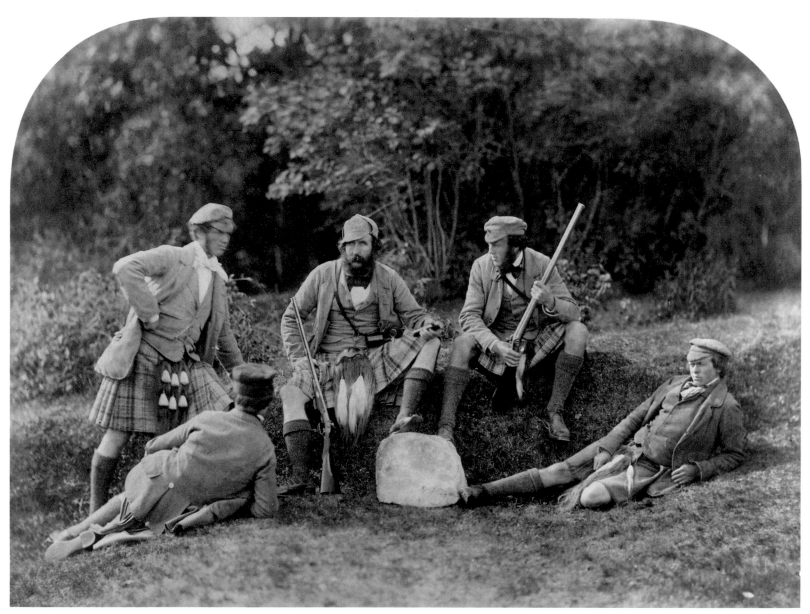

Cat. 10. Highland Ghillies at Balmoral (1856).

Cat. 11. A Ghillie at Balmoral (1856).

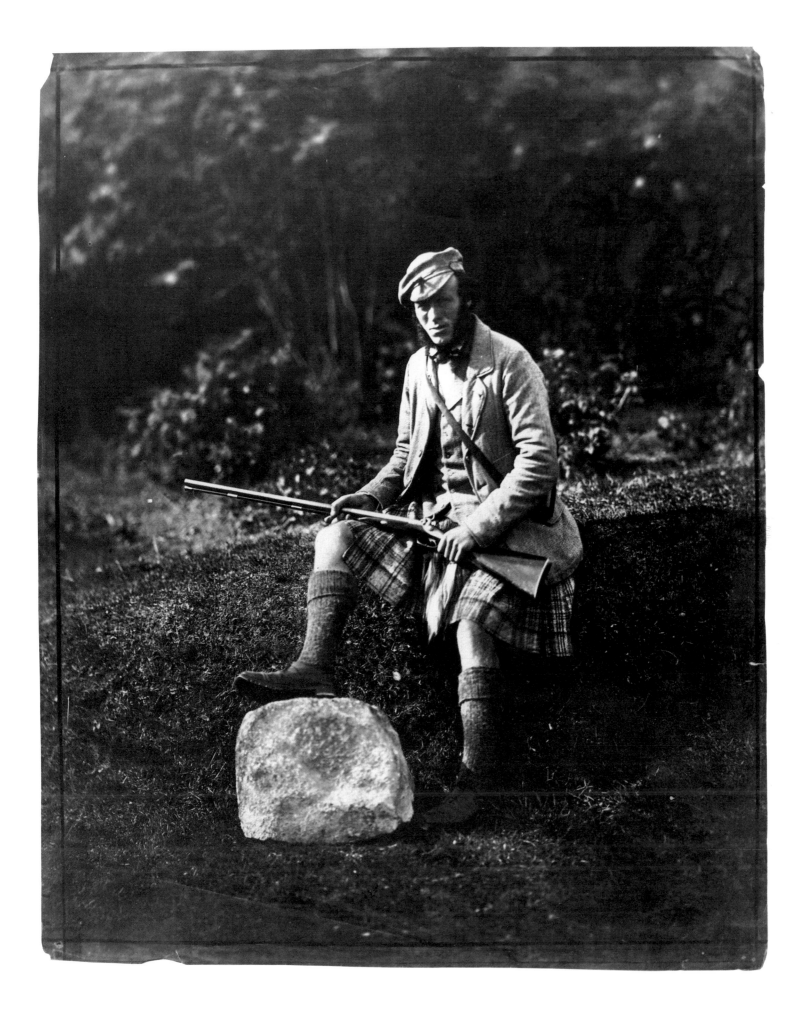

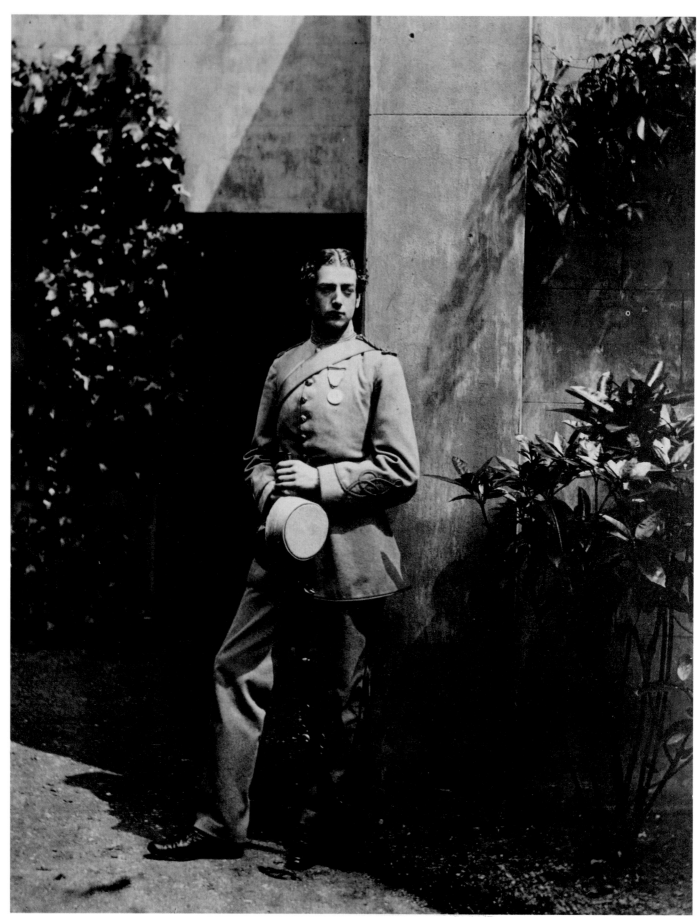

Cat. 12. Mr. Ross Jnr, the winner of the Queen's Prize, Wimbledon, July 1860.

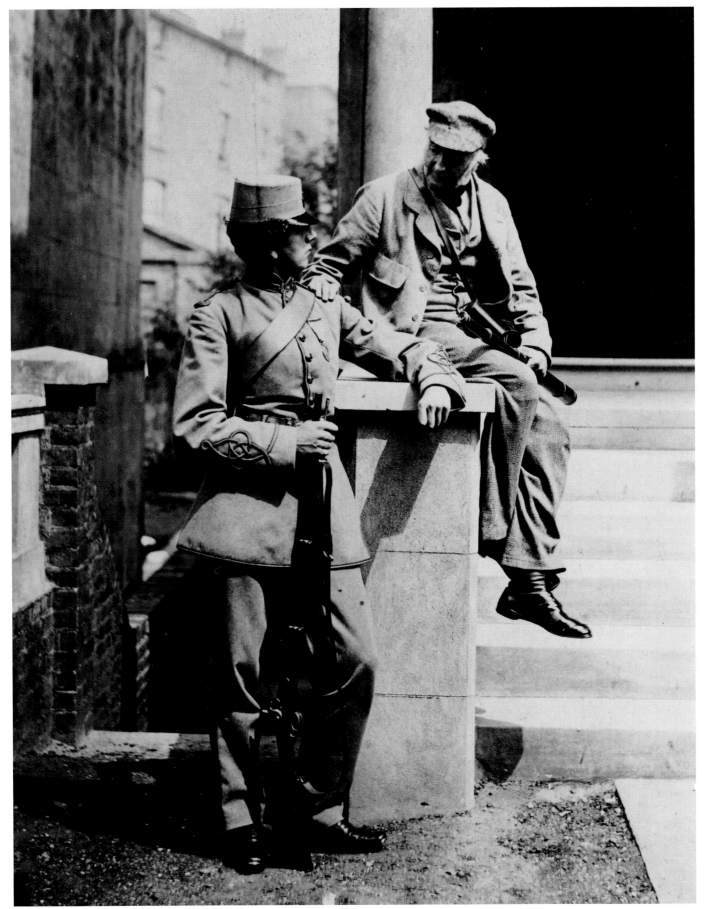

Cat. 13. Horatio Ross and Son, the teacher and pupil, Wimbledon, July 1860.

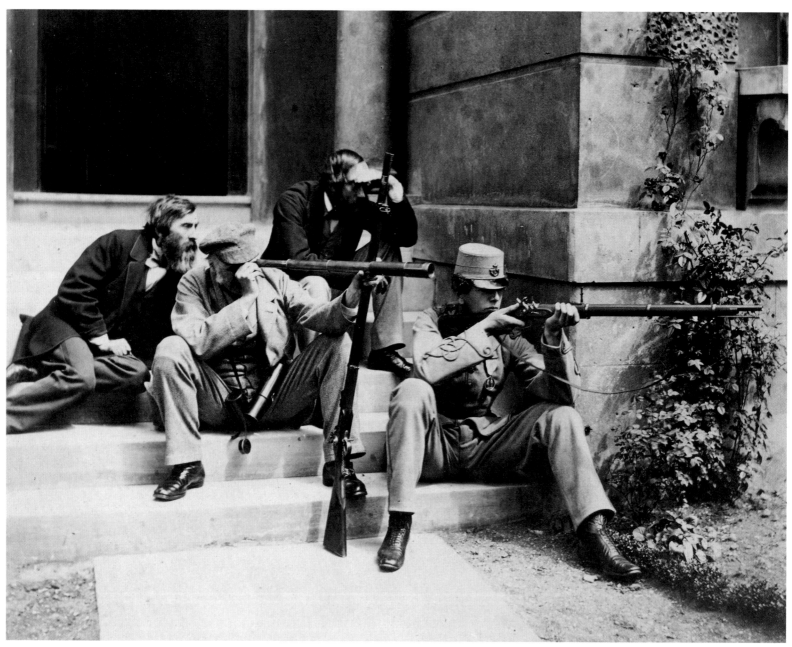

Cat. 15. Horatio Ross and his Son, the winner of the Queen's Prize, Wimbledon, July 1860 [from left: Charles Lucy, Horatio Ross, J. H. Parker, Mr Ross, Jnr.].

Cat. 14. Captain Ross, 57 points in the 3 periods, Wimbledon, July 1860.

Cat. 18 (following page). Roger Fenton in Volunteer's Uniform (1860).

THE BRITISH MUSEUM

Cat. 19. The British Museum, facade (1857).

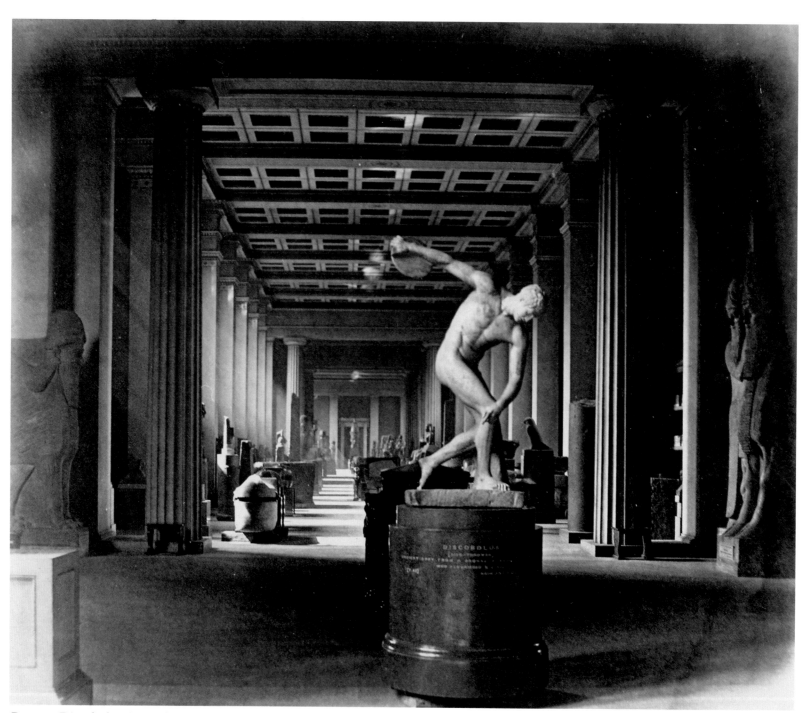

Cat. 20. Discobolus (*c*.1857).

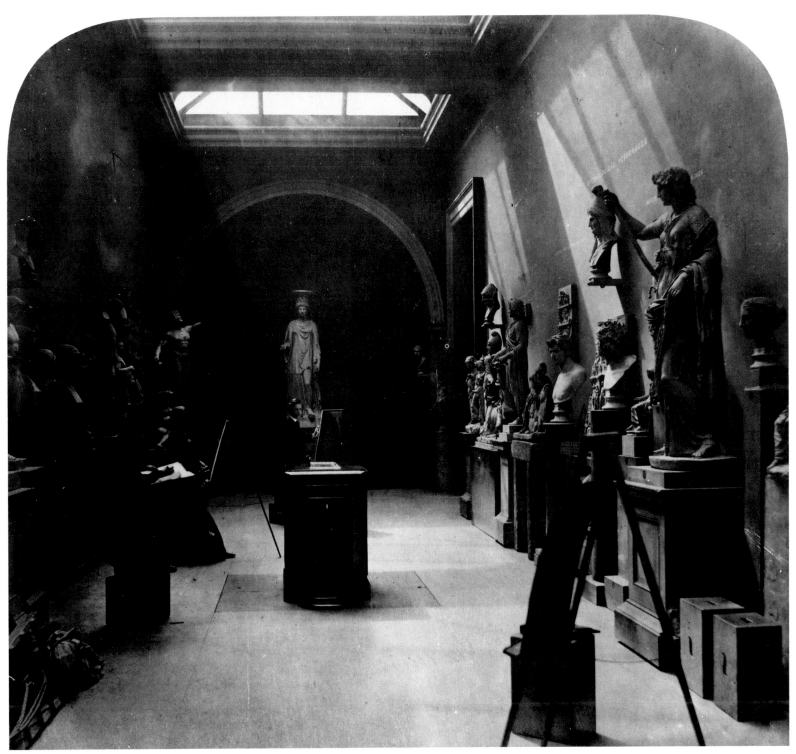

Cat. 21. British Museum, Gallery of Antiquities (*c*.1857)

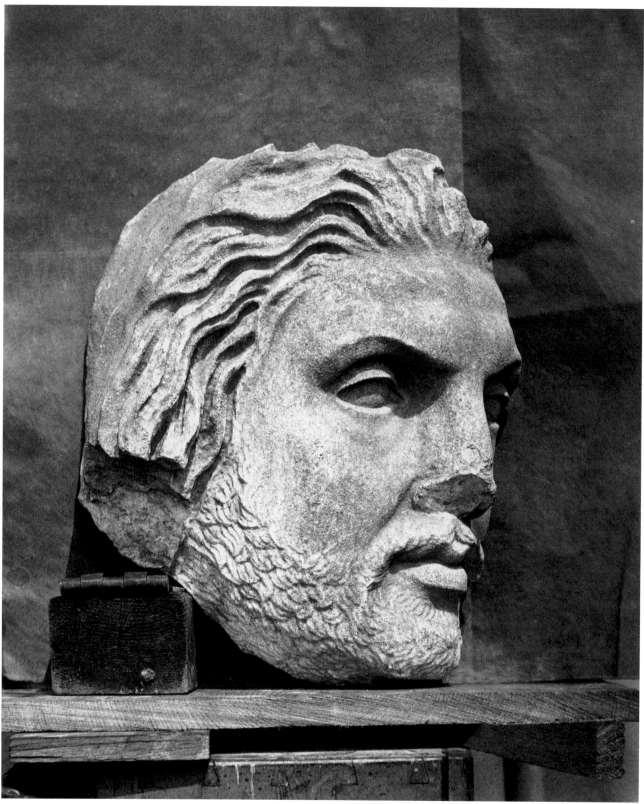

Cat. 22. Head from the tomb of Mausolus (*c*.1857).

Cat. 23. Greek Hero (*c*.1857).

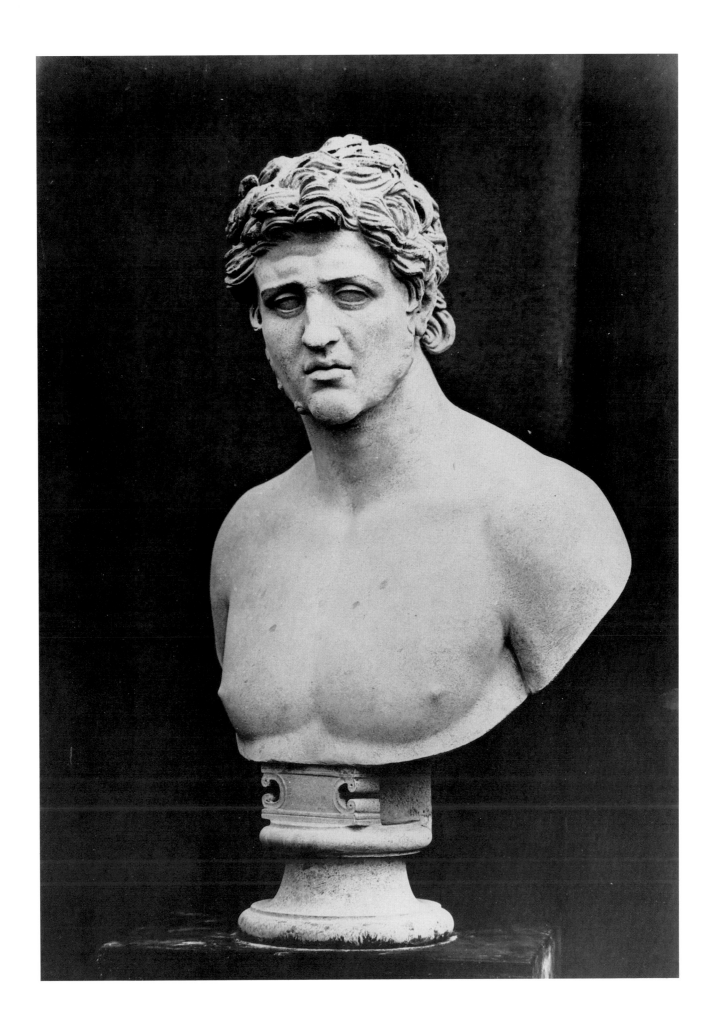

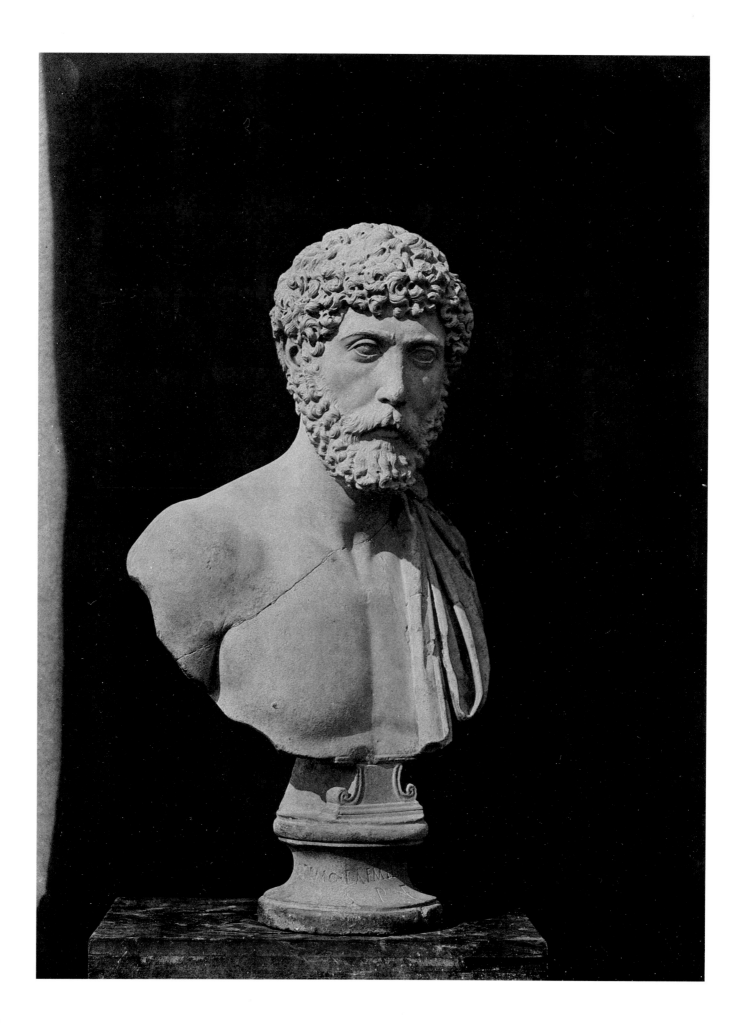

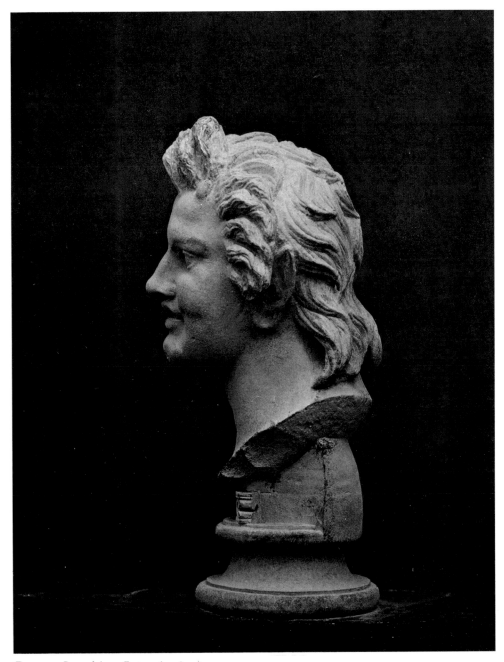

Cat. 25. Laughing Satyr (*c*.1857).

Cat. 24. Roman Portrait (*c*.1857).

Cat. 27. A Portion of the Crucifixion; after Memling, from a drawing in the British Museum (1858).

Cat. 28. Study of Drapery and Three Hands; after Raphael Sanzio, from a drawing in the British Museum (Payne Knight Collection) (1858).

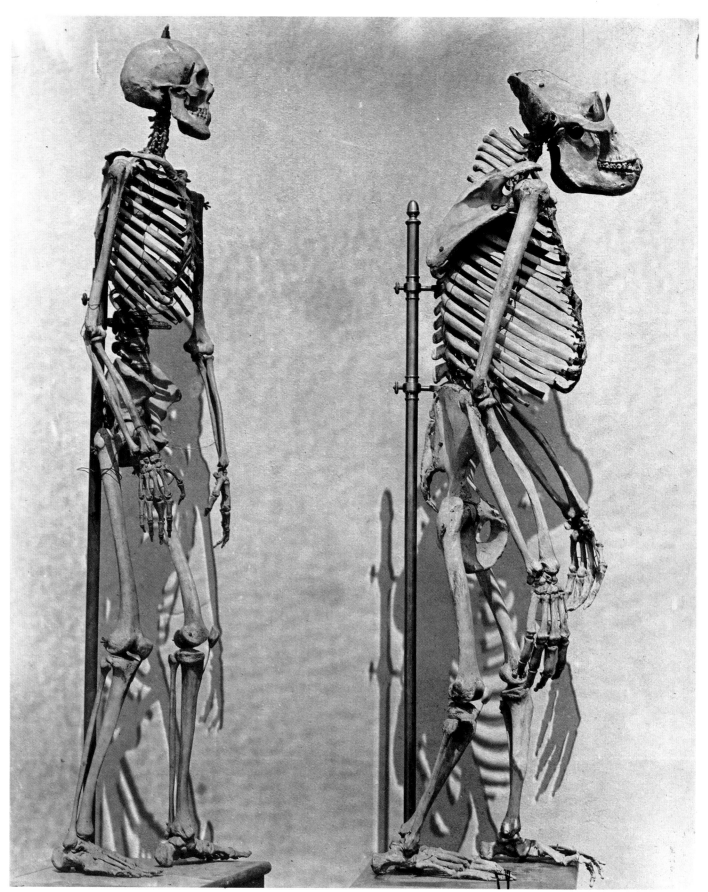

Cat. 29 and 30. Man and Male Gorilla Skeletons (*c*.1857).

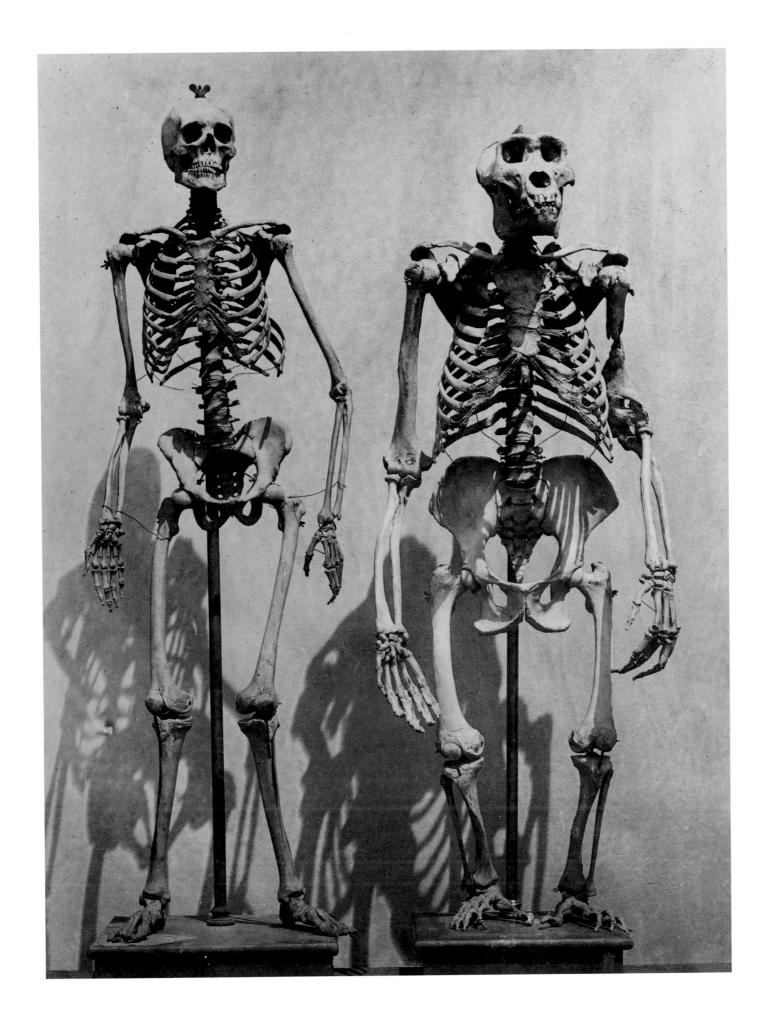

Cat. 26. The Gold Dish by Benvenuto Cellini (c.1857).

THE CRIMEAN WAR

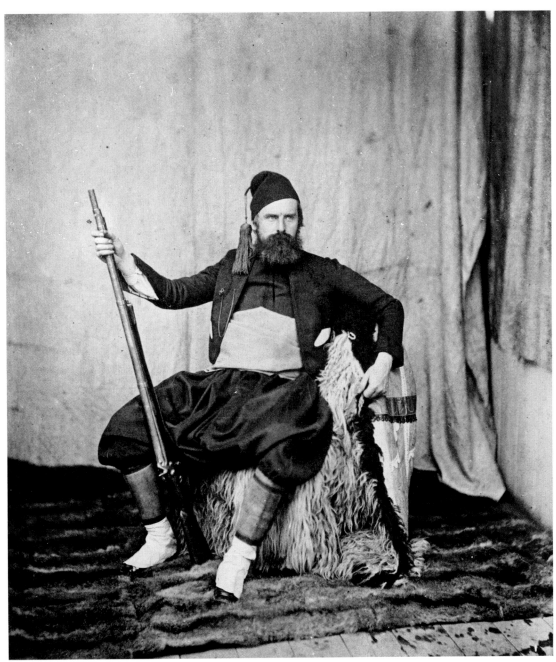

Cat. 31. Zouave, 2nd Division [Roger Fenton] (1855).

Cat. 32. Field Marshal Lord Raglan (1855).

Cat. 39. Marshal Pélissier (1855).

Cat. 38. Omar Pasha (1855).

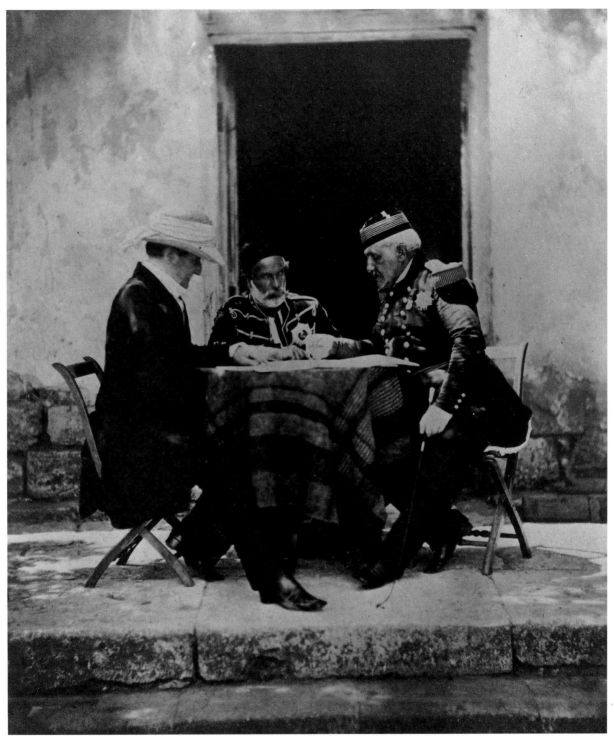

Cat. 47. The Council of War (1855).

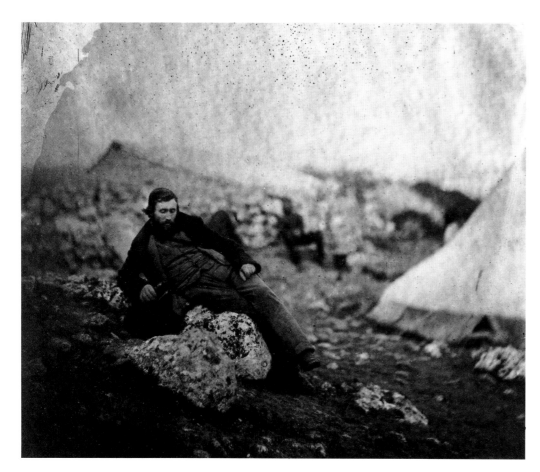

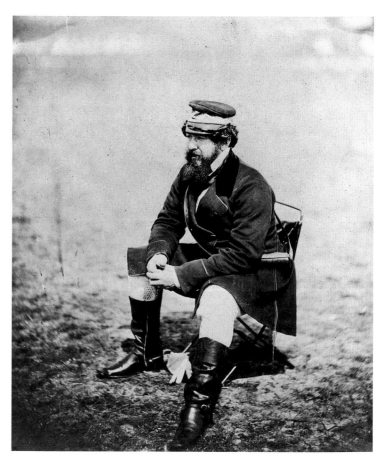

Cat. 44. William Russell of *The Times* (1855).

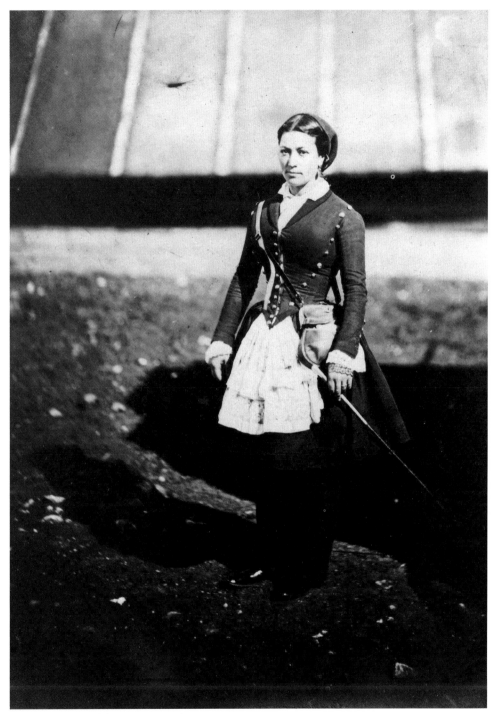

Cat. 42. Vivandière (Cantonière) (1855).

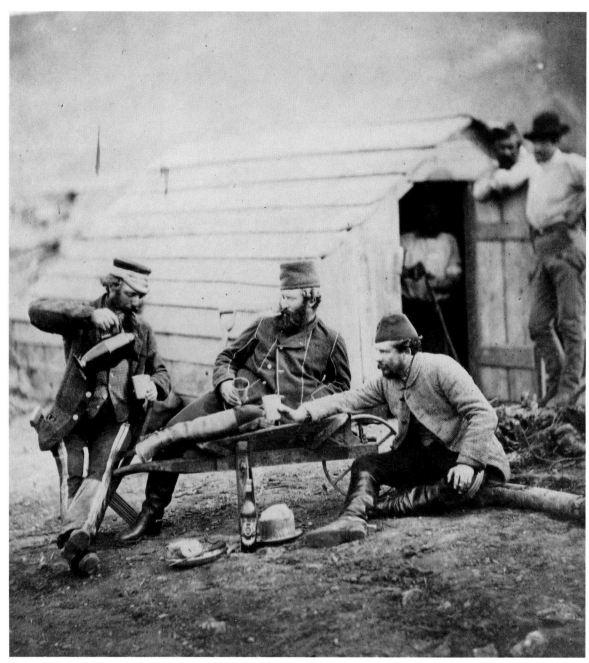

Cat. 45. Hardships in the Camp (Colonel and Captains Brown and George) (1855).

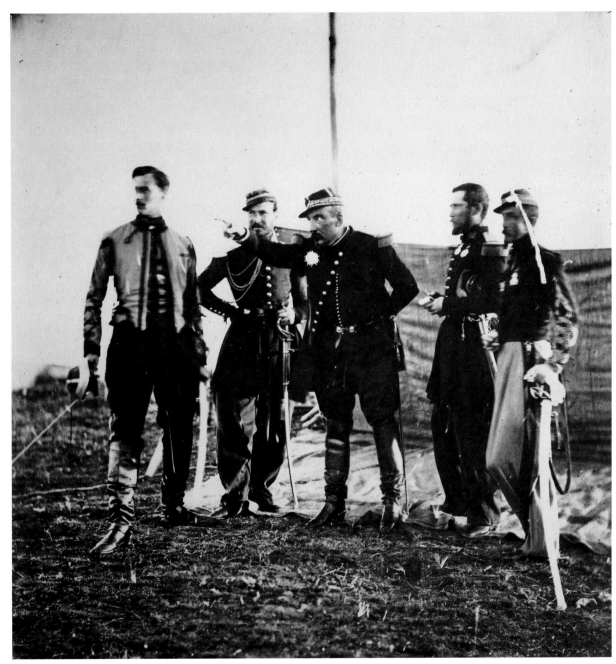

Cat. 46. General Bosquet and Staff (1855).

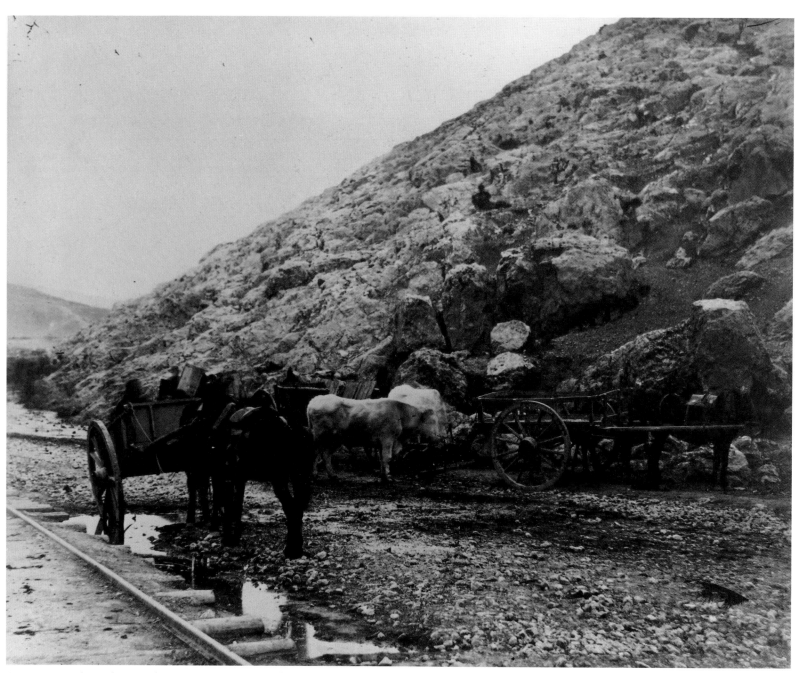

Cat. 50. Cattle and Carts leaving Balaclava Harbour (1855).

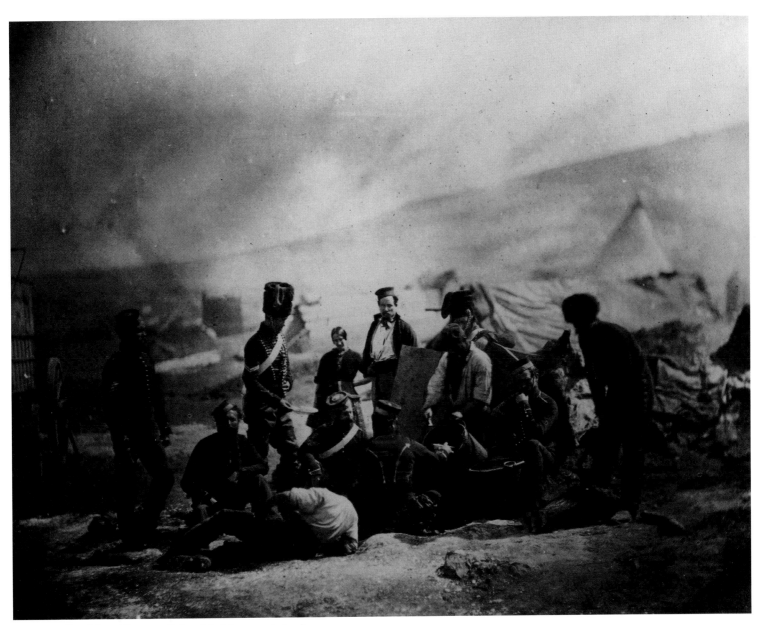

Cat. 61. Cooking House of the 8th Hussars (1855).

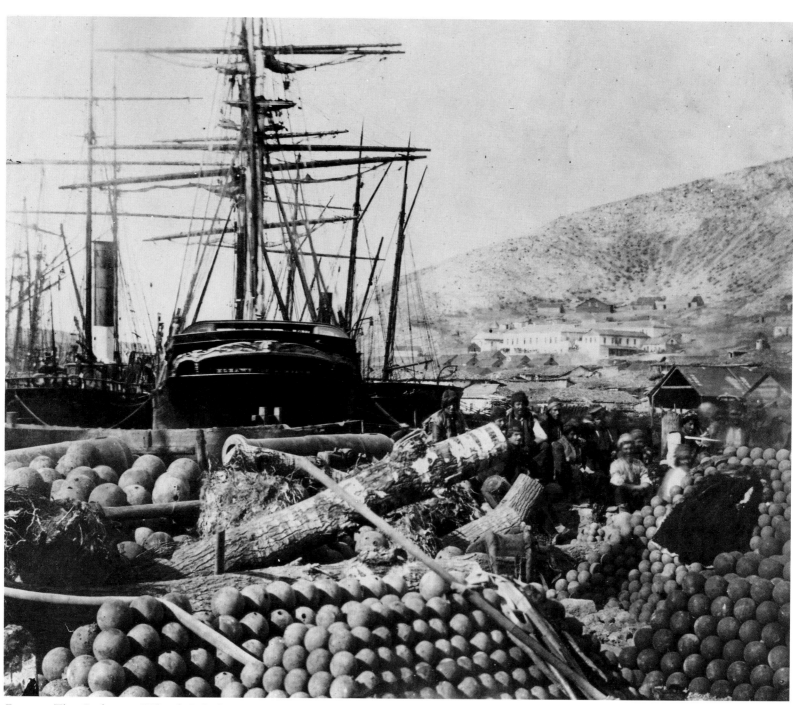

Cat. 54. The Ordnance Wharf, Balaclava (1855).

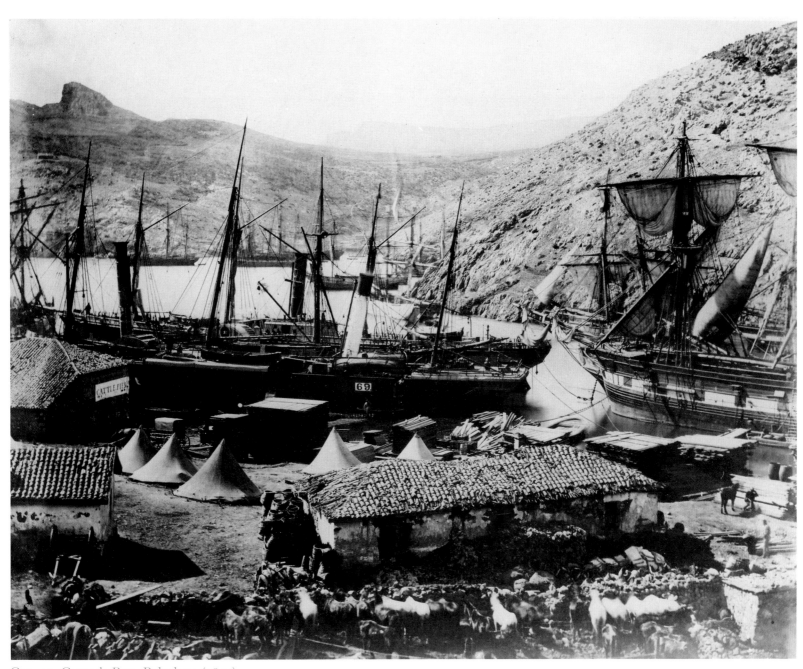

Cat. 53. Cossack Bay, Balaclava (1855).

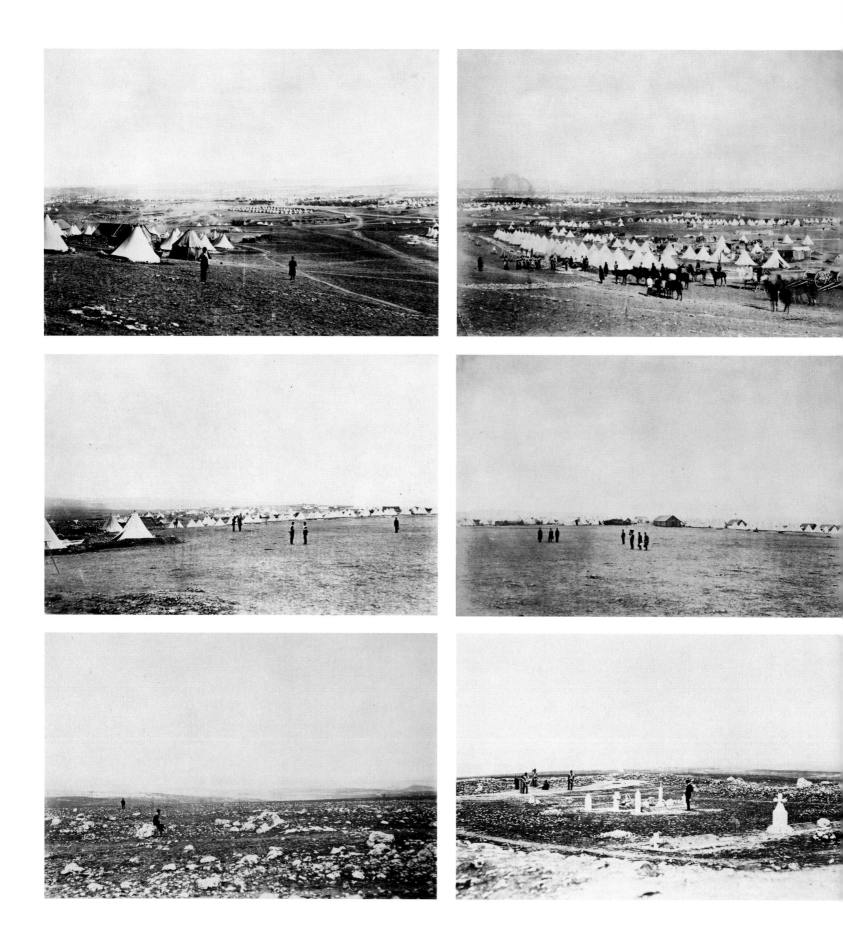

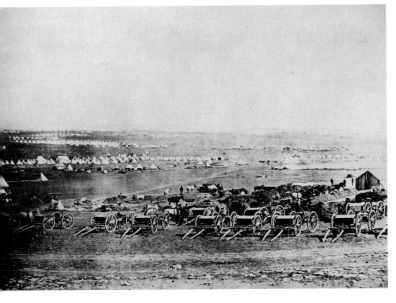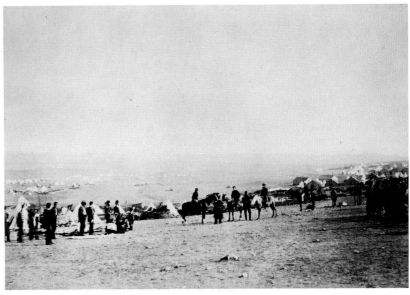

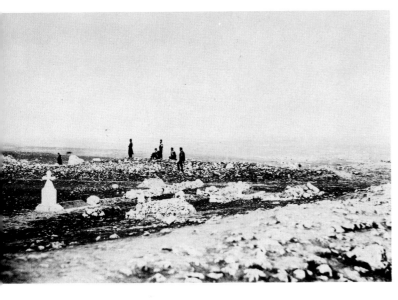

Cat. 51. Panorama of the Plateau of Sebastopol in eleven parts (1855).

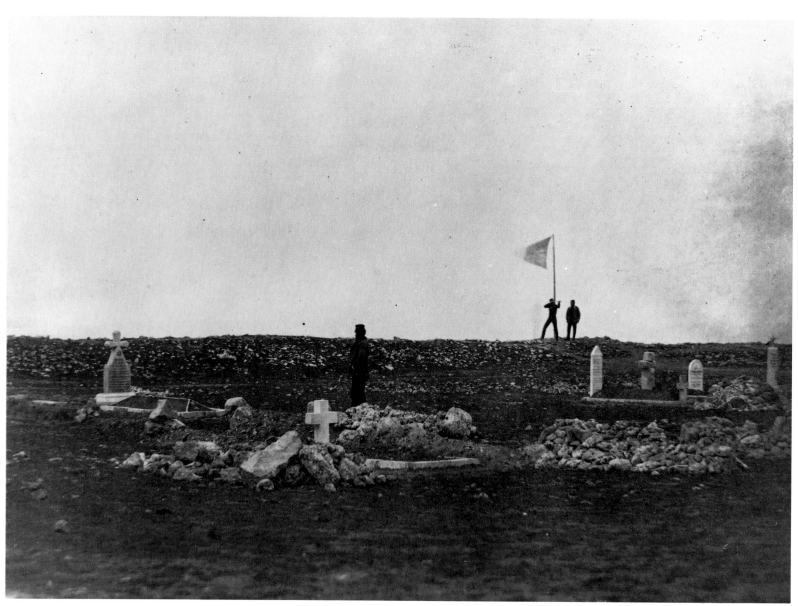

Cat. 60. The Tombs on Cathcart's Hill (1855).

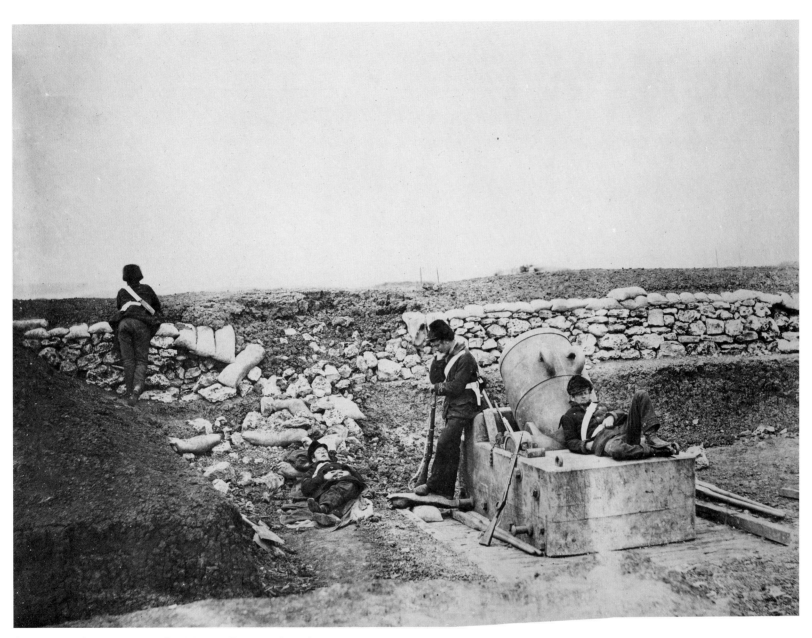

Cat. 57. A Quiet Day in the Mortar Battery (1855).

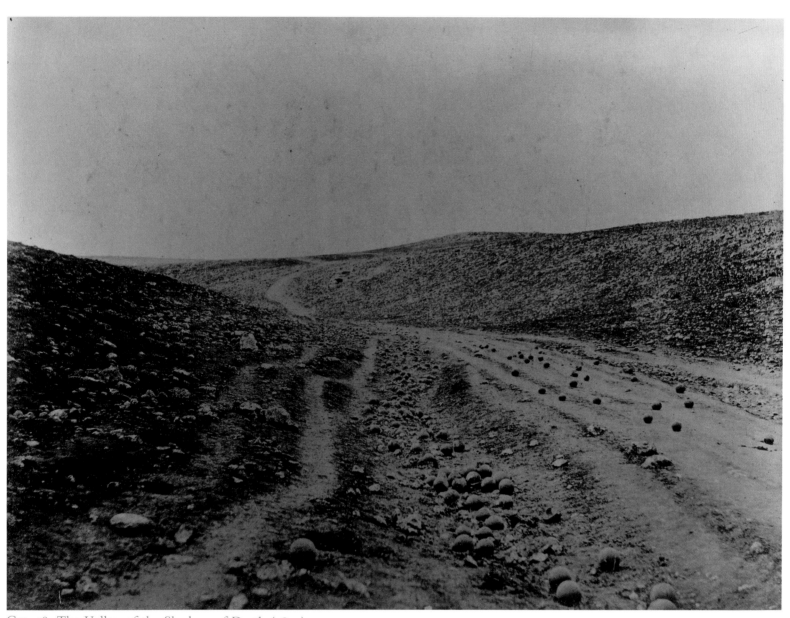

Cat. 58. The Valley of the Shadow of Death (1855).

LANDSCAPE

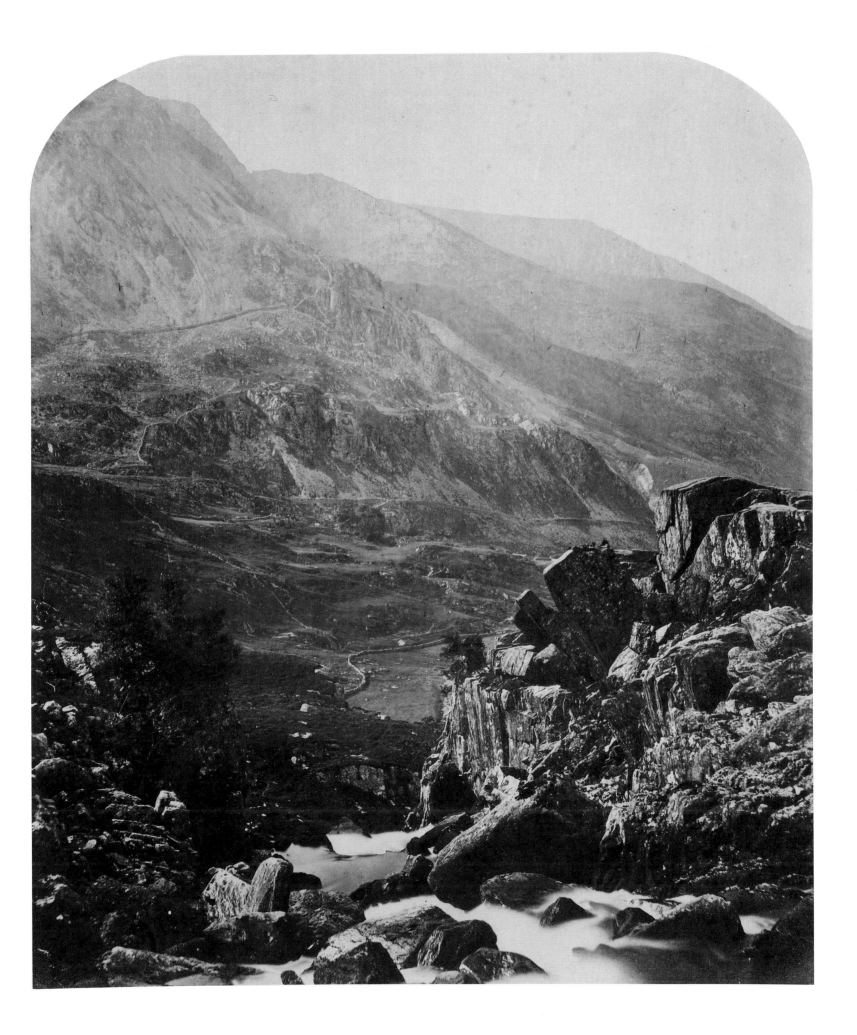

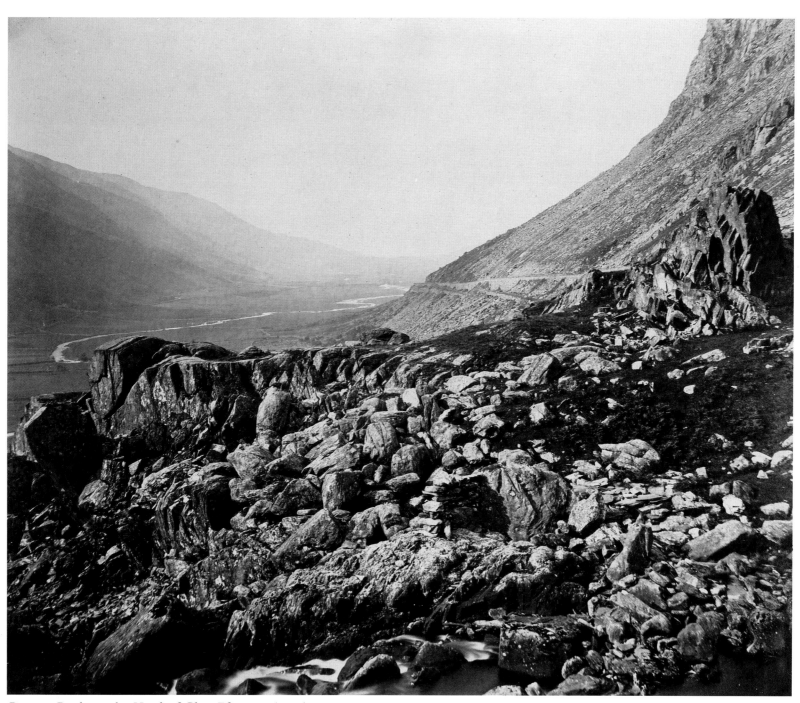

Cat. 73. Rocks at the Head of Glyn Ffrancon (1857).

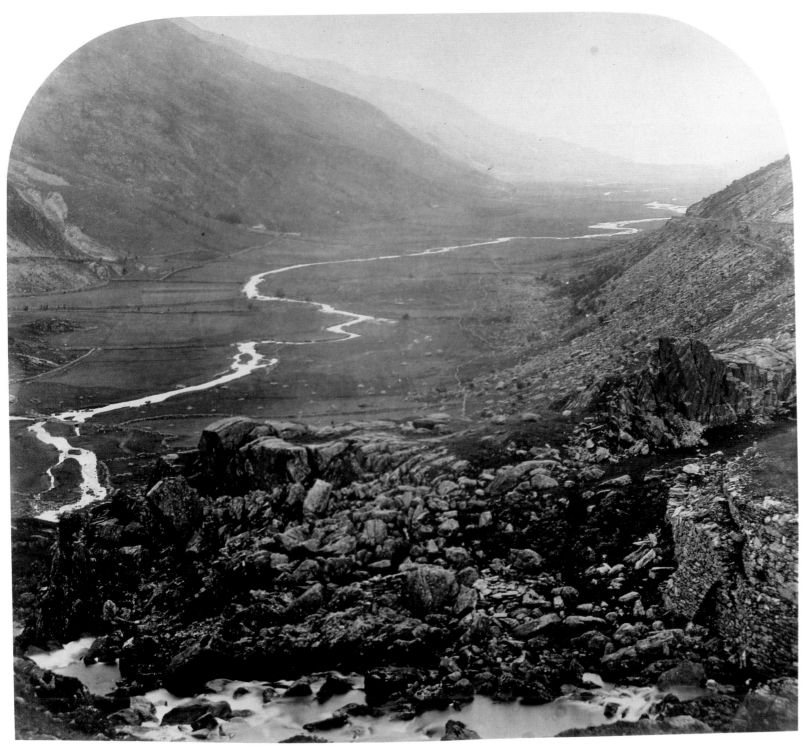

Cat. 72. The Nant Ffrancon Pass (1857).

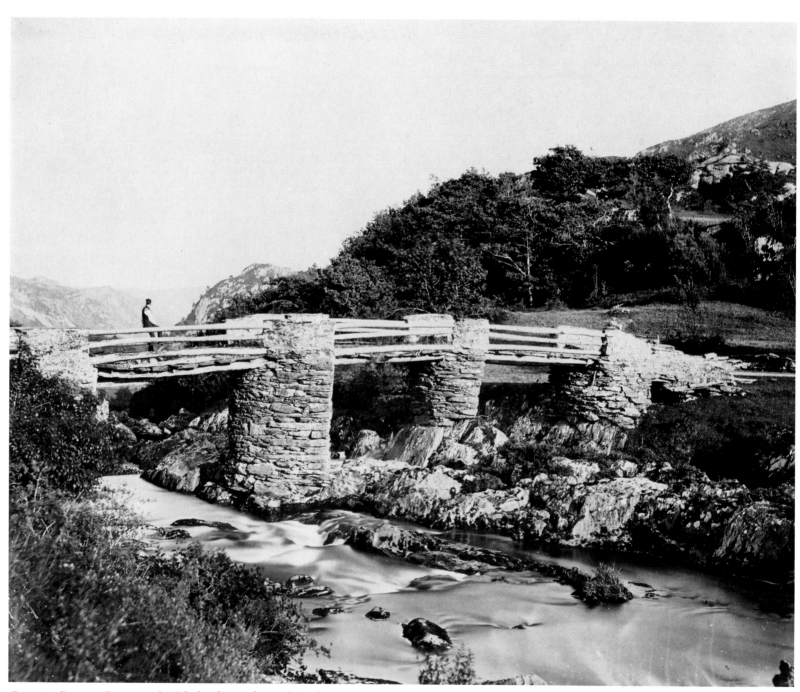

Cat. 69. Pont-y-Pant on the Lledr, from above (1857).

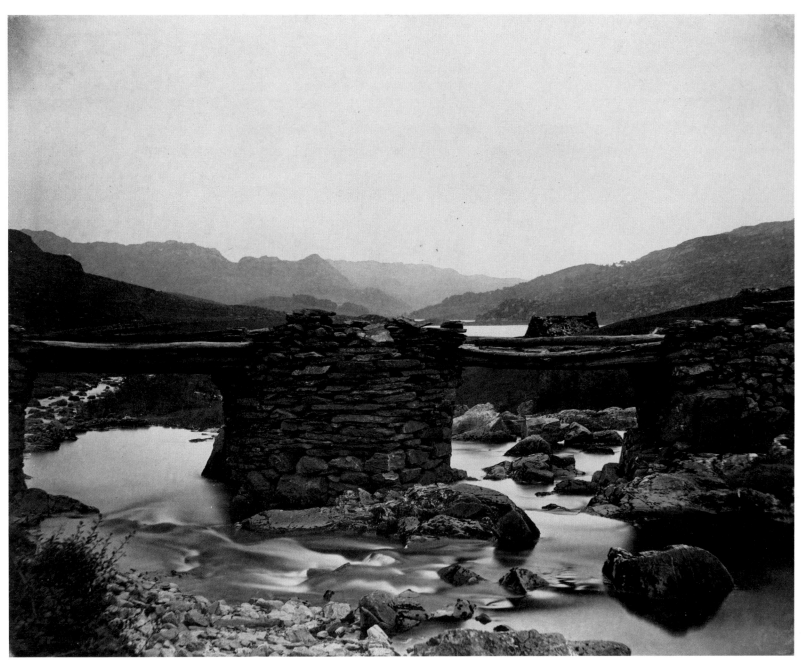

Cat. 66. Pont-y-Garth, near Capel Curig (1857).

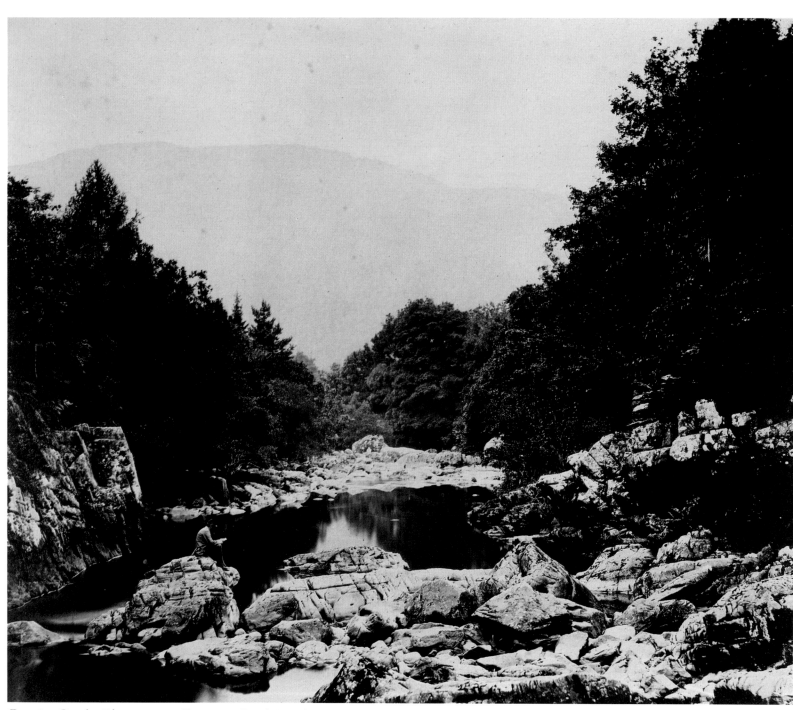

Cat. 67. On the Llugwy near Bettws y Coed (1857).

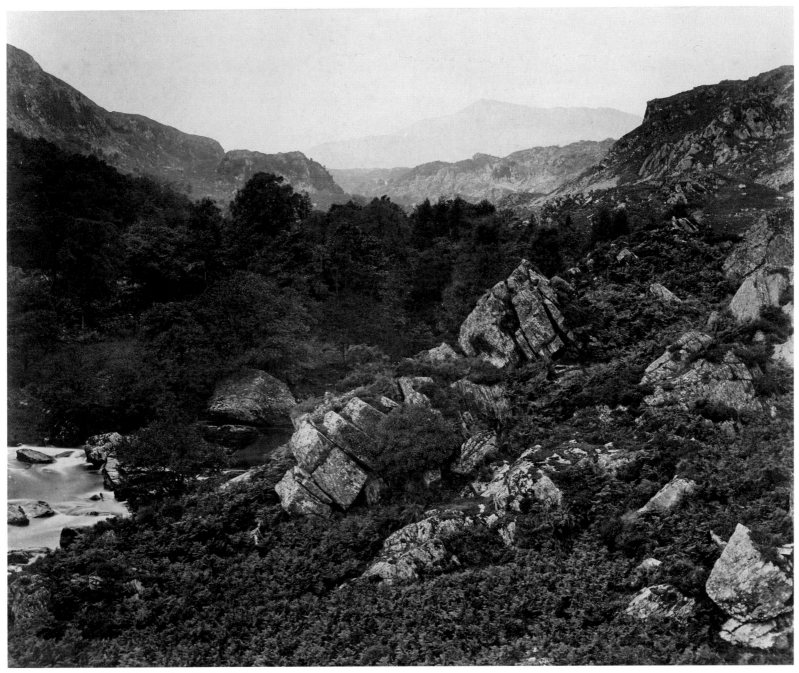

Cat. 68. Moel-siabod from the Lledr Valley (1857).

Cat. 65 (following page). Fors Nevin on the Conway (1857).

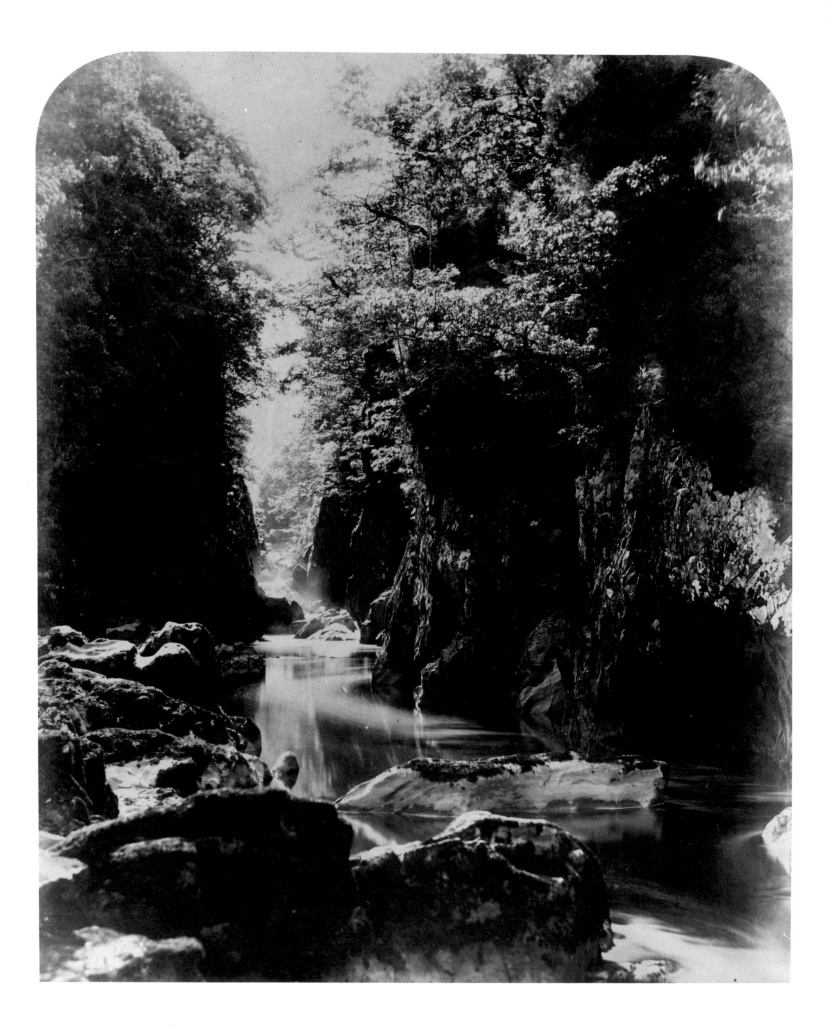

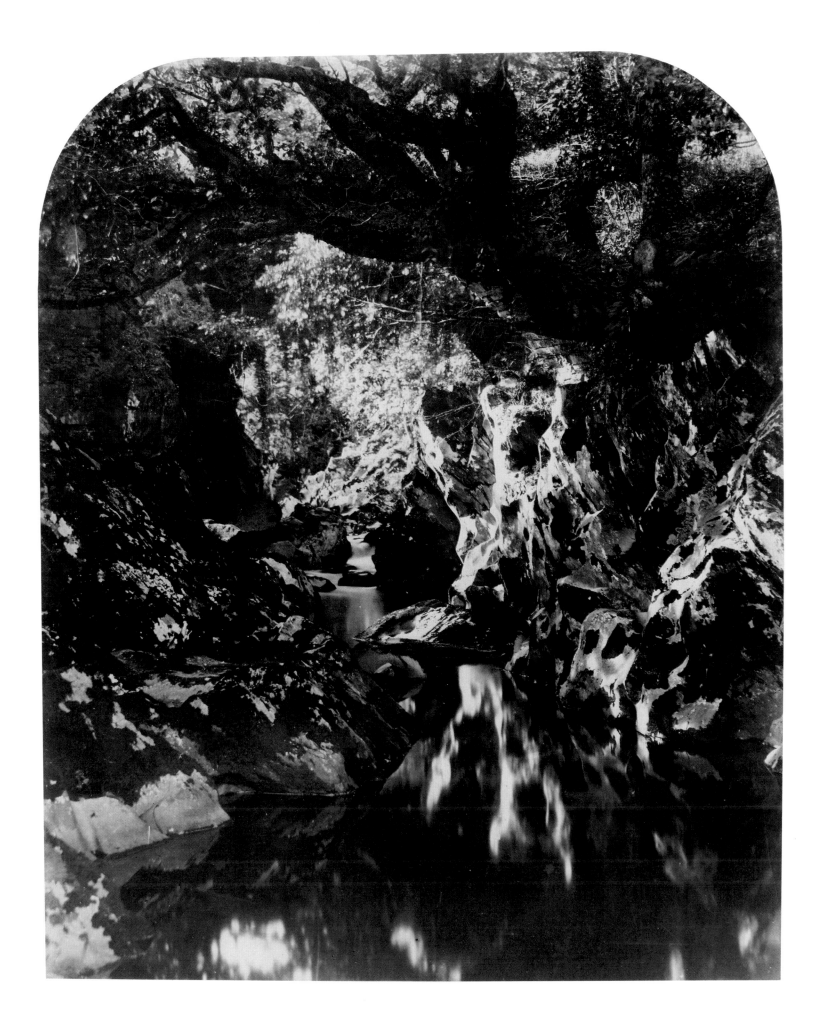

Cat. 63. Landscape near Edinburgh (1856).

Cat. 74 (previous page). The Double Bridge of the Machno (1857).

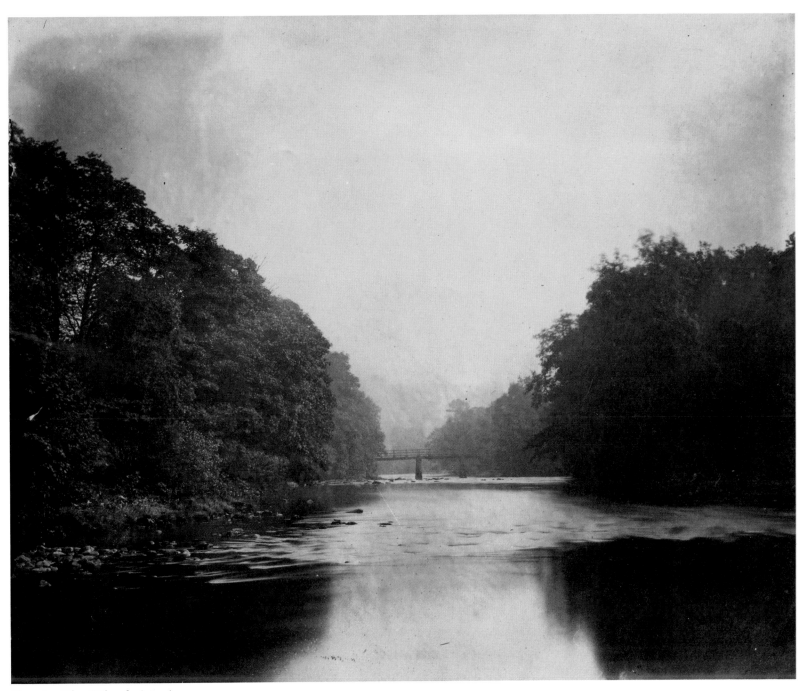

Cat. 62. The Wharfe (1854).

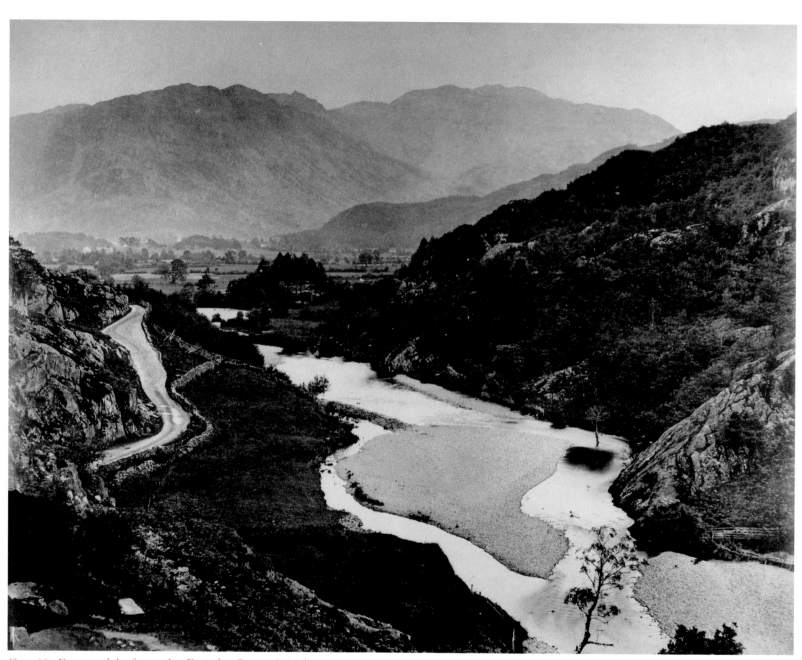

Cat. 88. Borrowdale from the Bowder Stone (1860).

Cat. 89. The Bowder Stone, Borrowdale (1860).

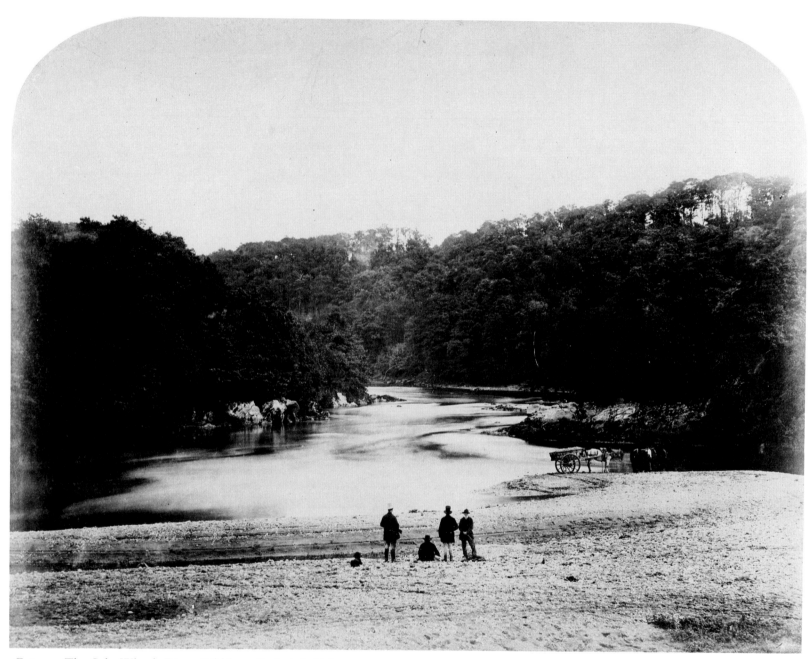

Cat. 77. The Sale Wheel, River Ribble, a fresh (1858/9).

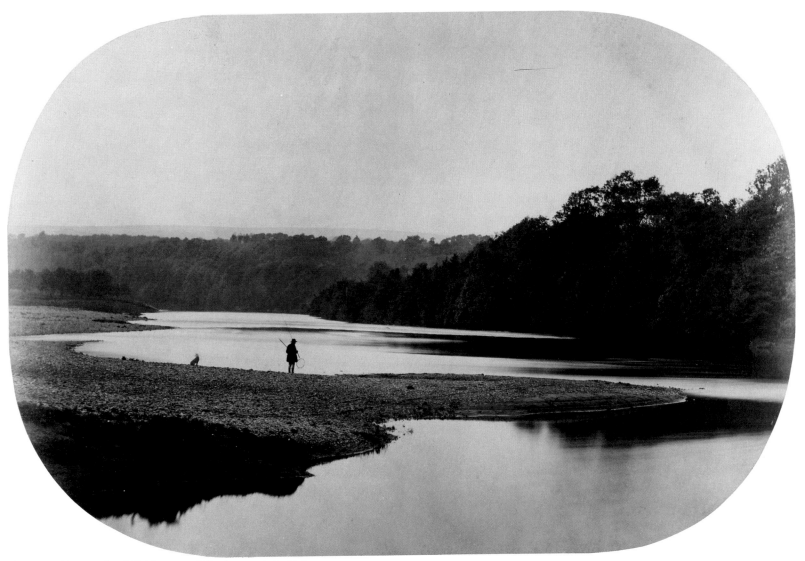

Cat. 83. Down the Ribble near Ribchester (1858/9).

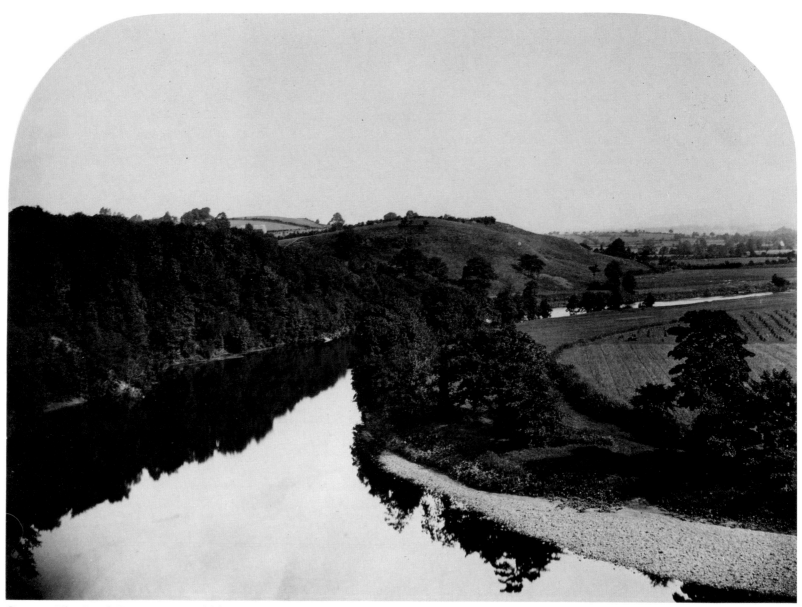

Cat. 80. The Reed Deep, River Ribble (1858/9).

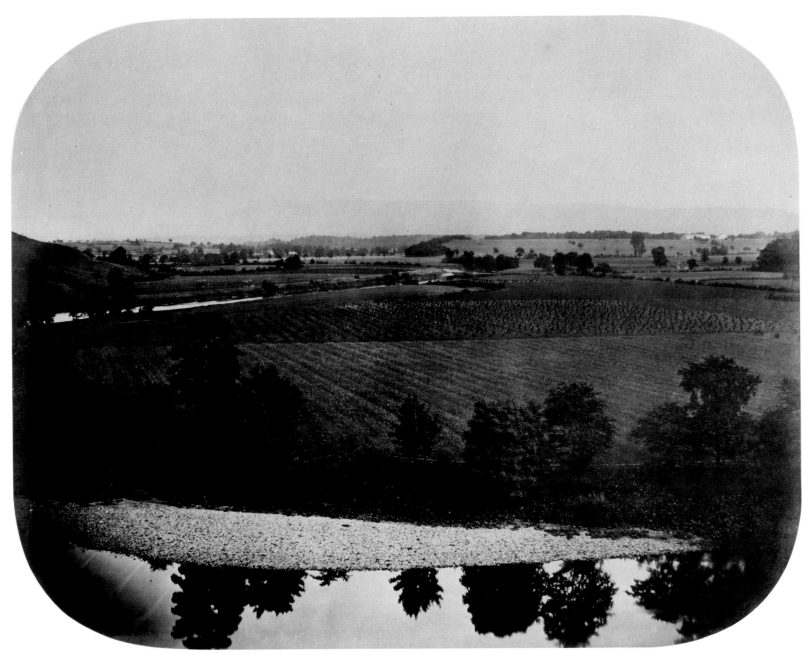

Cat. 81. Valley of the Ribble (1858/9).

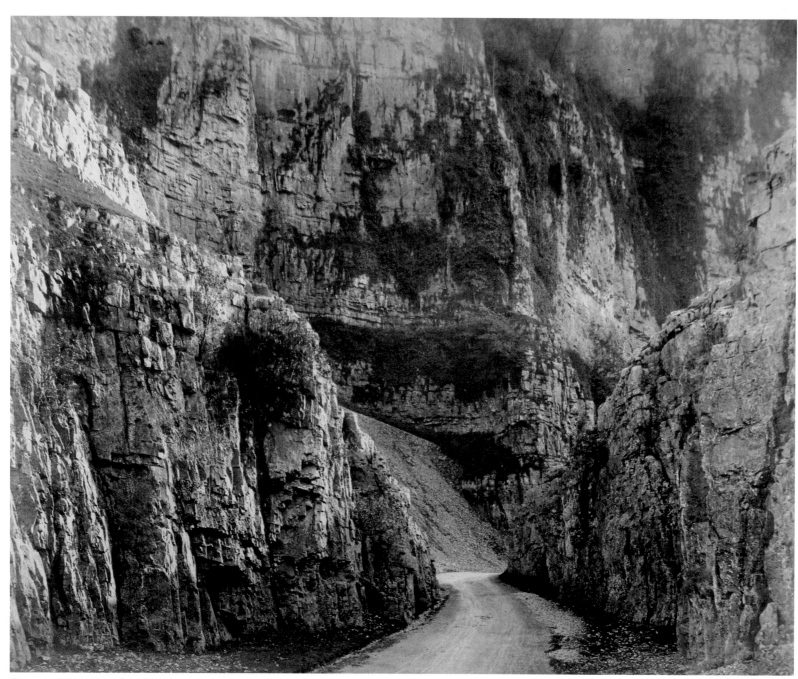

Cat. 78. The Cheddar Cliff (1858).

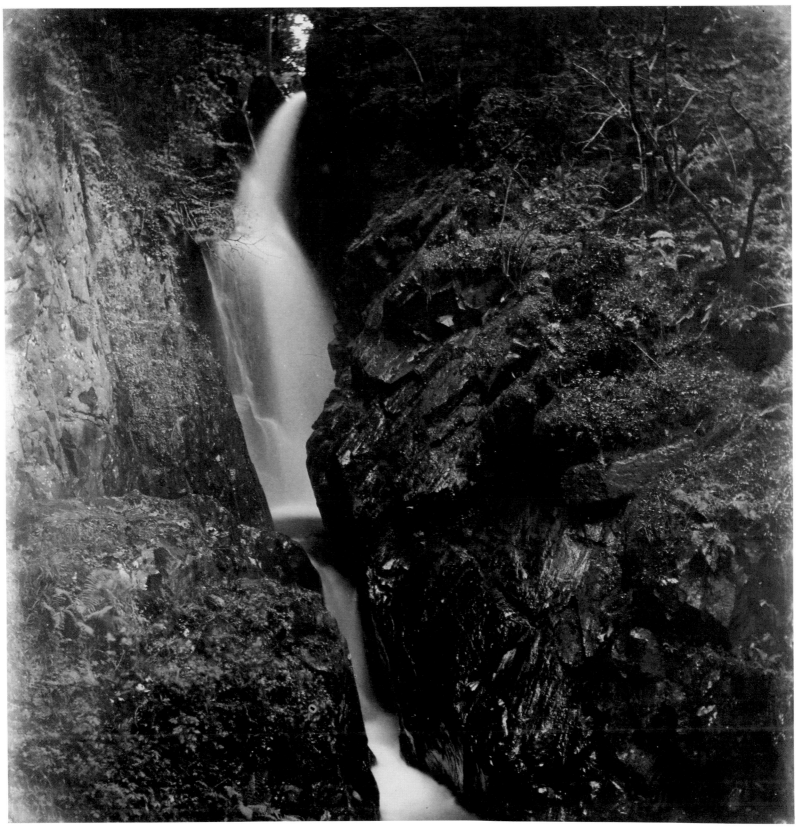

Cat. 91. Aira Force, Ullswater (1860).

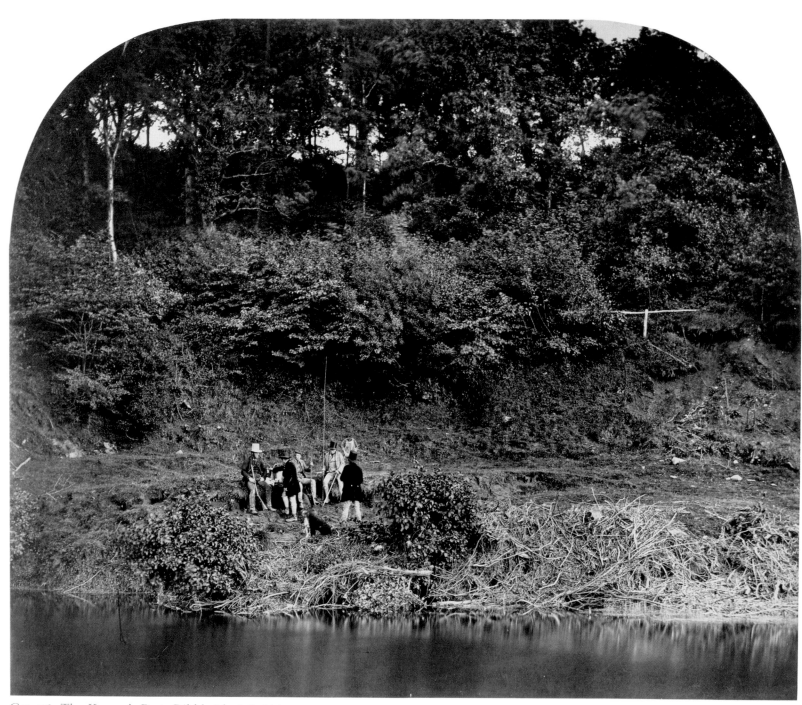

Cat. 76. The Keeper's Rest, Ribbleside (1858/9).

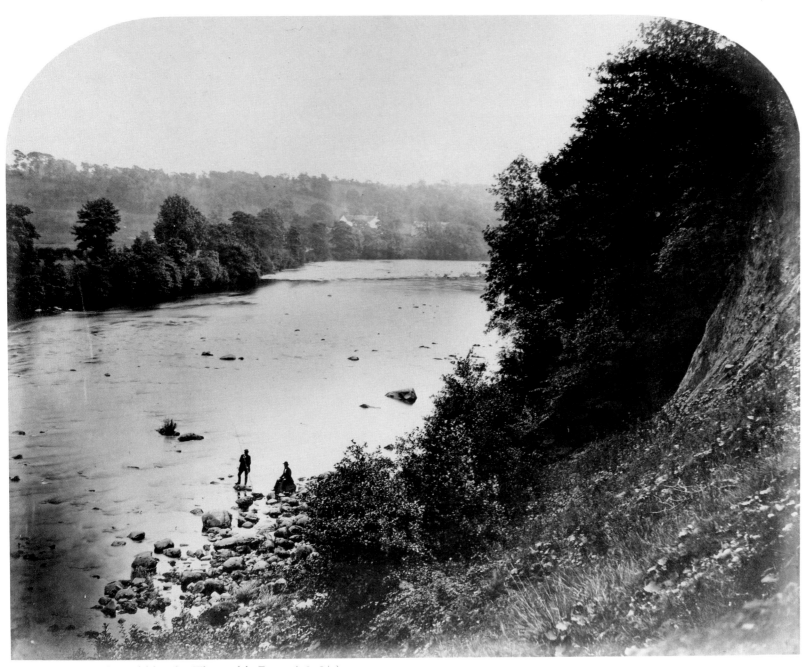

Cat. 79. Down the Ribble, the Through's Ferry (1858/9).

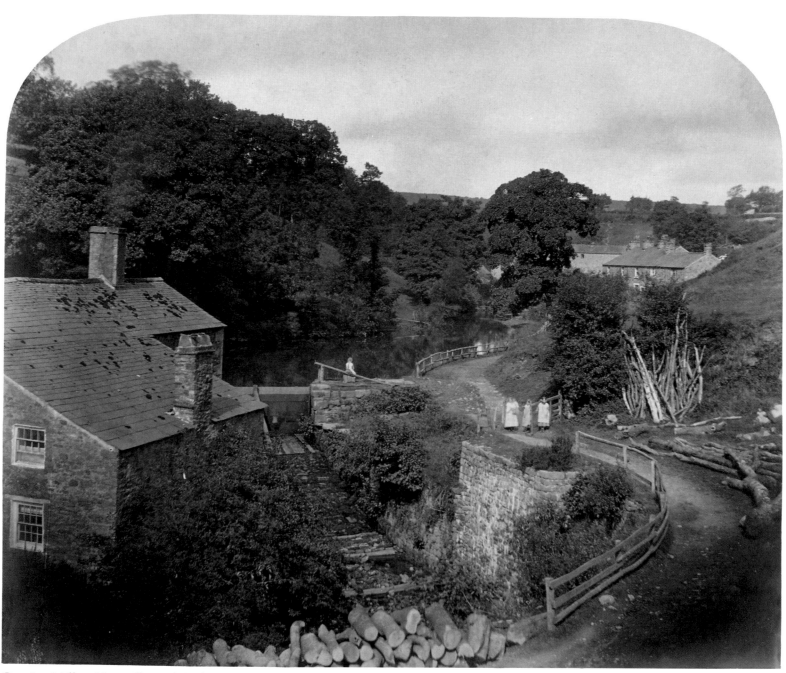

Cat. 84. Mill at Hurst Green (1859).

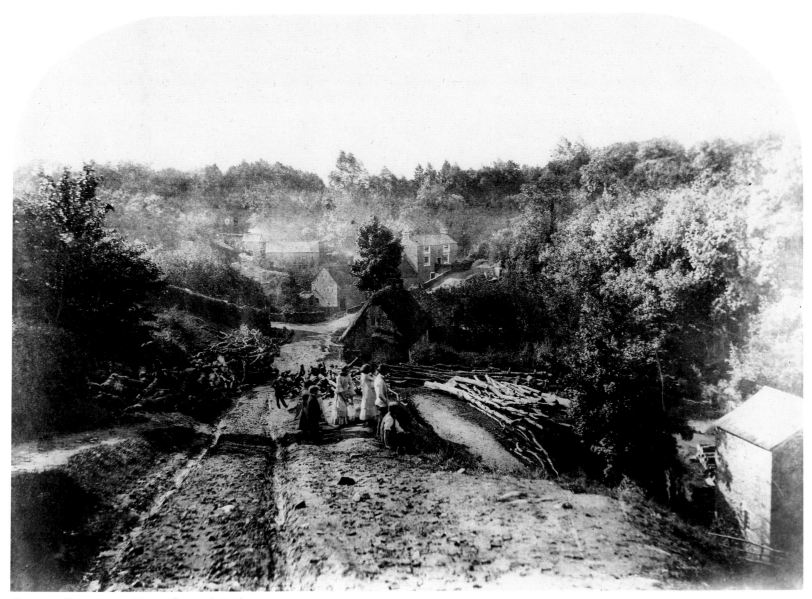

Cat. 85. Cottages at Hurst Green (1859).

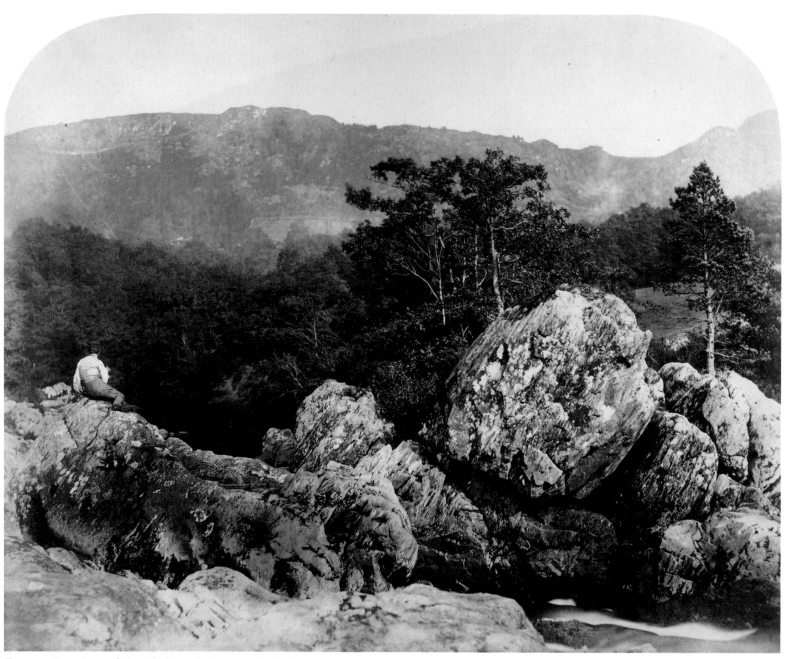

Cat. 70. Junction of the Lledr and Conway (1857).

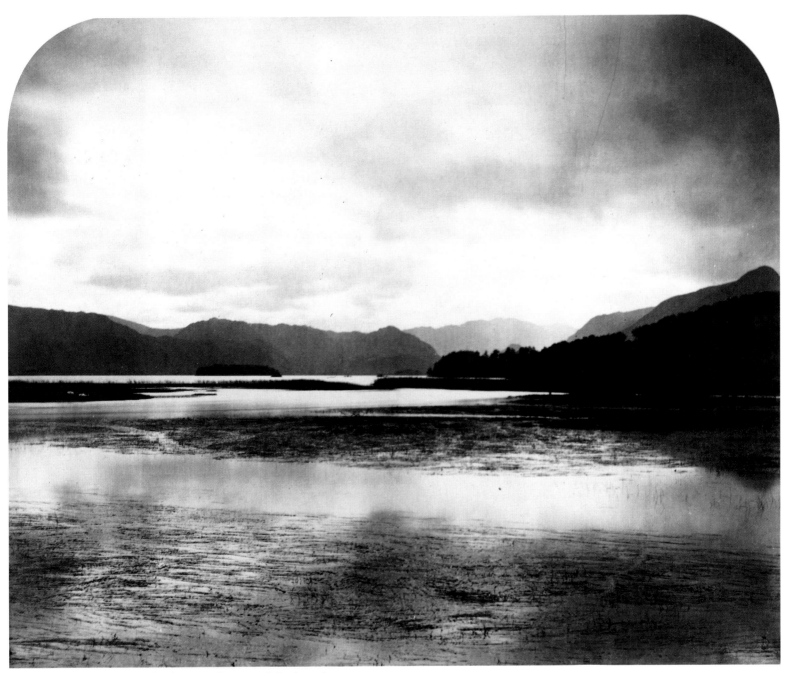

Cat. 90. Derwentwater, looking to Borrowdale (1860).

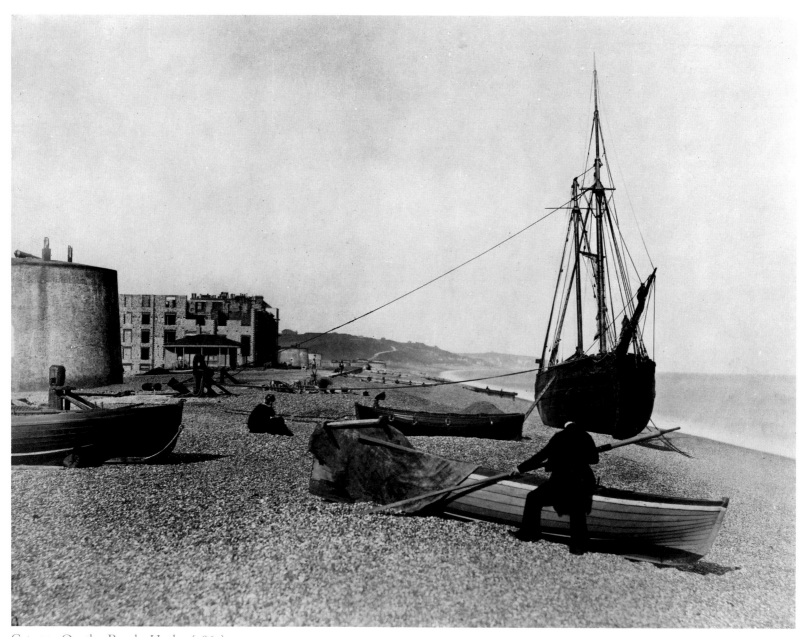

Cat. 92. On the Beach, Hythe (1860).

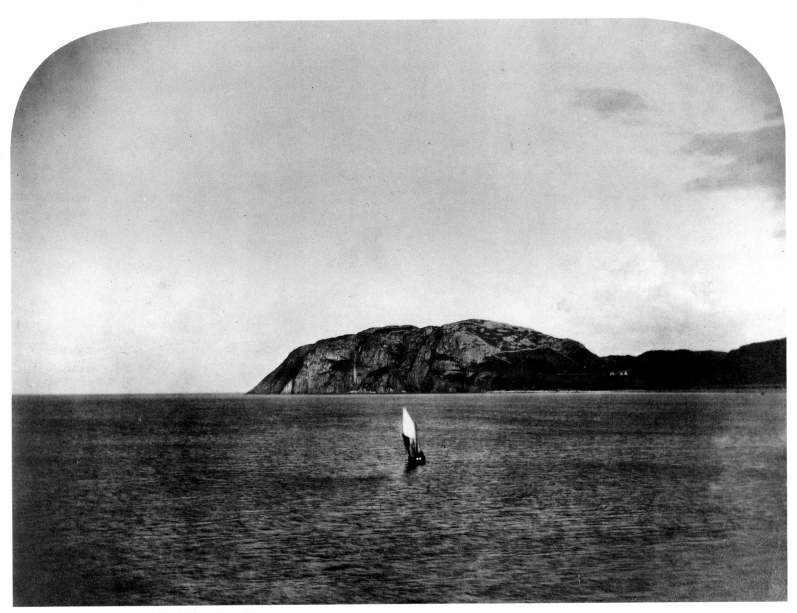

Cat. 75. Summer Seas, Llandudno (1857).

Cat. 86. September Clouds (I) (1859).

Cat. 87. September Clouds (II) (1859).

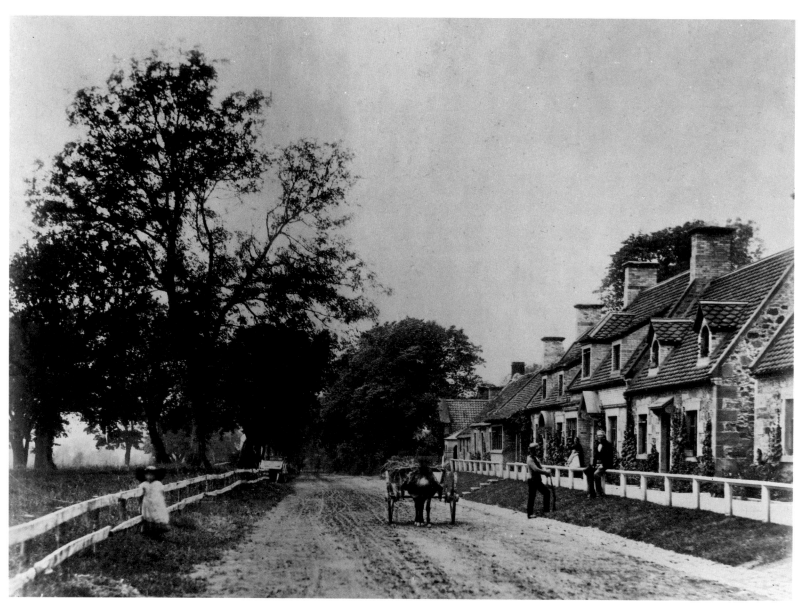

Cat. 64. Foulden near Berwick (1856).

ARCHITECTURE

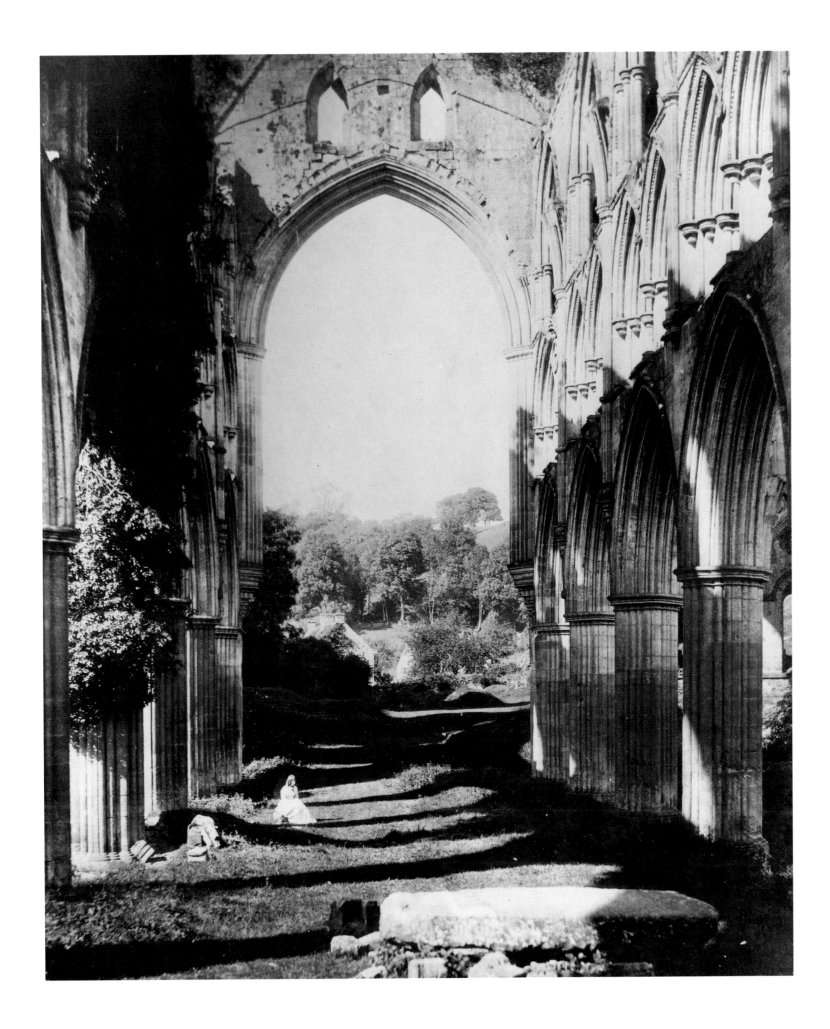

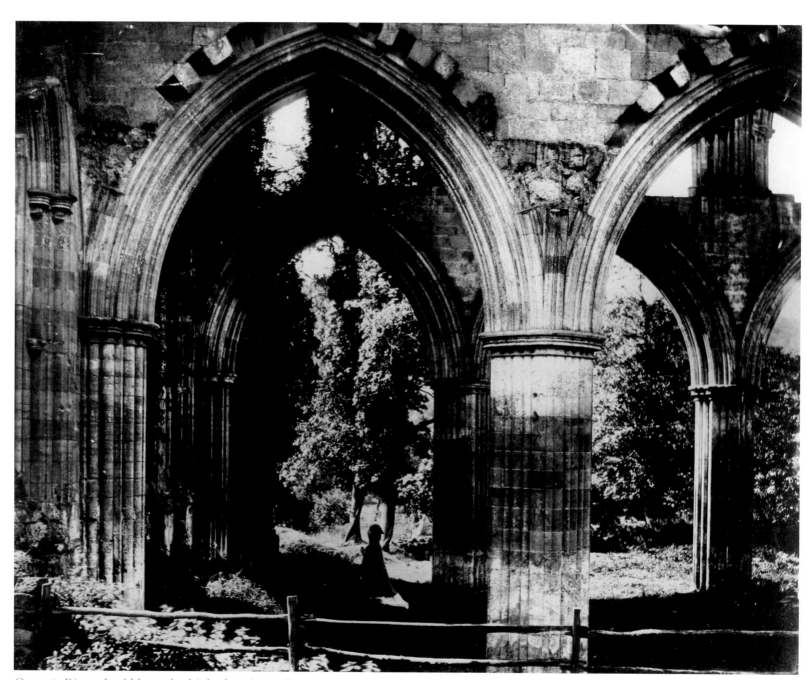

Cat. 96. Rievaulx Abbey, the high altar (*c.*1854).

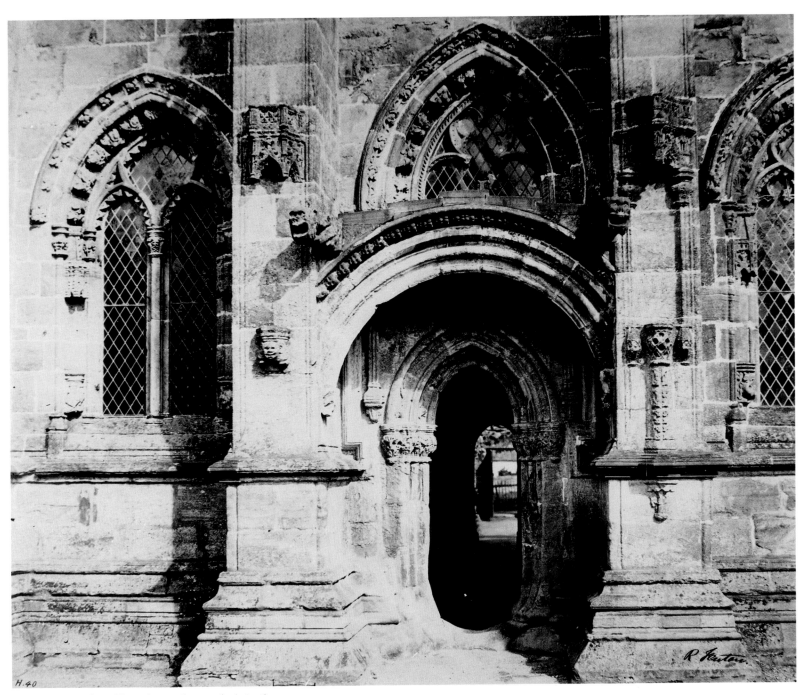

Cat. 108. Roslin Chapel, south porch (1856).

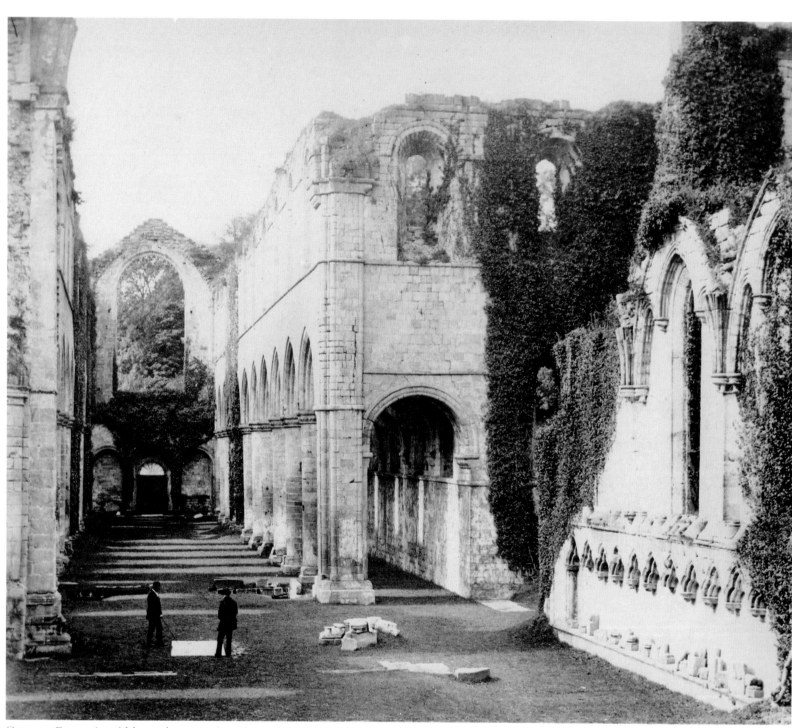

Cat. 97. Fountains Abbey, the nave (1854).

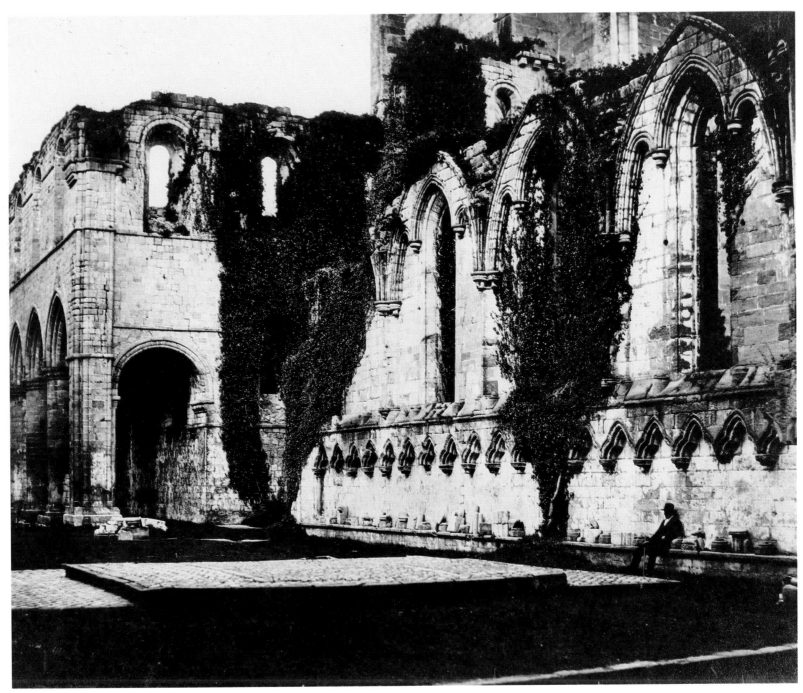

Cat. 98. Fountains Abbey, north side of the choir (1854).

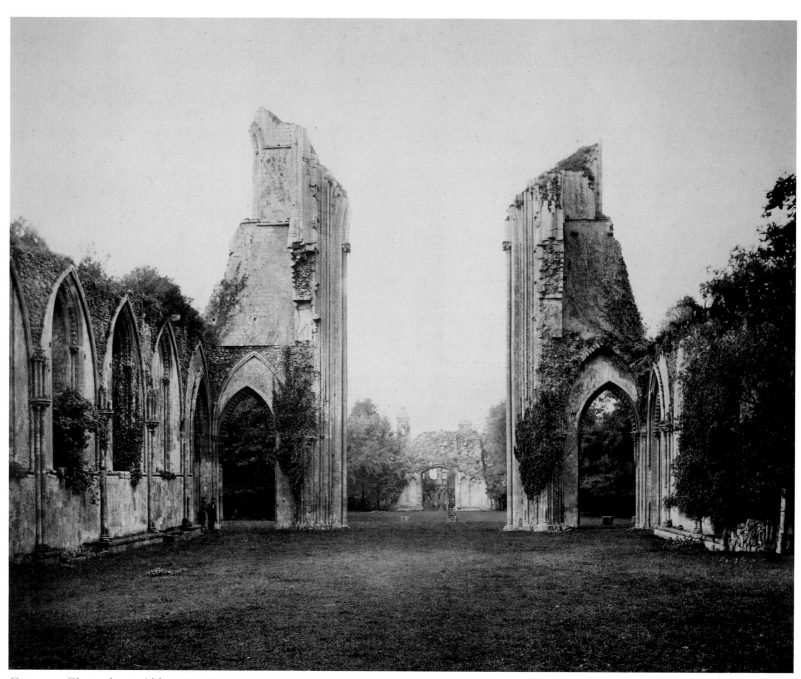

Cat. 102. Glastonbury Abbey (1858).

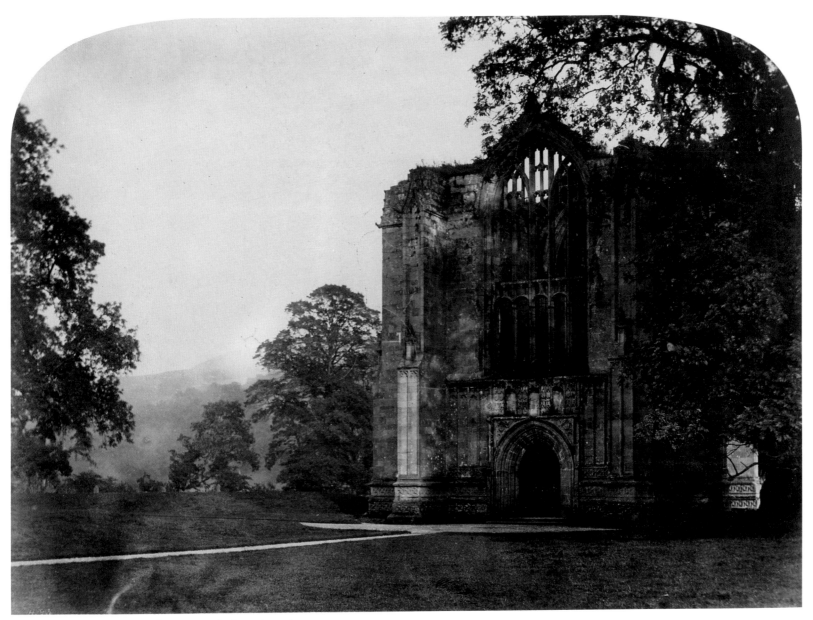

Cat. 99. Bolton Abbey, the west window (1854)

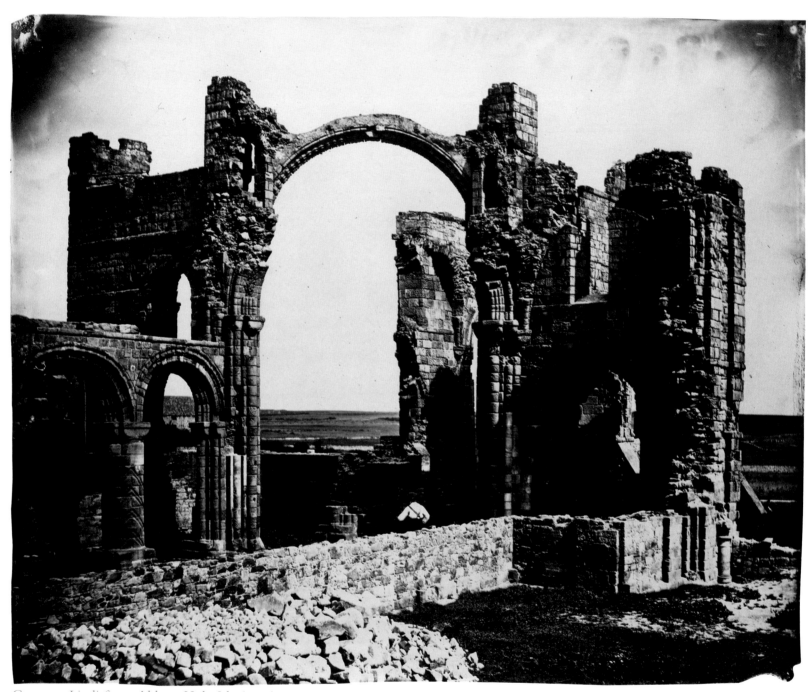

Cat. 100. Lindisfarne Abbey, Holy Isle (1856).

Cat. 101. Interior of Lindisfarne, west end (1856).

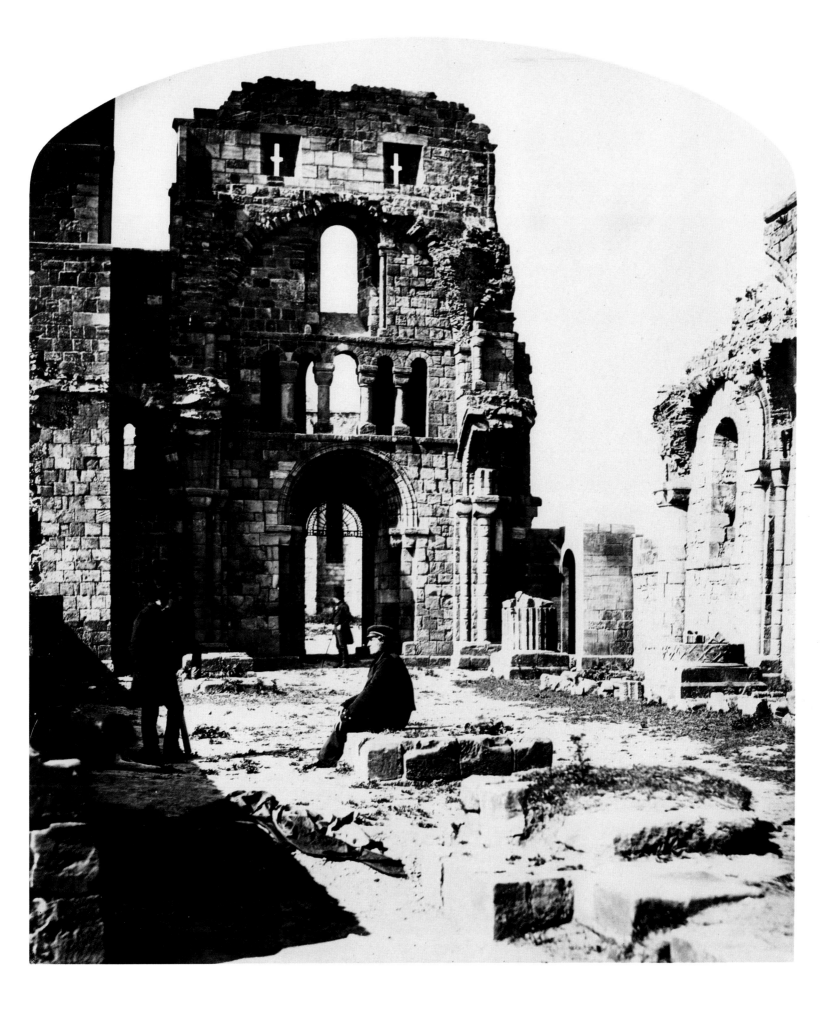

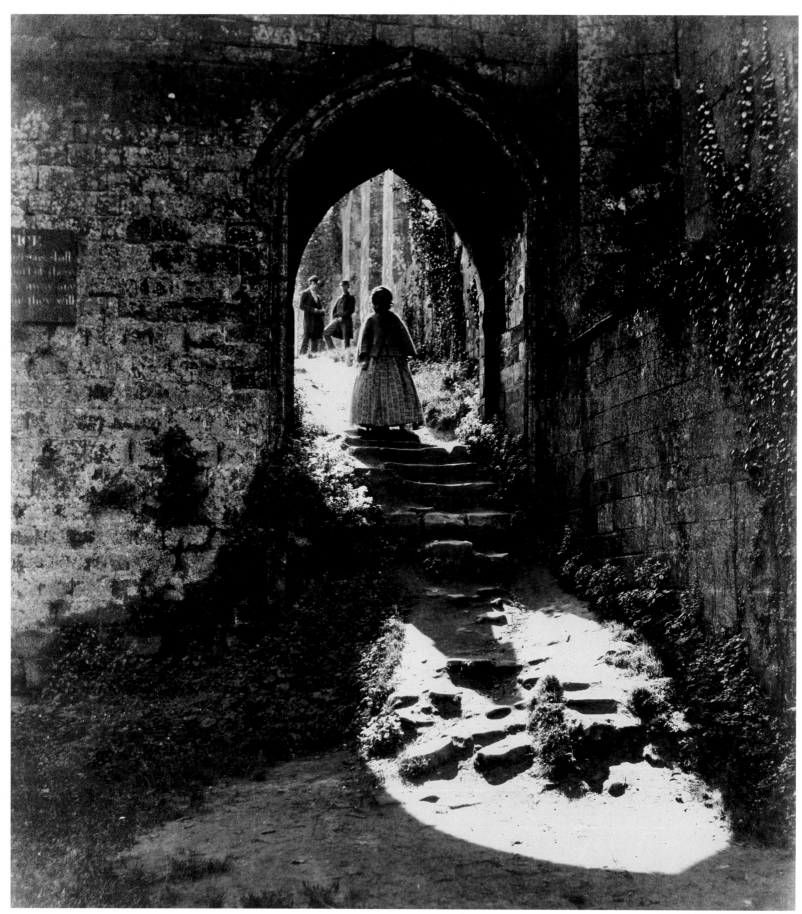

Cat. 103. A Vista, Furness Abbey (1860).

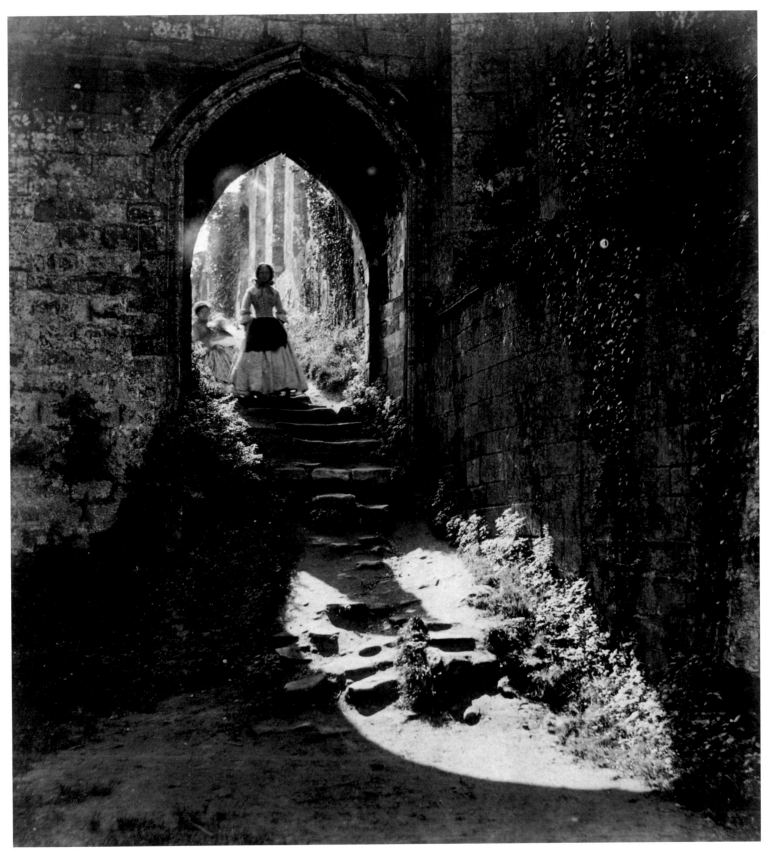

Cat. 104. A Memento of Furness Abbey (1860).

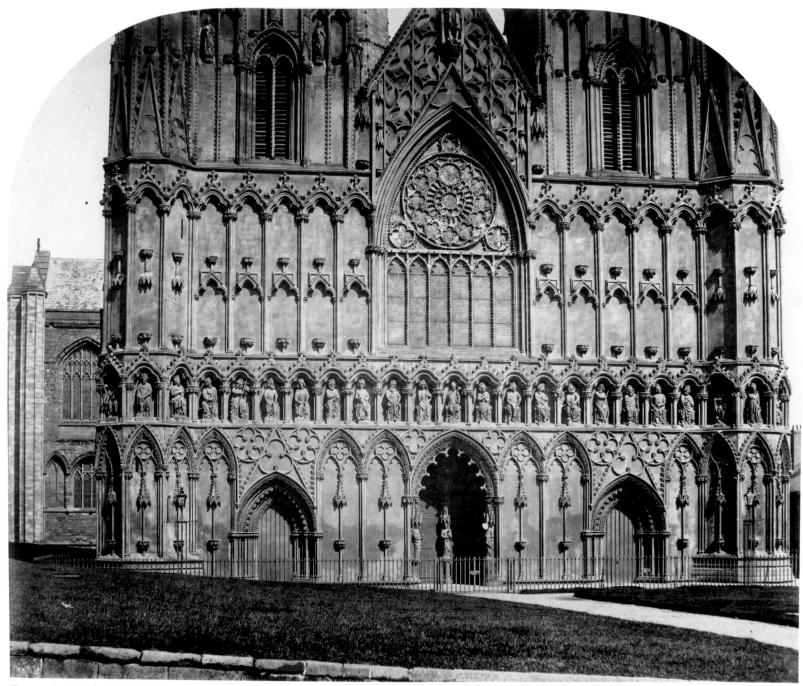

Cat. 118. Lichfield Cathedral, west front (1858).

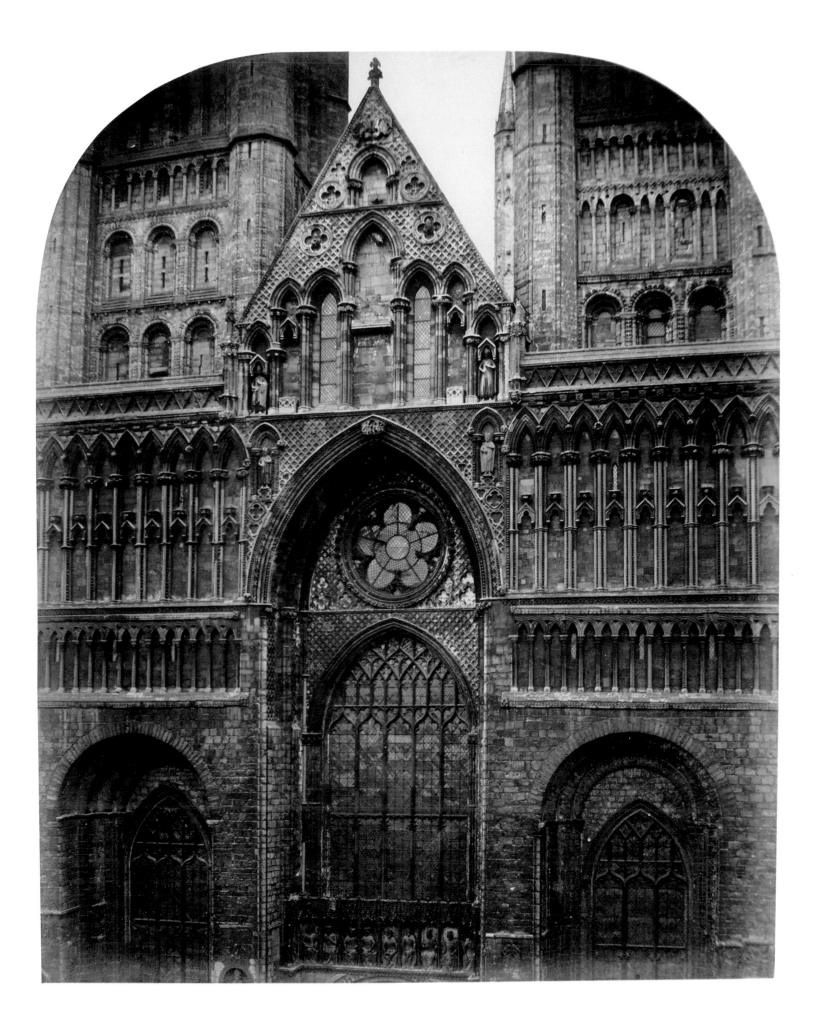

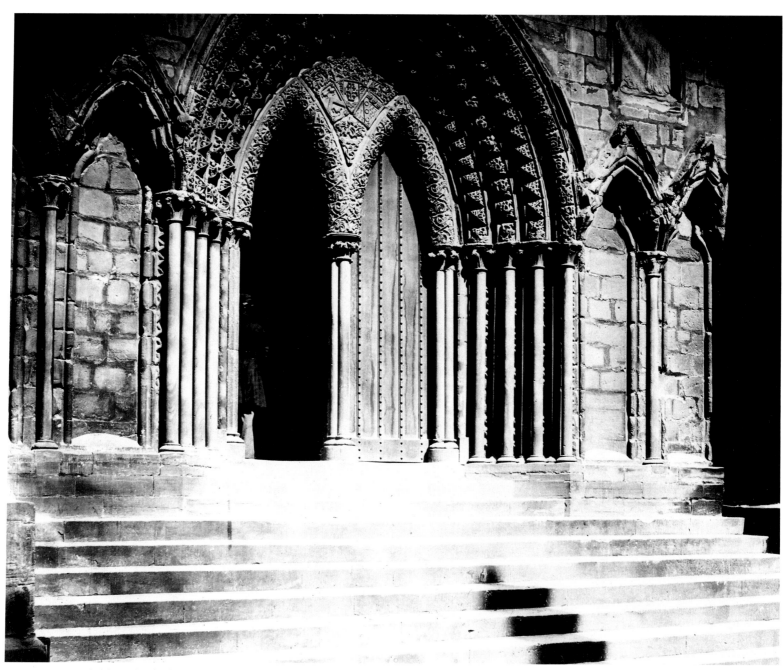

Cat. 119. Lichfield Cathedral, porch of the south transept (1858).

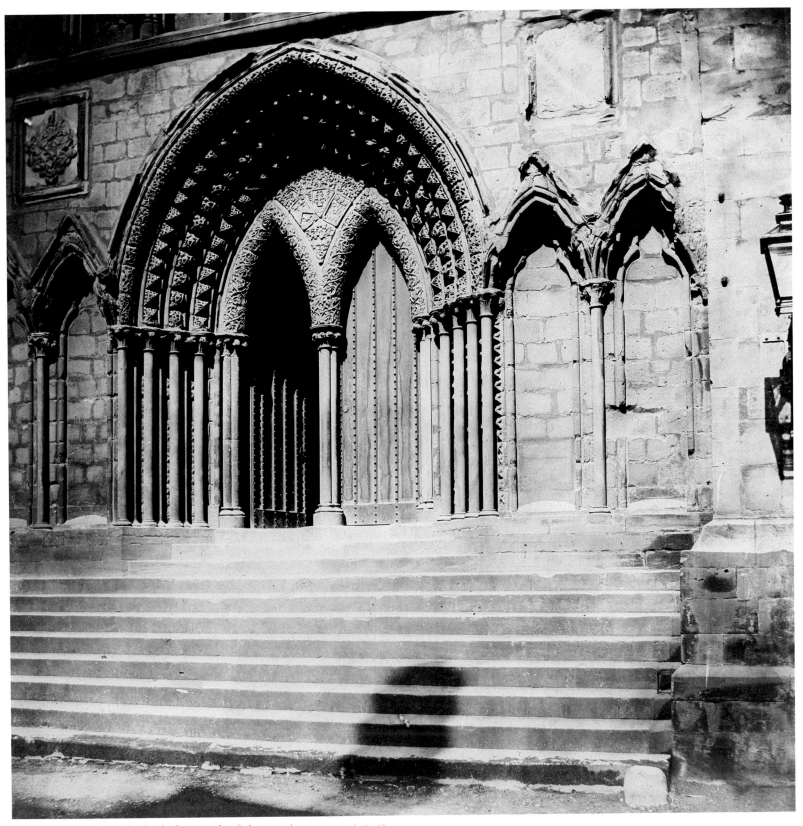

Cat. 120. Lichfield Cathedral, portal of the south transept (1858).

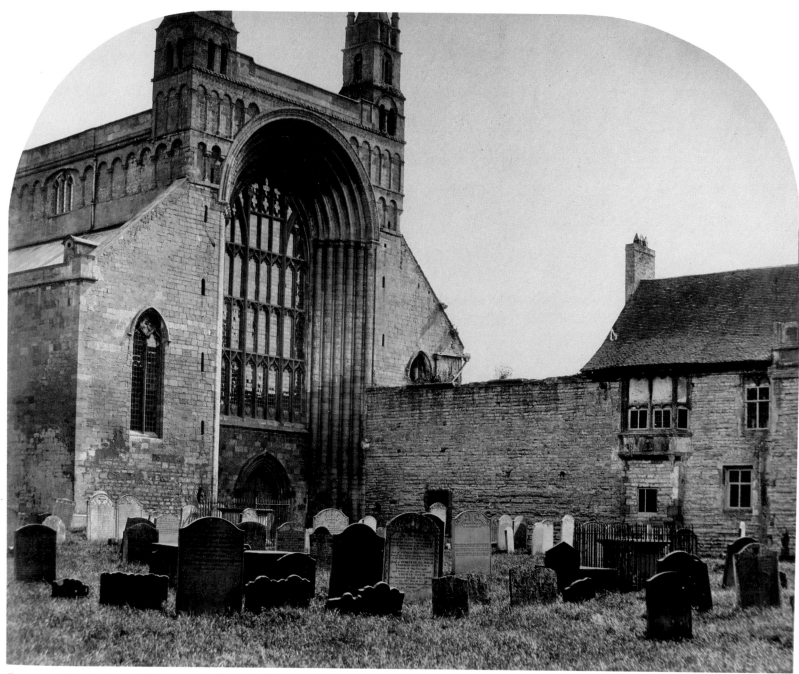

Cat. 107. Tewkesbury Abbey, west front (n.d.).

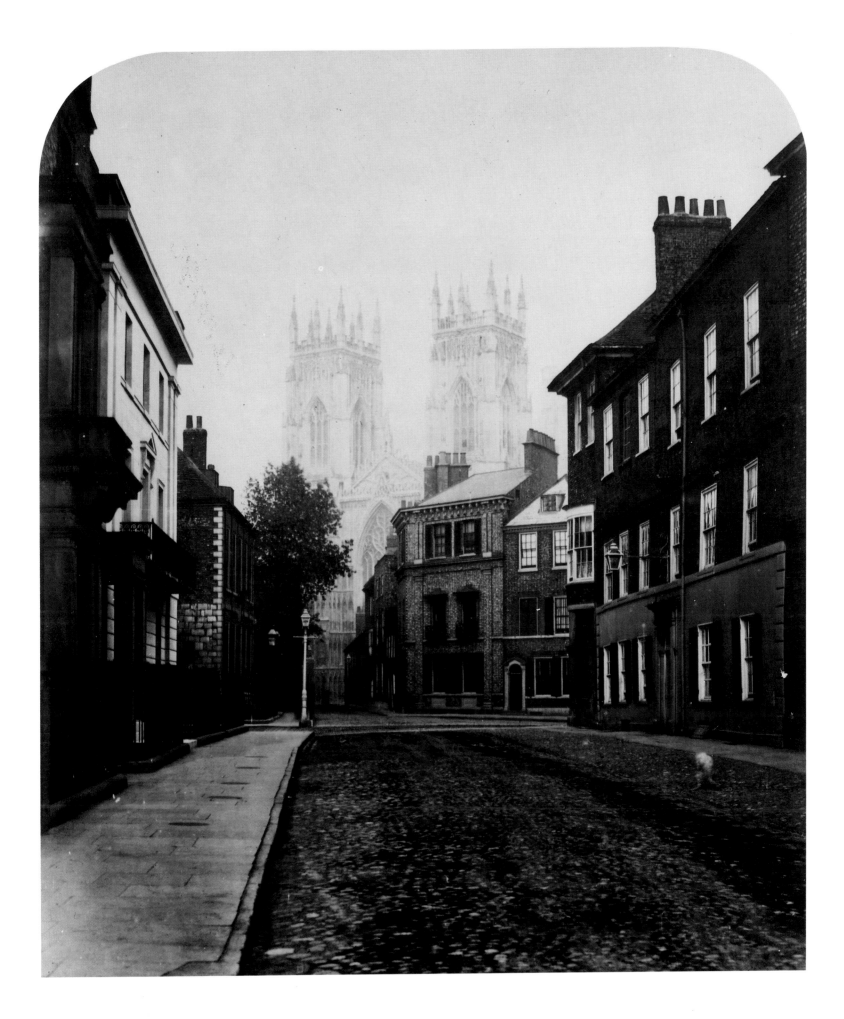

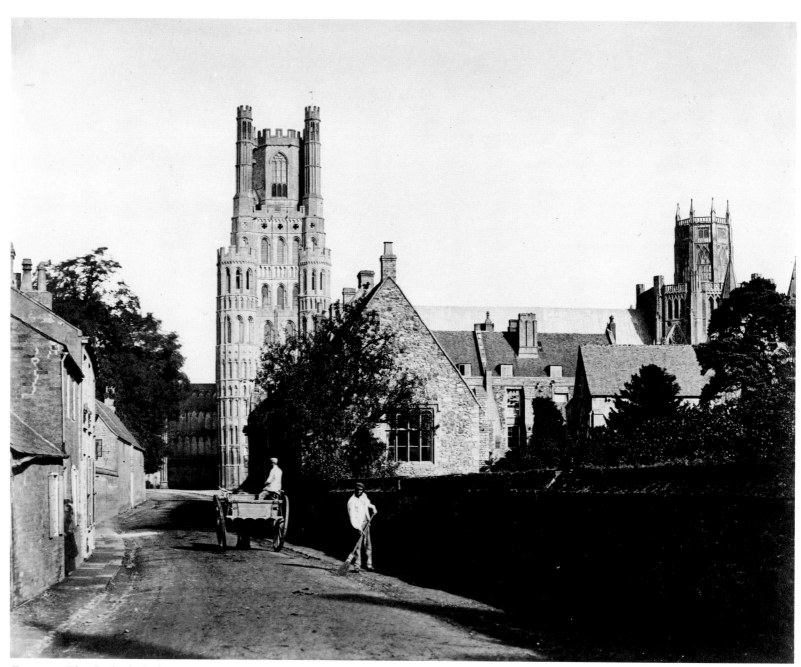

Cat. 116. Ely Cathedral, from the grammar school (c.1857).

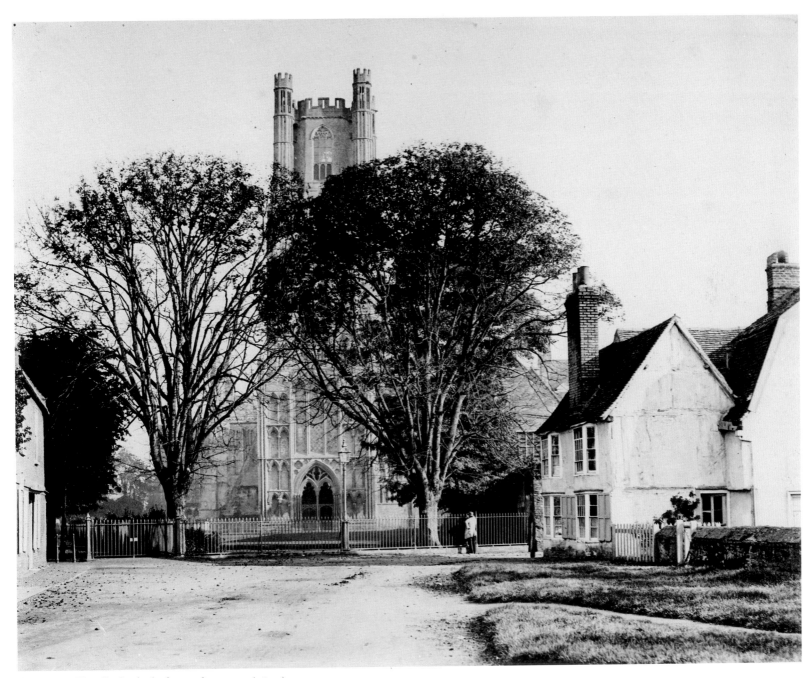

Cat. 114. Ely Cathedral, from the west (1857).

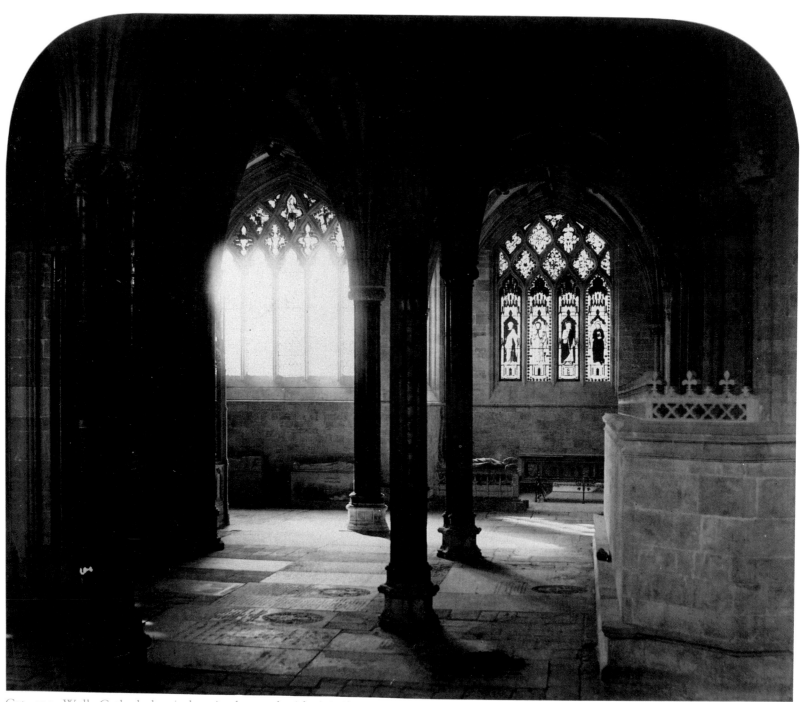

Cat. 123. Wells Cathedral, window in the south aisle (1858).

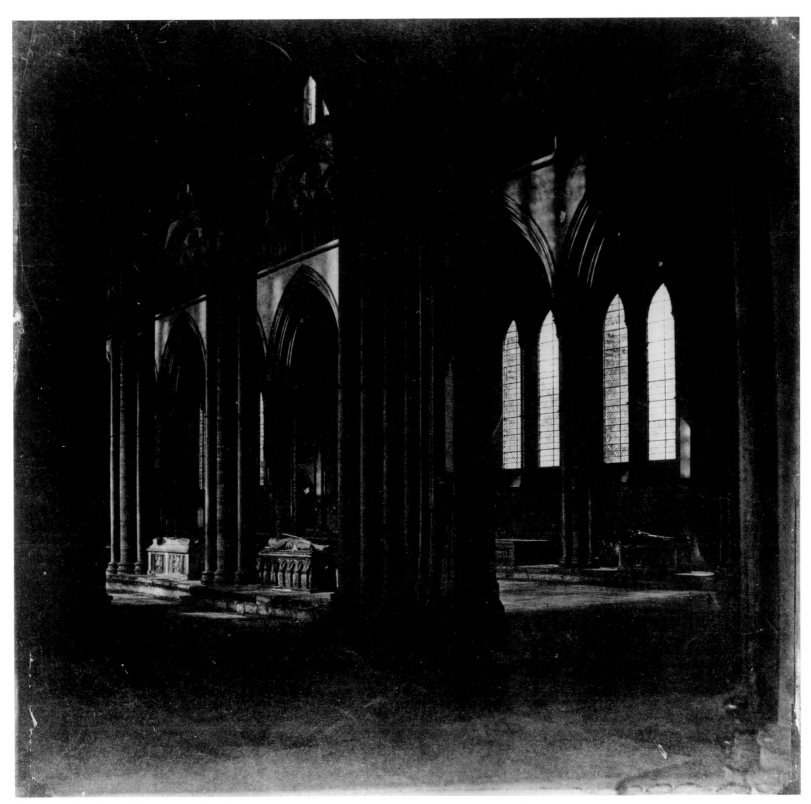

Cat. 125. Interior, Westminster (n.d.).

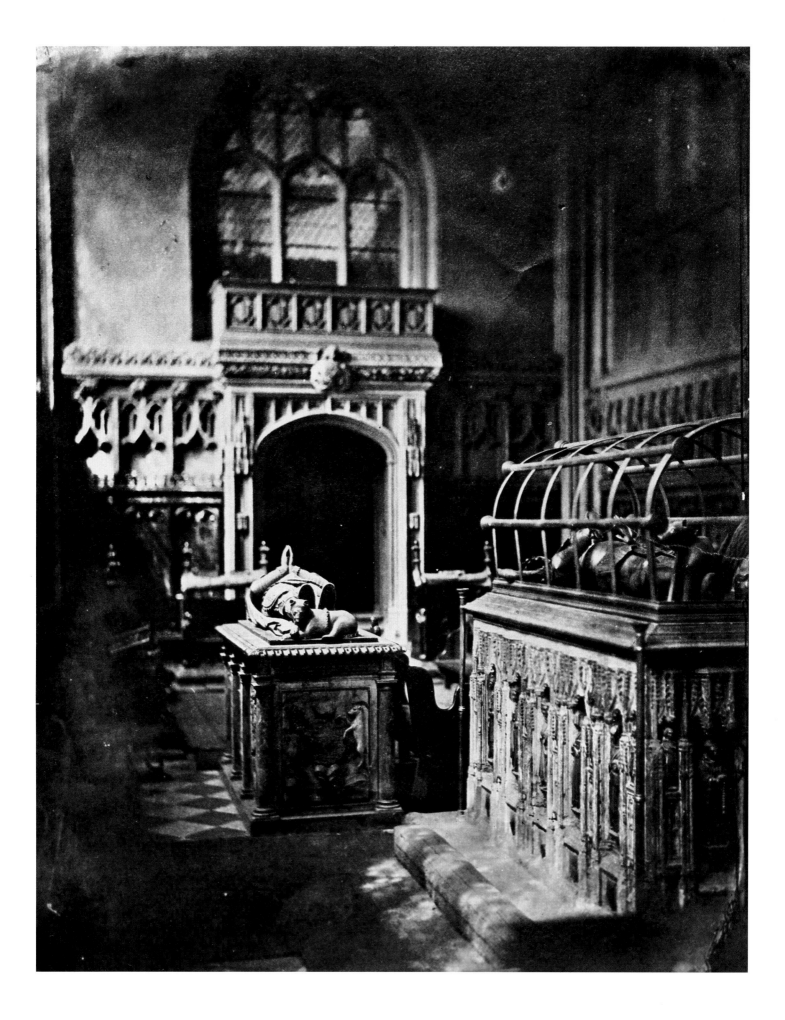

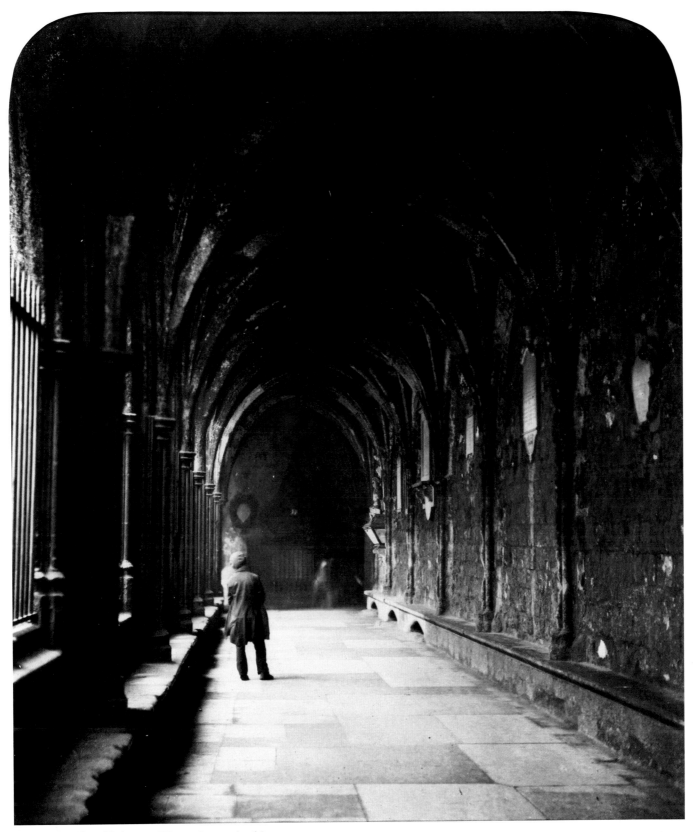

Cat. 106. The Cloisters, Westminster (n.d.).

Cat. 105. Interior of Chapel, Westminster (n.d.).

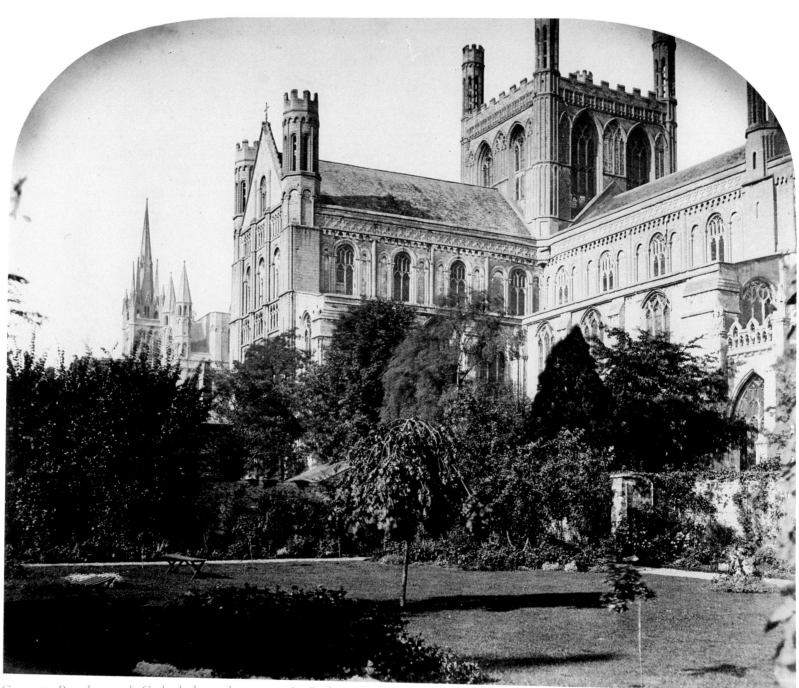

Cat. 117. Peterborough Cathedral, south transept (c.1857).

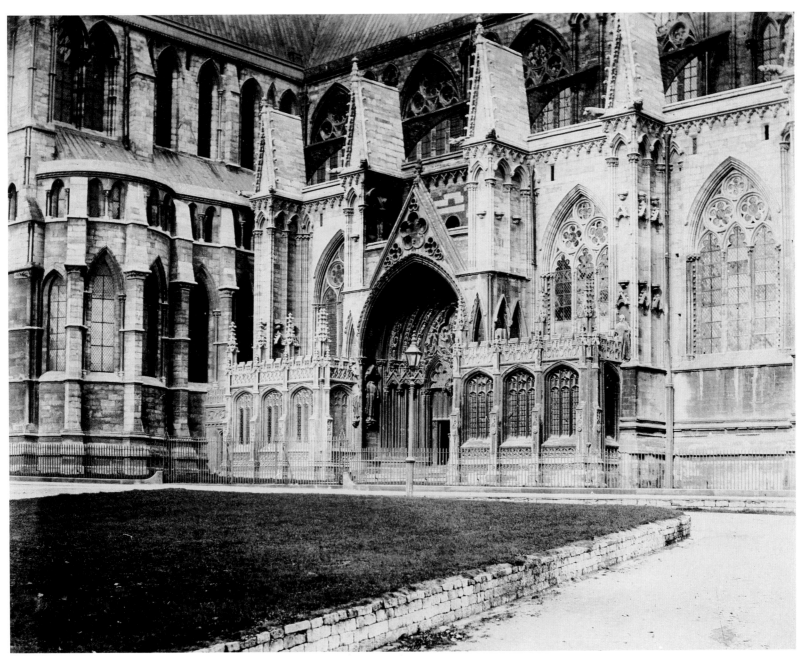

Cat. 112. Lincoln Cathedral, south porch (1857).

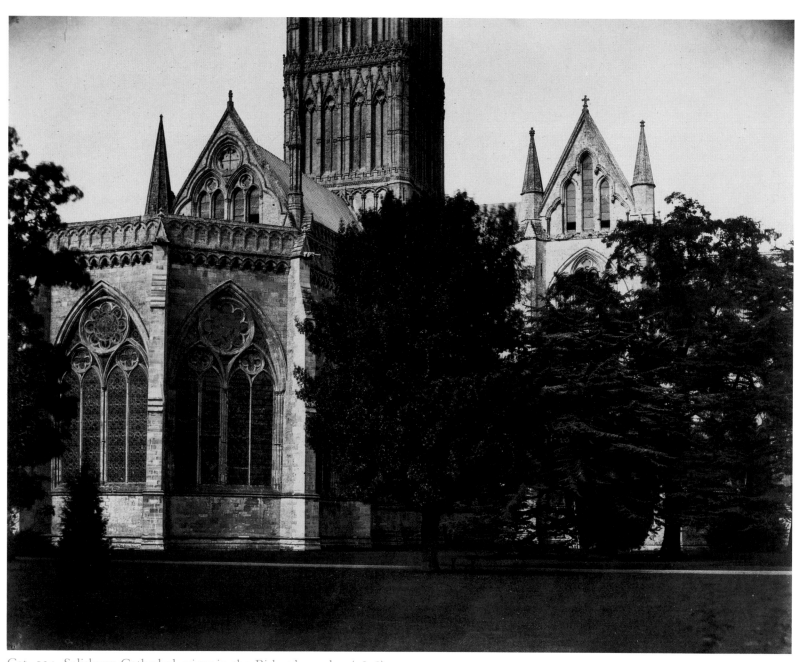

Cat. 124. Salisbury Cathedral, view in the Bishop's garden (1858).

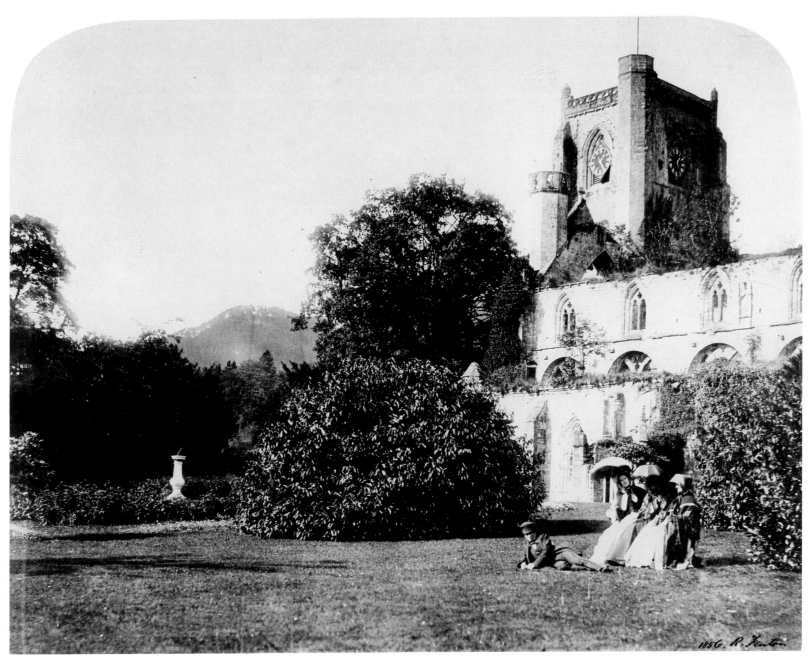

Cat. 109. Dunkeld Cathedral (1856).

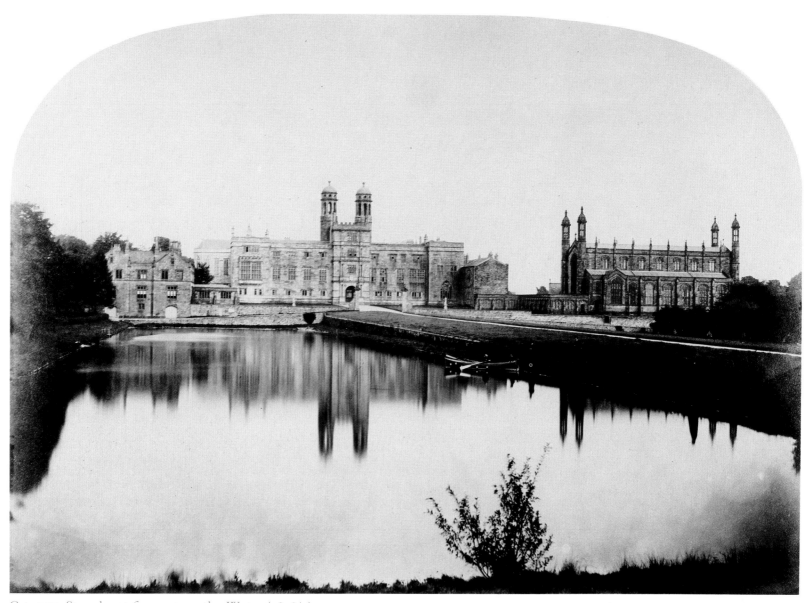

Cat. 131. Stonyhurst from across the Water (1858/9).

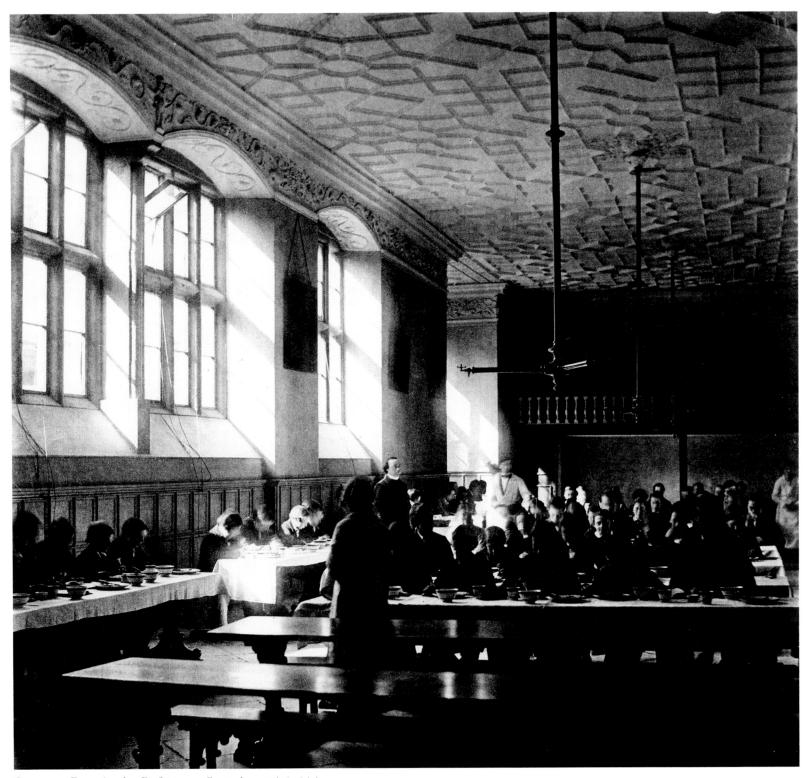

Cat. 132. Boys in the Refectory, Stonyhurst (1858/9).

Cat. 138. Windsor Castle from the Town Park (1860).

Cat. 139. The Long Walk (1860).

Cat. 133. Haddon Hall, the garden front [Roger Fenton in the foreground] (1858).

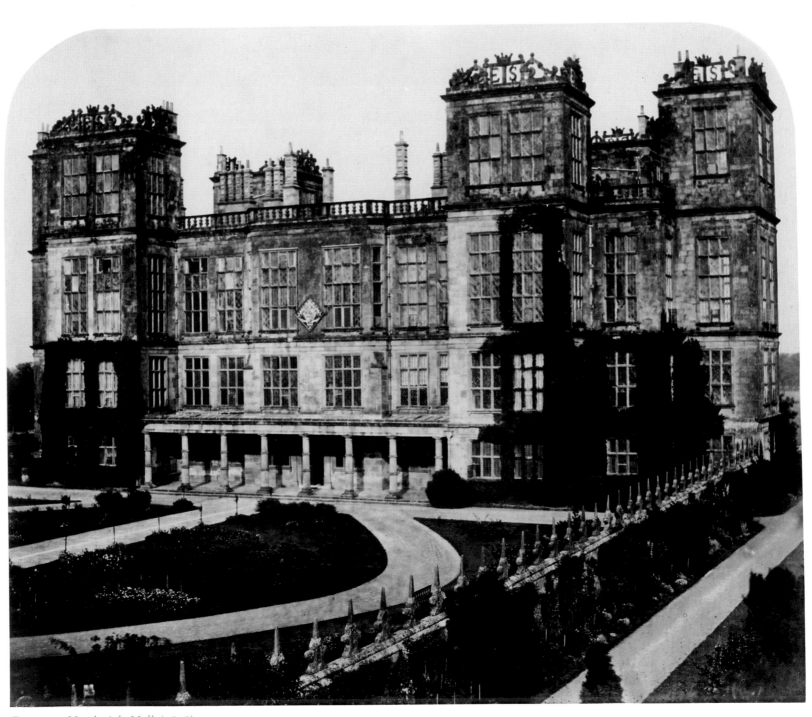

Cat. 134. Hardwick Hall (1858).

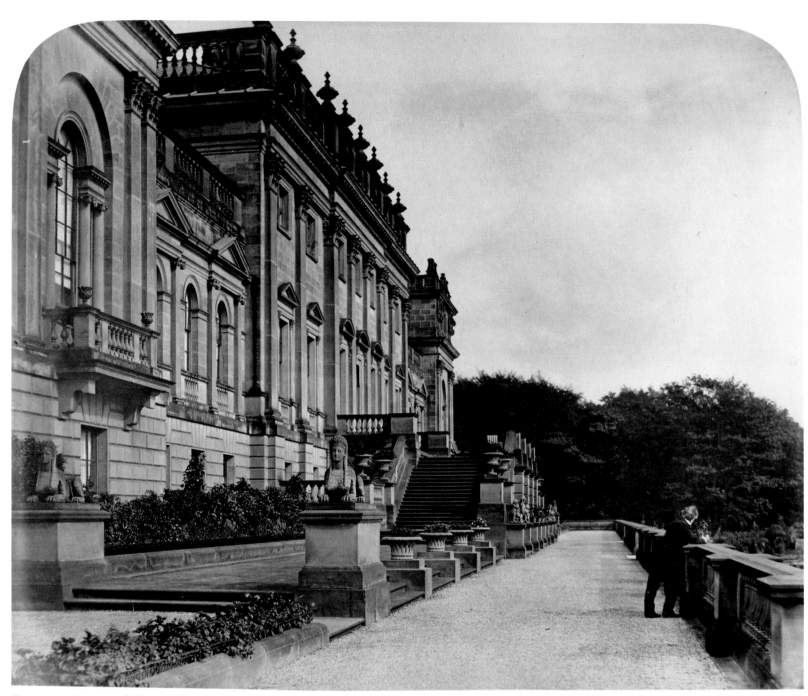

Cat. 136. Harewood House, the upper terrace (1860).

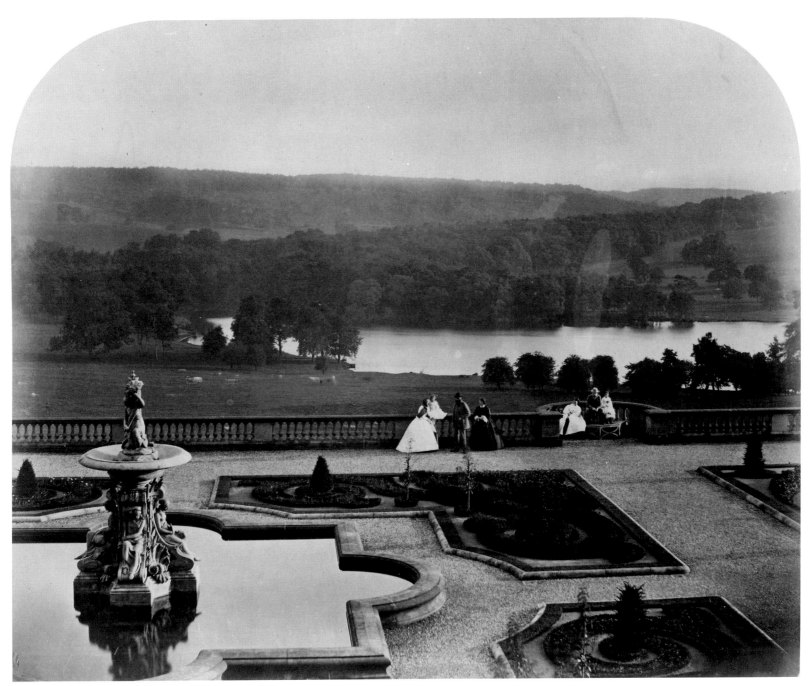

Cat. 137. Terrace and Park at Harewood (1860).

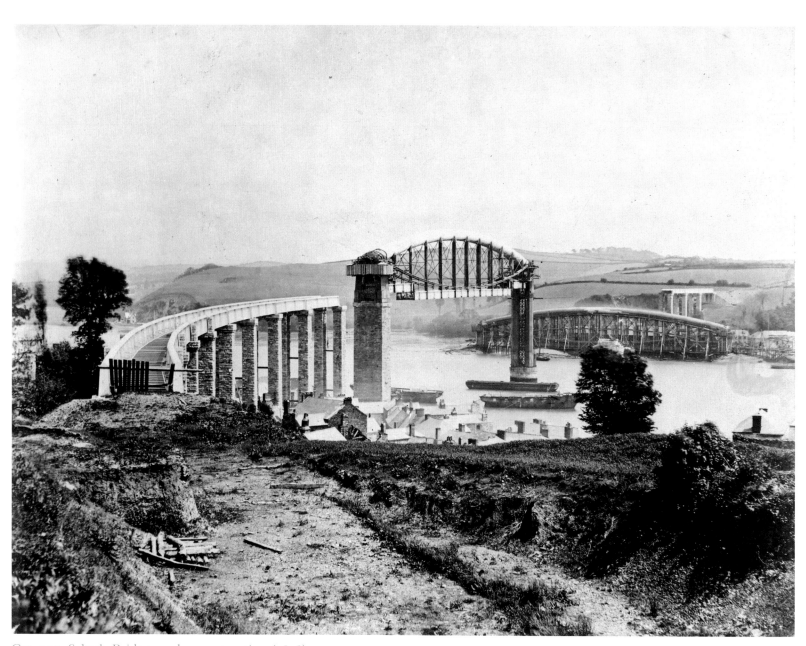

Cat. 130. Saltash Bridge, under construction (1858).

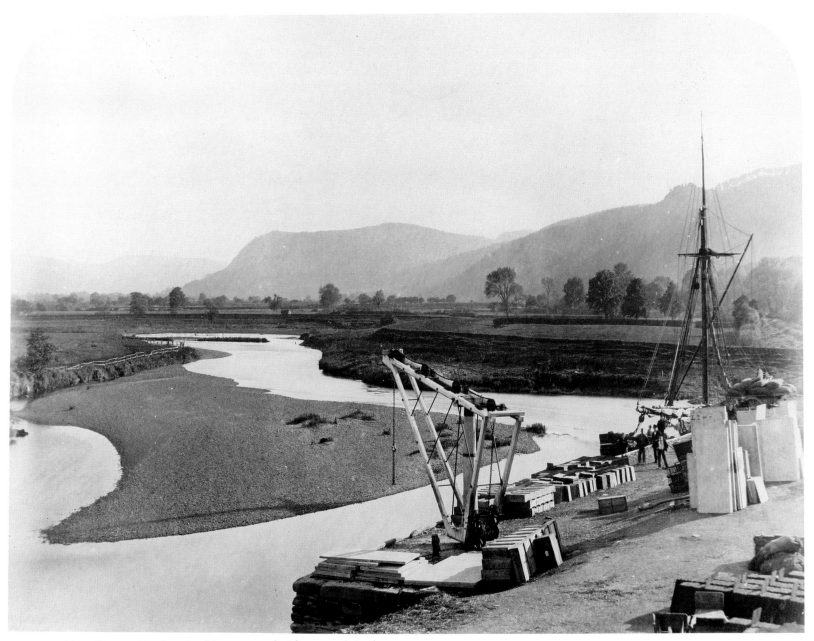

Cat. 129. Slate Pier at Trefiw, looking towards Llanrwst (1857).

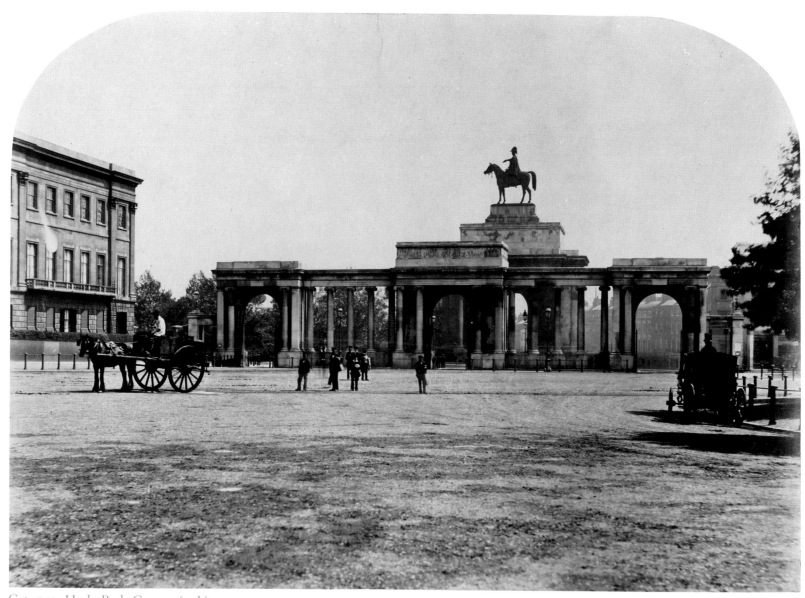

Cat. 142. Hyde Park Corner (n.d.).

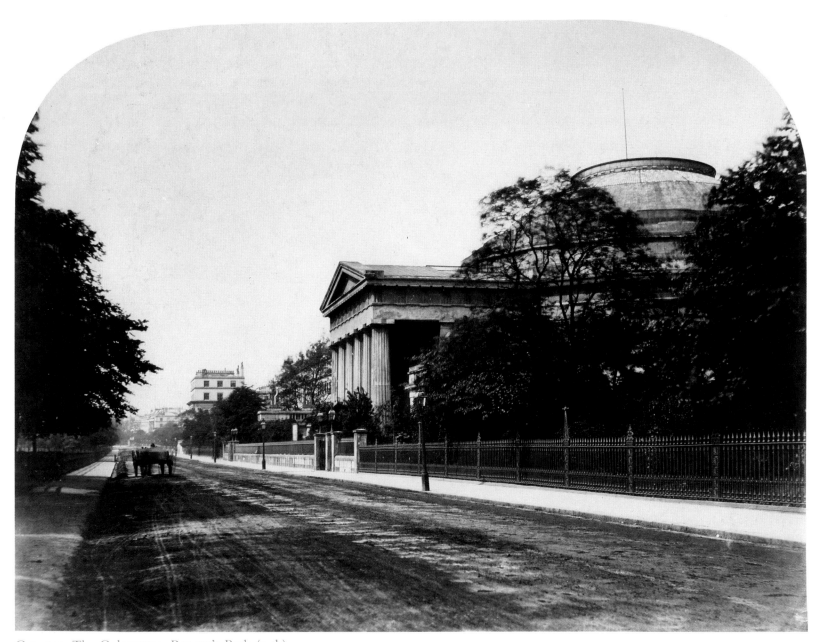

Cat. 143. The Colosseum, Regent's Park (n.d.).

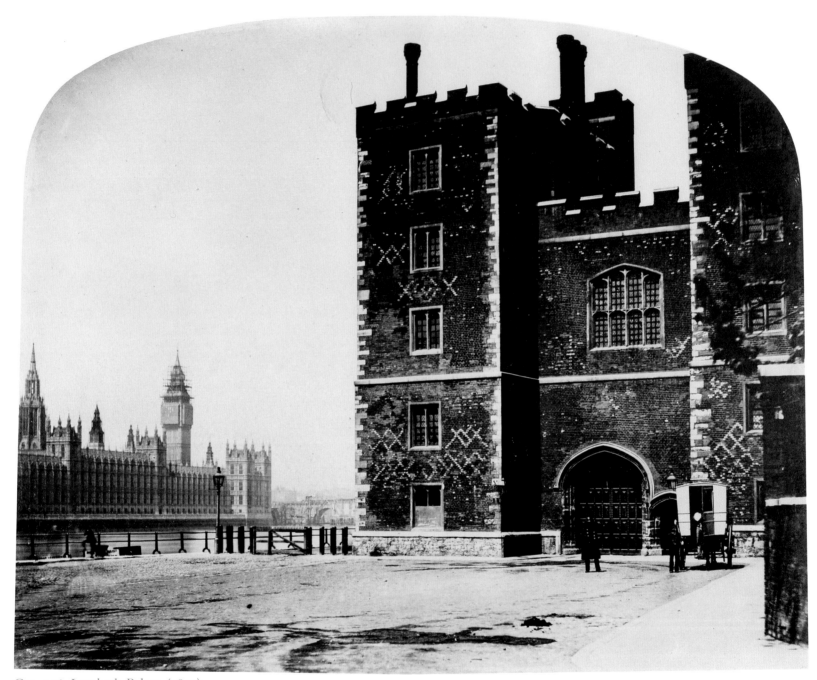

Cat. 126. Lambeth Palace (1857).

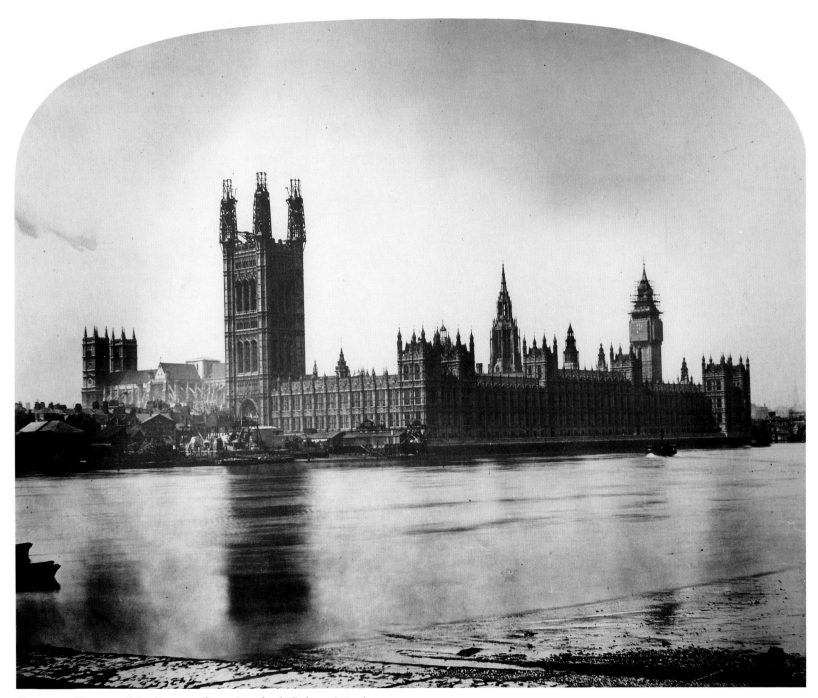

Cat. 127. Houses of Parliament from Lambeth Palace (1857).

Cat. 128. House of Lords, Peers' Entrance (1857).

Cat. 140. Museum, Oxford [Pitt Rivers Museum] (1859).

Cat. 141. Magdalen Tower and Bridge (1859).

COSTUMES AND STILL LIFES

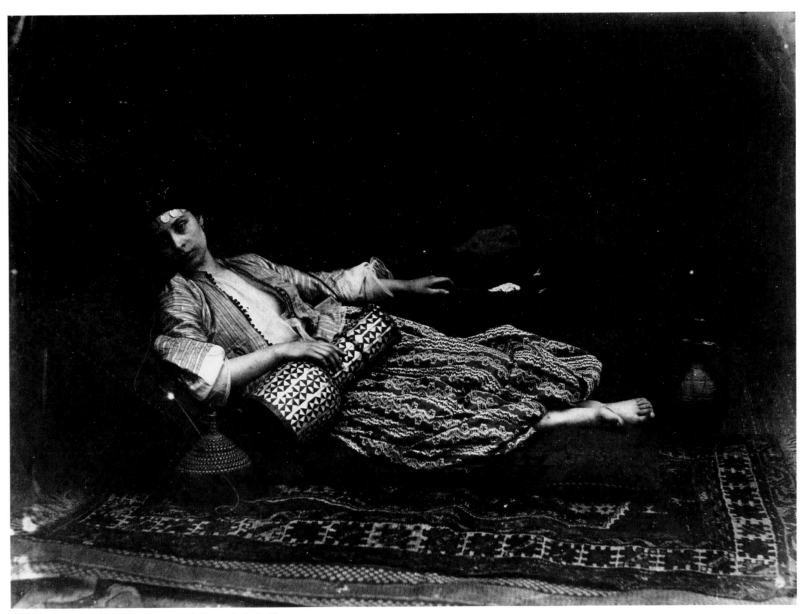

Cat. 144. Untitled (reclining odalisque) (1858).

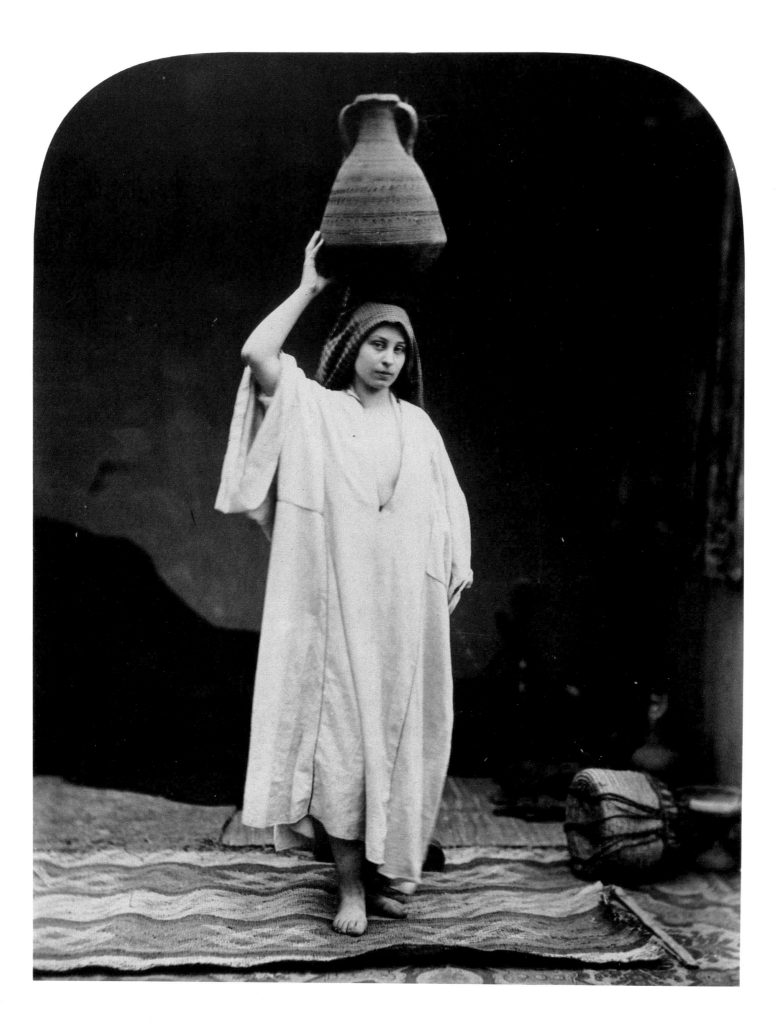

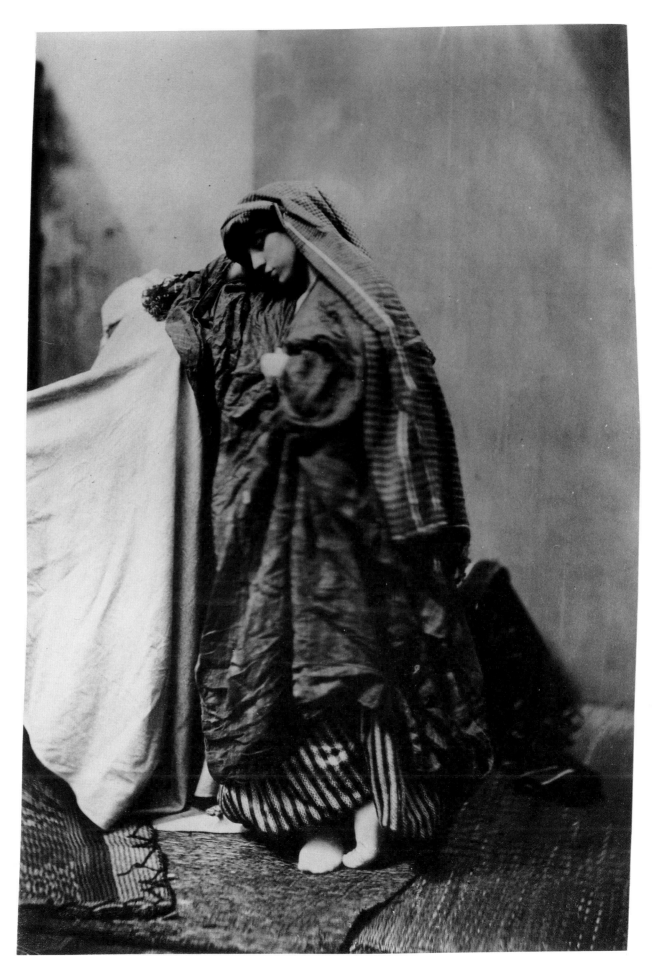

Cat. 147. Girl in Eastern
Costume (1858).

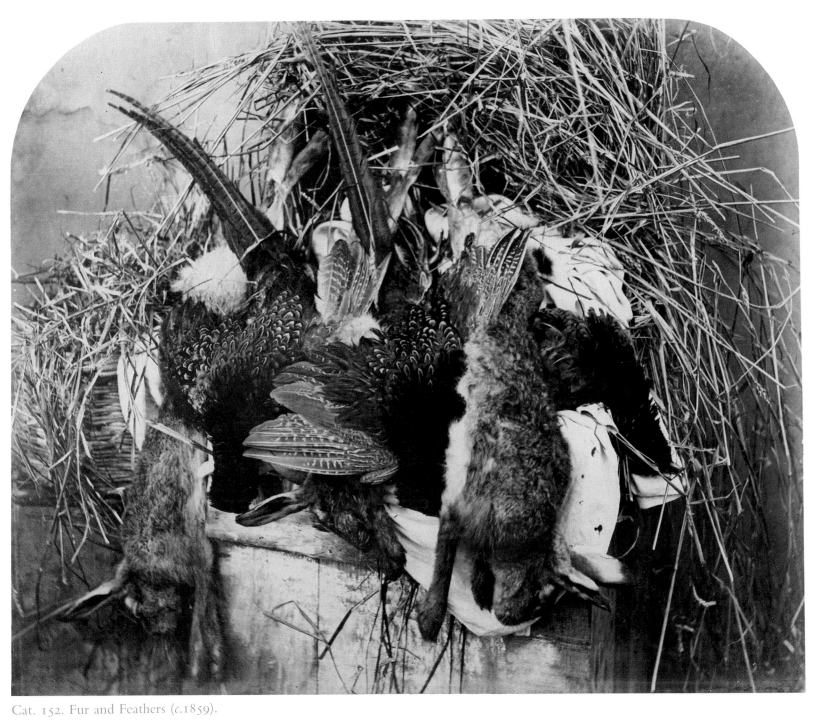

Cat. 152. Fur and Feathers (*c*.1859).

Cat. 151. Game (*c*.1859).

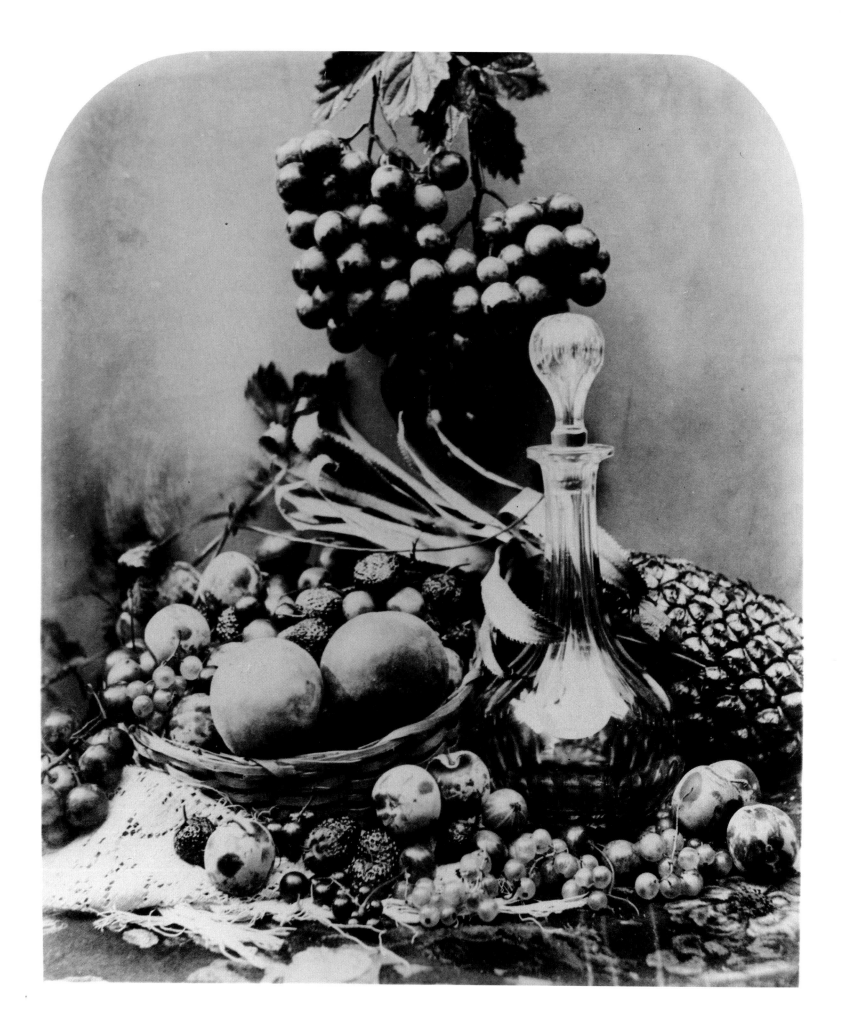

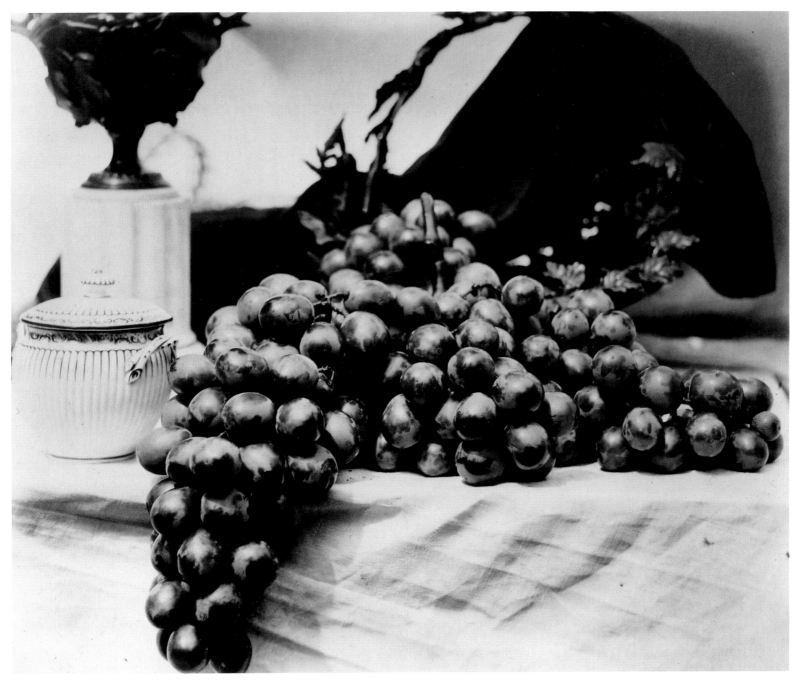

Cat. 154. Grapes and Jar (1860).

Cat. 153. Decanter and Fruit (1860).

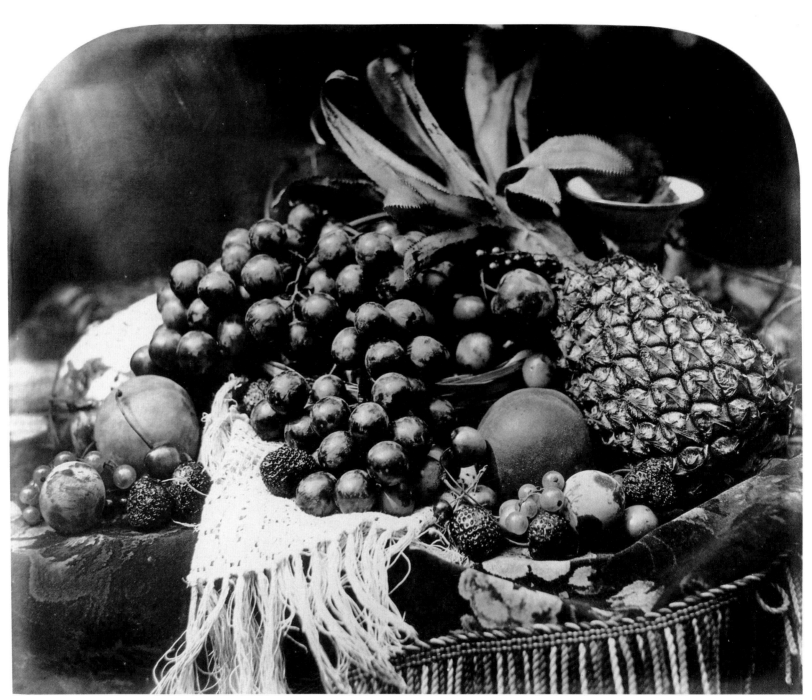

Cat. 155. Fruit (1860).

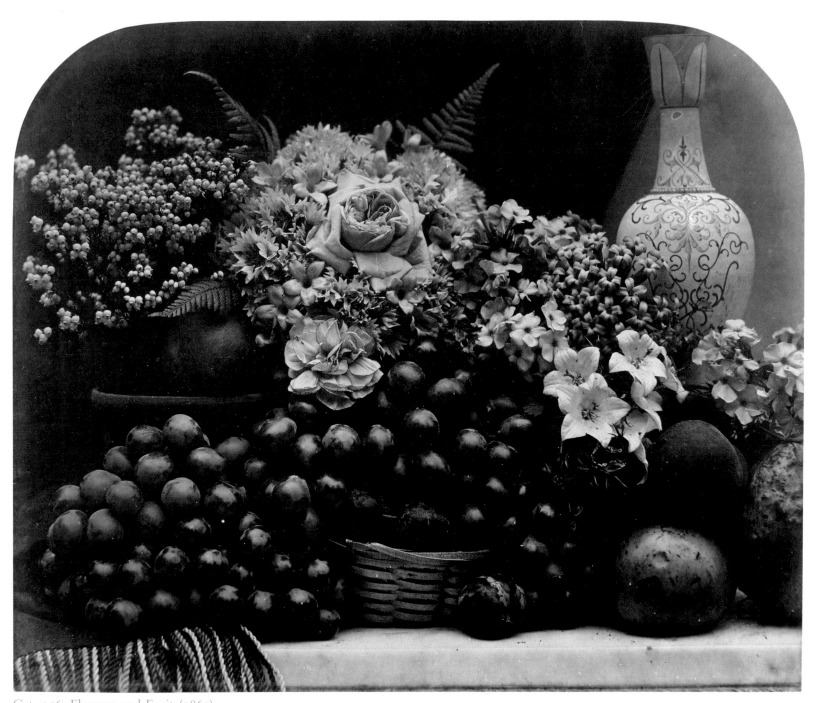

Cat. 156. Flowers and Fruit (1860).

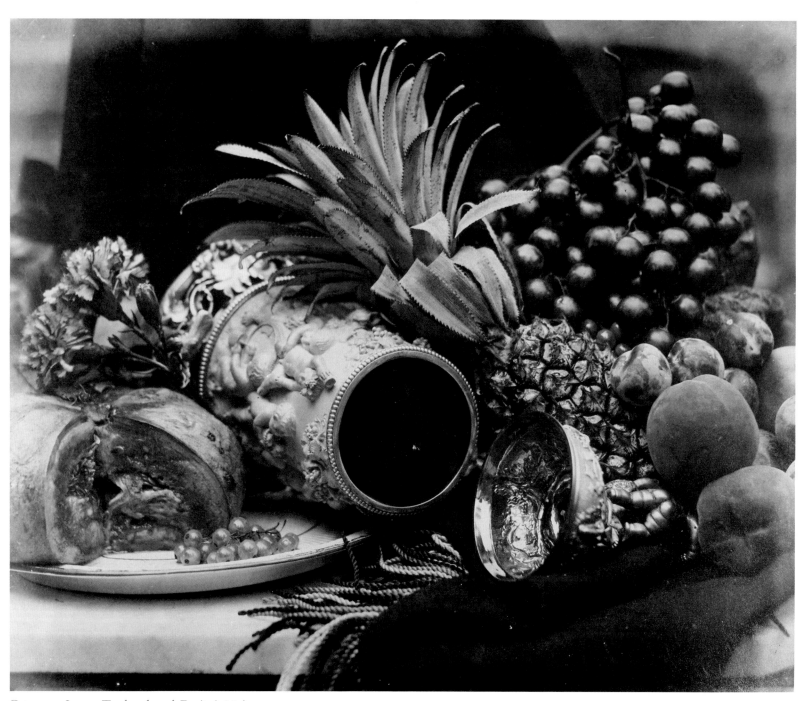

Cat. 157. Ivory Tankard and Fruit (1860).

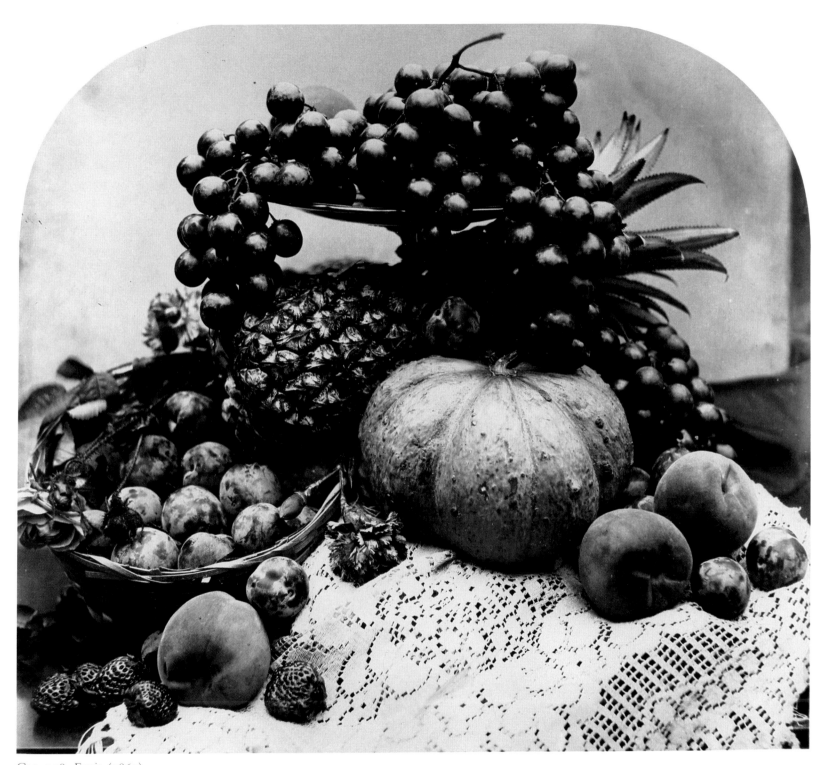

Cat. 158. Fruit (1860).

Cat. 150. Spoils of Wood and Stream (1858/9).

Chronology

1819

28 March — Roger Fenton born at Crimble Hall, Heap, near Bury, Lancashire, the fourth child of John Fenton (1796–1863) and Elizabeth Aipedaile (1792–1829), of Crimble Hall, and grandson of Joseph Fenton (1765–1840), cotton merchant and banker, originally of Top o' the Hill, Crimble and later of Bamford Hall, and Ann (née Kay).

9 November — Christened at Bamford Independent Chapel, Heap, by Thomas Jackson. The chapel had been founded and built largely through the exertions of Ann Fenton and her brother Robert Kay.

Roger had been preceded by two brothers and a sister: John, b.11 February 1814; Elizabeth, b.10 May 1815; and Joseph, b.7 September 1817.

Roger's grandfather, Joseph, establishes the Fenton, Eccles, Cunliffe & Roby bank in Rochdale. John Roby, historian of Lancashire and prominent Independent, was an active partner until after Joseph's death in 1840.

1820

15 June — Third brother, William, born.

Joseph Fenton purchases Bamford Hall from last surviving Bamford descendent and occupies it henceforth.

1822

6 February — Second sister, Sarah, born.

1824

21 June — Third sister, Ann, born.

1826

Joseph Fenton begins to build Hooley Bridge Mill on the bank of the River Roch near Heywood. The five storey, brick 'fire proof' building was gas-lit, and during the following years about three hundred workers' dwellings were built and a large weaving shed was added in 1837, where cotton and fustian were woven. The firm had a good reputation as a fair employer and rose rapidly in repute. Joseph Fenton also built Simpson Clough Mill in the Cheesden Valley for wool fulling and acquired extensive property in and around Heap, and further north in Lancashire, in the parishes of Ribchester and Mitton, including several estates and the bobbin mills at Hurst Green, next to Stonyhurst College. He was Lord of the manors of Dutton and Bailey, Aighton and Chaigley at the time of his death.

1828

28 March — John, Fenton's eldest brother, buried, age 13.

1829

22 July — Mother, Elizabeth, dies, age 37.

1830 — Father, John, marries second wife, Hannah Owston, daughter of William Owston of Brigg, Lincolnshire. They were to have ten more children not all listed here.

1831

2 May — Paternal grandmother, Ann, dies.

1832

11 December — Father, John Fenton, returned as Whig Member of Parliament for the new constituency of Rochdale in the new reformed parliament. With the exception of a short period from 1835–37, when the Tories temporarily gained the seat, he remained M.P. until 1841, when he retired.

In the same year William Henry Fox Talbot was elected M.P. for Chippenham and Horatio Ross, for Aberdeen.

1834

25 April — Uncle, Robert Kay, dies. He was father of James Phillips Kay-Shuttleworth, founder of the English national education system, and Joseph Kay, Q.C., called to the bar in 1848, a member of the same Inn as Fenton.

1835–6 — James, Fenton's second half-brother, born.

1836 — Goes to London with his brother William to attend University College, London, where he studies Latin, Greek, mathematics and logic.

1837 — Studies Latin, Greek and English.

1838 — Matriculates.

Studies Latin, Greek and mathematics.

1839 — Studies Greek and English with literature.

29 May — Admitted as member of the Honorable Society of the Inner Temple

1840 — Graduates B.A., and in the following year studies law, still at U.C.L.

Grandfather, Joseph Fenton, dies, leaving an estate worth in excess of £500,000. His true value was rumoured to be double this

figure, since he had previously bought estates jointly in the names of his two sons and himself. Each of his grandchildren was left £1,000 on reaching the age of 21, Roger being that age in that year. Joseph's funeral was attended by local dignitaries including John Bright.

1841 Resident at 11 Gower Place.

Drawing class started at University College, London; G. B. Moore appointed as teacher.

John Fenton retires as M.P. for Rochdale; his brother James contests the seat unsuccessfully on behalf of the Tories.

1843
29 August Marries Grace Elizabeth Maynard, daughter of John Charles Maynard of Harlsey Hall, East Harlsey, Yorkshire, in the parish church.

1844
17 May Anonymous watercolour in private collection titled and dated 'Roger Fenton, Paris, May 17, 1844'.

1845 First child, daughter, Josephine Frances, born, possibly in Paris.

1846 Second daughter, Annie Grace, born in Paris.

1848
25 February Mentioned in diary of Ford Madox Brown: 'French Revolution proclaimed . . . went at eleven at night to see Lucy, found him in great excitement about Paris, Fenton his pupil in sad state about it. We all three have associations with Paris.' [Virginia Surtees, ed., *The Diary of Ford Madox Brown*, New Haven and London, 1981; hereafter referred to as FMB.] (Charles Lucy, 1814–73, a history painter, had studied under Delaroche in Paris and was Fenton's tutor.)

3 June FMB: 'went to see fenton [*sic*], Lucy, & the university. . .'.

29 November FMB: 'nothing but idle, spent the evening with Lucy. Fenton there. . .'.

2 December FMB: 'did no work, called on Fenton'.

12 December FMB: 'Evening to fenton [*sic*] till 2. . .'.

1849
19 March FMB: 'repainted at the head of Cordelia . . . Lucy & Fenton called in, did not like her. . .'. (Brown was painting *Lear and Cordelia*.).

Painting exhibited at Royal Academy, no. 603: *From Tennyson's ballad of the May Queen. 'You must wake and call me early, etc.'*

1850
March Member of the founding committee of the North London School of Drawing and Modelling, with Lucy, Brown, E. H. Baily, S. C. Hall, Thomas Seddon and George Truefitt. [*Almanack of the Fine Arts*, 1850.] The Honorary Secretary was J. Neville Warren; he and Lucy were later to join the Photographic Society.

13 March FMB: 'went to Fenton to paint his dead child'. (This was Fenton's eldest daughter, Josephine Frances, who died, age 5, on 12 March.)

14 March FMB: 'to Fenton's, finished the head—and back to work. . . .

17 April Charles Blacker Vignoles elected member of Society of Arts; Antoine Claudet gives lecture on glass cutting. Robert Hunt lectures on electromagnetism at the following meeting.

1 May North London School of Drawing and Modelling opens in Mary's Terrace, Camden Town, under the patronage of Prince Albert. Evening classes in drawing were intended to teach those working in masonry, carving, plastering, cabinet making, casting and chasing of metals, a 'true knowledge of form.' [FMB]

6 June Third daughter, Aimée Frances, born at London residence, 2 Albert Terrace, Regent's Park.

Painting exhibited at Royal Academy, no. 71: *The Letter to Mamma: What shall we write?*

1851
9 May Called to the Bar; from then on in chambers in the Temple until 1864/5. His address listed as 2 Albert Terrace.

Painting exhibited at Royal Academy, no. 148: *There's music in his very steps as he comes up the stairs.*

The Great Exhibition of Works of Industry of All Nations opens in Hyde Park. The Philosophical Instruments section contains photographs including those by Le Gray, Le Secq and Martens.

October/
November In Paris, taking great interest in the Société Héliographique and the various achievements of photographers in Paris. He was shown the several hundred negatives of 'the provinces' made by Le Gray and Mestral for the French Government. [*Chemist*, February 1852, p. 221.]

1852
February Article by Fenton describing the activities of the Société Héliographique. [*Chemist*, February 1852.]

18 February Earliest photographs signed and dated by Fenton include views of Regent's Park, Albert Road and St Marks Church, dated 18 February 1852 and taken by Le Gray's dry waxed-paper method; also six portraits, including one self-portrait, taken on collodion, dated February. [Collection of Société Française de Photographie, Paul Jeuffrain album.]

March The *Chemist* publishes a 'Proposal for the Formation of a Photographical Society. . . . The Science of photography, gradually progressing for several years, seems to have advanced at a more rapid pace during and since the Exhibition of 1851. . .'. Those interested were invited to apply to their offices or to Roger Fenton, Esq., 2 Albert Terrace, etc. [*Chemist*, March 1852, p. 265.]

24 March Letter from Talbot to Hunt, suggesting a meeting with representatives (of the Calotype Club) to discuss the problem of his patent rights. Six names, Berger, Foster, Fry, Fenton, Newton and Hunt himself, listed on reverse in Hunt's writing.

April Following publication in the *Chemist* of the 'Proposal', Hunt applies to the Society of Arts for a meeting room to enable interested parties to discuss the formation of a formal society.

19 June Meeting held at the Society of Arts to discuss the formation of a New Photographic Society. A Provisional Committee was formed consisting of Berger, Fenton (elected Honorary Secretary), Le Neve Foster, Fry, Goodeve, Hunt, Newton, Percy and Wheatstone, which subsequently held its first meeting in the

offices of the *Art Journal*. 'The committee finding considerable difficulty in making satisfactory arrangements for that purpose, owing to the existence of Mr Fox Talbot's patents, entered into communication with that gentleman; and they have every reason to believe he will throw open all his patent rights to the public if requested to do so by letter numerously and influentially signed.' [Royal Society of Arts, Sessions 8-4-86.]

Contributes section 'Photography on Waxed Paper' to W. H. Thornthwaite's *A Guide to Photography . . .*, London, 1852. Essentially a re-working of Le Gray's process for use in Britain, it was published in August.

September — Arrives in Kiev with Charles Blacker Vignoles and John Cooke Bourne to make pictures of the works in progress on Vignoles's bridge across the Dnieper which had been commissioned by Tsar Nicholas I. These works particularly concerned the hoisting of the first suspension chains.

October — First part of *The Photographic Album* published for Joseph Cundall by David Bogue, London, containing four views by Fenton. Reviewed as 'calotypes' by the *Illustrated London News*, these were, in fact, albumen prints from collodion negatives: *Village Stocks*, *Old Well Walk*, *Tewkesbury Abbey*, and *Old Barn*. The publication of this folio probably marks the end of Talbot's restrictive enforcement of his patents.

10 November — Leaves Kiev with Vignoles, leaving Bourne behind to continue with the photographs.

December — Second part of *The Photographic Album* published, including two plates by Fenton: *The Plough Inn*, *Prestbury* and *Pittville Spa, Cheltenham*, and two plates by P. H. Delamotte.

8 December — Elected member of the Society of Arts (proposed by Peter Le Neve Foster).

20 December — Exhibition of Recent Specimens of Photography opens at the Society of Arts. Fenton reads a paper 'On the present Position and future Prospects of the art of Photography', and contributes thirty-eight prints, including three views in Russia (two of Moscow, the other Kiev), the remainder taken in or near London, Gloucester, Cheltenham, Tewkesbury, Tintern, Portskewit, Southam and Windsor Forest. All were taken by the waxed-paper method.

1853

20 January — Inaugural Meeting of the Photographic Society in the Great Room of the Society of Arts, 4 p.m. Sir Charles Lock Eastlake, P.R.A. elected President. Fenton, as Secretary to the Provisional Committee, reads the Advertisement, previously placed in principal papers; then the Report of the Provisional Committee: 'The want of a centre of union is not now felt for the first time among photographers. Attempts were made at an early period in the history of the art. . .'; and finally the Rules of the Photographic Society. Officers elected: Earl Somers, Sir William Newton and Professor Charles Wheatstone as Vice Presidents; Fenton as Honorary Secretary.

3 February — First Ordinary Meeting of the Photographic Society held at the Society of Arts at which Sir William Newton reads a paper on 'Photography in its relation to Art' and Fenton one 'On the mode to be adopted in the management of the Ordinary Meetings of the Society and of generally forwarding the advancement of the Art.'

10 February — The Photographic Society Publication Committee forms to start monthly journal, consisting of Fenton, Hunt and Vignoles; Wheatstone and Percy join later.

24 February — Fenton and Percy registered at Stamp Office as proprietors of the journal which they are to hold in trust for the Society.

Publication Committee to take *La Lumière*, *Le Cosmos* from Paris.

3 March — First number of the *Journal of the Photographic Society* printed and laid before the Council.

Exhibits in Photographic Institution exhibition (proprietor P. H. Delamotte) forty-eight views, including ones of Russia, Cheltenham, Gloucester, Tintern Abbey, Totteridge and Burnham Beeches.

17 March — Fourth daughter, Eva Katherine, born at 2 Albert Terrace.

May — Between May and August, Talbot distributes examples of his 'photoglyptic' engravings to Brewster, Biot, Hunt, Lord Rosse, Wheatsone, Fenton, Claudet and Herschel.

5 May — Photographs taken for Wheatstone's reflecting stereoscope by Claudet, Delamotte, Fenton, Henneman, Clarke and Roslin exhibited at the 4th Ordinary Meeting of the Photographic Society.

14 July — Letter from Fenton to E. Hawkins, British Museum, giving lengthy and considered advice on the type of studio and darkroom suitable for the museum, and detailed information as to the latest equipment appropriate for photographing objects of great disparity. [BM. Letter 1751, 14 July 1853.]

25 July — Letter from P. H. Delamotte to Vaux, British Museum, giving list of useful photographic apparatus for projected studio. [BM, Original Papers, 25 July 1853.]

22 August — Letter from Delamotte to British Museum, offering himself as candidate for post of Photographer. [BM, Original Papers, 22 August 1853.]

4 October — Letter from Fenton to Sir Henry Ellis offering his services as Photographer to the British Museum. [BM, Original Papers, 4 October 1853.]

6 October — Letter from Wheatstone to Hawkins, British Museum, recommending Fenton as museum photographer: 'I do not know any person better qualified to superintend the proposed photographic arrangements at the British Museum than Mr. Fenton . . .'. [BM, Original Papers, 6 October 1853.]

8 October — Fenton recommended as photographer to British Museum Committee.

1854

3 January — Eastlake, Wheatstone, Fenton and Rosling escort Queen Victoria and Prince Albert, as patrons, round the Photographic Society's first Exhibition of Photographs and Daguerreotypes at Rooms of the Society of British Artists, Suffolk Street. Fenton exhibits views in Russia of the suspension bridge under construction in Kiev, and also views of monasteries, churches, etc. in Moscow, St Petersburg and Kiev, from waxed paper negatives, and other views taken on collodion.

March — Photographs the Baltic Fleet leaving harbour at Spithead bound for the Crimea.

11 March	Terms of Fenton's engagement as photographer approved by British Museum. [Minutes of the Committee of Trustees, 8681.]
8 April	Report ordered as to agreement with Fenton by British Museum. [Minutes of the Committee of Trustees, 8681 and 8690.]
10 April	Photographing at Buckingham Palace; also on 1, 5, 6 and 21 May and 30 June.
12 June	Photographs Lady Harriet Hamilton, also 30 June.
15 July	British Museum terminates Fenton's engagement for photography. [Minutes of the Sub-Committee 879.]

1855

January	Photographic Society's annual Exhibition of Photographs and Daguerreotypes opens at the Gallery of the Society of Watercolour Painters, Pall Mall East. Fenton contributes forty-four prints, taken mainly in Yorkshire, but including six views of the Baltic Fleet leaving Spithead for the Crimea in March 1854. All taken on collodion negatives. J. C. Bourne exhibits a number of prints taken in Russia on Talbotype negatives, including several of Vignoles's bridge in Kiev.
1 February	Lord Aberdeen's coalition government resigns amid controversy as to the administration of the war in the Crimea.
20 February	Leaves London in H.M.S. *Hecla* bound for the Crimea.
8 March	Arrives at Balaclava
April	Photographs near Kadikoi.
May	Exhibition of photographic pictures at the Photographic Institution, 168 New Bond Street. Eleven views by Fenton exhibited in his absence, taken at Burnham Beeches, Raglan Castle, Tintern, Fountains and Rievaulx abbeys and the valley of the Wharfe, Yorkshire, variously taken on paper or collodion negatives.
	[End of month] Fenton goes on expedition to Kertch and makes watercolour sketches.
2 June	J. C. Bourne elected member of Photographic Society.
7 June	5 a.m. photographs *The Council of War*, with Lord Raglan, Omar Pasha and Marechal Pelissier. Later is an eyewitness when the French storm the Mamelon.
18 June	Watches from Cathcart Hill as the Russians repulse the attack on the Malakoff.
26 June	Sails from Balaclava, suffering from cholera.
2 July	Fifth daughter, Rose Maynard, born at 2 Albert Terrace.
September	Exhibition of 312 views taken in the Crimea at the Gallery of the Water Colour Society, Pall Mall East.
11 and 12 September	Commanded, with William Agnew, to attend the Emperor of France and submit a selection of views of the Crimea.

1856

February	Resigns as Hon. Secretary of the Photographic Society.
	Photographic Society's third annual Exhibition of Photographs and Daguerreotypes opens at the Gallery of British Artists. Fenton exhibits about sixteen prints, including subjects from the British Museum, portraits and a study of children.

	British Museum publishes *Photographic Facsimiles of the Remains of the Epistles of Clement of Rome, made from the unique copy preserved in the Codex Alexandrinus*, in an edition of fifty, the pages being original, unmounted, matt silver prints.
	Fenton one of the executives for the Patent Photogalvanograph Company, formed to exploit Pretsch's photo-engraving technique, which commenced publishing *Photographic Art Treasures* in parts, including prints from photographs by Fenton and other well-known names. Many more images by Fenton were used than anyone else, and were also issued separately.
1 May	Fenton, W. Lake Price, P. H. Delamotte, T. F. Hardwich, and later Vignoles, obliged to resign from the Council of the Photographic Society following their advertisement for a Photographic Association which would offer and exhibit prints for sale; such a plan was seen as unacceptable under the rules of the P.S.
September	At Balmoral: eight negatives made; also, views made in surrounding area, valley of the Dee and Braemar, etc.
6 December	Account at the British Museum to be inquired into. [Minutes of the Committee of Trustees, 9121.]

1857

	Photographic Society Exhibition of Photographs opens at the Gallery of the Society of Water Colour Painters. Fenton exhibits forty-seven views taken in Scotland, Newcastle, Berwick, Holy Island, Yorkshire and Raglan.
1 May	Letter from Bolton to Talbot; reports losses of the Patent Photogalvanograph Company to be about £4,000. [Lacock Abbey, 57-15.]
7 July	Letter from Fenton to Hawkins at the British Museum arranging to meet Smirke, Architect to the Ministry of Works and responsible for the Museum, advising that he should first see the glasshouse then in the course of construction at Albert Terrace.
	Contributes eight prints to the exhibition of the Art Treasures of the United Kingdom, Manchester, all taken in or near Scotland.

1858

	The Photographic Society's fifth annual Exhibition of Photographs and Daguerreotypes opens at the South Kensington Museum. Fenton exhibits forty-one prints, all from collodion negatives, twenty-two of them views in North Wales, fourteen, objects in the British Museum, York, Lincoln, Peterborough and Ely cathedrals, and a view of St James's Park in the fog, February 1858.

1859

13 January	First son, Anthony Maynard, born at 2 Albert Terrace.
	Sixth annual Photographic Society Exhibition of Photographs and Daguerreotypes opens at Gallery of Society of British Artists, Fenton exhibits forty-two views, including Hardwick, Chatsworth, Haddon, Lichfield, Salisbury, Wells, Glastonbury and Cheddar.
November	The *Stereoscopic Cabinet*, published in parts by Lovell Reeve between November 1859 and December 1860. Issued in packets containing usually three stereocards, the series consisted of twenty-four parts. Other series were published by Lovell Reeve at this time, including a series of fifteen cards, *Stonyhurst College and Its Environs*, by Fenton.

1860 Seventh Photographic Society Exhibition of Photographs and Daguerreotypes opens at Gallery of Society of Painters in Watercolours. Fenton exhibits thirty-six views, mainly of Lancashire (including Stonyhurst) and Oxford.

16 April Joins 9th (West Middlesex) Rifle Volunteers as a Captain

Makes series of photographs at the Hythe School of Musketry, where Rifle Volunteers were encouraged to attend courses to become instructors for their units. Fenton's younger half brother, James, belonged to the 24th Lancashire Rifle Volunteers, and was an internationally successful shot.

July Makes series of photographs of shooting competition on Wimbledon Common for the Queen's Prize and the Duke of Cambridge Prize. After competition, series of photographs taken, probably on steps of 2 Albert Terrace, including Charles Lucy, Horatio Ross (founder of the Scottish Photographic Society in 1856 and a crack shot) and Ross's son, who won the Queen's Prize.

Conway in the Stereoscope, illustrated by Roger Fenton Esq. M.A., published by Lovell Reeve, London, containing twenty albumen stereo prints, taken in the Conway valley and its tributaries, North Wales.

24 April Only son Anthony Maynard dies, age 2.

1861 Eighth annual Photographic Society Exhibition of Photographs and Daguerreotypes opens at the Gallery of the Society of Painters in Watercolours. Fenton exhibits thirty-eight views, including Furness Abbey, Lake District, Harewood House and still-life studies of fruit and flowers.

Hooley Bridge Mill ceases working following a family dispute. Valued at £180,000 in 1857, the mill lay empty until 1896, when it was sold for £6,150. John Fenton, having bought out the third partner in 1858 owned two thirds to his nephew Joseph's one third.

Onset of the cotton famine.

1862

15 October *Journal of the Photographic Society* announces Fenton's retirement from photography and from the Photographic Society. Advertisement appears for sale of Fenton's negatives and photographic equipment to be held on second Tuesday in November.

Address given in Law List as 4 Harcourt Buildings, Temple, E.C. This almost certainly coincides with his more frequent or permanent residence at Potters Bar and his giving up photography.

Disappears from Volunteers in Army List.

Two plates of Furness Abbey by Fenton (albumen prints) published in *Ruined Abbeys and Castles of Great Britain*, by William and Mary Howitt.

1863

25 July Father, John, dies, age 72.

Details in Law List ammended to include Northern Circuit, Manchester and Salford Sessions, implying briefs in his home county. This may be connected with his cousin Joseph Kay's becoming Judge of the Salford Hundred Sessions the previous year.

1865 Gives up chambers in the Temple; only details of Northern Circuit appear in Law List.

1869

9 August Dies at his home, Mount Grace, Little Heath, Potter's Bar; causes listed as nervous exhaustion, weakness of the heart and congestion of the lungs (heart failure). His occupation listed as gentleman.

Will leaves Mount Grace and household effects to Grace. A separate codicil detailing instructions for his picture collection was intended, but not made.

1871 Wife and three surviving daughters, Annie, Eva and Rose, still resident at Potter's Bar. Annie and Rose, both painters, exhibited at the R.A. a number of times between 1877 and 1885.

1873 Law List mistakenly repeats last entry on Fenton, onus on relatives to cancel.

1878

25 November Messrs J. & J. Fenton and Sons, the family bank, then of Rochdale and Heywood, fails, leaving catastrophic debts. Partners at that time were Joseph, cousin of Bamford Hall, William, brother, James, half-brother, and Jonathan Nield, managing director. This completes the ruin of the empire built up by grandfather Joseph, and with the effects of the cotton famine, the cotton industry in that part of Lancashire sinks into decline everywhere.

1879

3 May Sale of Jonathan Nield's, William Fenton's and cousin Joseph Fenton's picture collections at Christie, Manson and Woods Auction Rooms, London. Nield's collection of eighty-six pictures included Landseer, Constable, Cox, Caulderon, Frith, Creswick, Goodall, Muller, Webster, Ansdell, Linnell, Martin; and sculpture by Bailey, Foley and Woolner. William Fenton's collection included pictures by Hayes, Mulready, Hendrichs and *A Girl and Dove* by Roger Fenton. Joseph Fenton's collection included works by Turner, Constable, Linnell, Landseer, Stansfield, Crome, de Loutherbourg, Muller, Reynolds, Wilkie, Ward. Many of the works were important, and a great many were purchased by Agnew.

1880

8 September Bamford estate sold by auction in Rochdale.

Glossary

Note on Fenton's Prints

The identification of photographic processes of the period when Fenton was practising is not straightforward. Although some processes, such as Talbot's calotype, were patented, many were simply reported in Photographic Society meetings. Of these, a great many were minor modifications of one of the basic processes: salt or albumen prints, calotype, albumen or collodion negatives.

Fenton, when adapting Gustave Le Gray's waxed-paper process for use in Britain, added egg-white (albumen). Most photographers of the time experimented with chemicals to improve exposure time and to suit the papers available. Literally hundreds of combinations were available and communicated to a greater or lesser extent between amateurs. Fenton appears not to have used the plain salted-paper method for his prints, and precise details of his printing processes are not known—and in any case would have varied. The matt prints by Fenton usually referred to as 'salt prints' are almost certainly a modification using, among other things, egg-white, but not enough to leave the prints glossy. Other colloids were used, including whey, agar and karogene, and for this reason, lacking specific information, I have elected to call Fenton's matt prints matt silver prints rather than matt albumen.

Calotype or Talbotype

The calotype process is a negative process on paper—essentially a much improved version of the photogenic drawing process—invented by Talbot and patented by him in 1841. This process, with various modifications and improvements, formed the basis for all paper negative techniques until the introduction of the albumen and wet collodion methods on glass, and was used by many photographers into the late 1850s.

For the calotype, a good-quality writing paper was prepared by brushing one side with a solution of silver nitrate. It was dried and then immersed in a solution of potassium iodide for two or three minutes to allow the formation of silver iodide. The paper was then washed and dried, at which point it appeared pale yellow on the coated side. When needed for use the paper was brushed with, or floated on a bath of, a mixture called gallo-nitrate of silver. The paper could then be placed either wet or dry in a dark slide and exposed in the camera. In good light the latent, or invisible, image formed in not much more than a minute. It was then developed, or 'brought out,' by washing with gallo-nitrate of silver; finally, it was thoroughly washed and fixed in a bath of sodium thiosulphate ('hypo'). The discovery of the latent image, subsequently developed, made exposure times much faster and formed the basis for most of today's photographic procedures.

Although the term calotype was often used to refer to positives, it strictly applies only to the negative process patented by Talbot.

Salt Print or Salted Paper Print

This literally refers to plain (salted) paper printing, which consists of sensitising a good-quality writing paper by immersing it in a solution of common salt and then floating it on a bath of silver nitrate. The paper is exposed by contact in printing frames until the image reaches the required depth, and then it is washed, toned and fixed with sodium thiosulphate ('hypo').

This method is virtually Talbot's original one for photogenic drawing paper, with the use of sodium thiosulphate ('hypo') subsequently added to fix the image. However, the term is commonly applied—when cataloging photographs where there is no more specific documentation—to all plain methods based on the photogenic drawing or calotype processes. Prints from these processes have a matt surface, the image or silver salts appearing to be slightly embedded in the paper rather than clearly contained in a medium or emulsion on the surface of the paper, as with the slightly glossy albumen paper.

Waxed-Paper Process of Gustave Le Gray

Gustave Le Gray, in France, perfected a development of Talbot's calotype process which, from its communication to the Académie des Sciences in February and publication in December 1851 (roughly coinciding with the relaxation of Talbot's patent restrictions in England), caused a renewed enthusiasm for the paper negative against the new wet collodion method on glass. The majority of photographers in Paris were using the method by the autumn of 1851, presumably having learnt it at Le Gray's photographic school.

Le Gray's method, by waxing the paper before sensitisation, produced a very fine and detailed image. In addition, his method had the advantage over the calotype (which had to be used within a day of preparing the paper and developed within a day after exposure) of being able to be kept for up to two weeks after preparation and to be left several days after exposure before being developed. It was thus ideal for the travelling architectural or landscape photographer, and was particularly popular among amateurs until the latter 1850s.

A good-quality, smooth paper was placed on a heated, silvered copper plate, and pure white wax was rubbed into it. It was then ironed between sheets of blotting paper to remove the excess. This had the effect not only of rendering the paper translucent, but also of filling up all the pores of the paper and making a continuous surface for coating that slightly absorbed the silver salts. The iodizing solution was made from rice water, milk sugar, potassium iodide, potassium cyanide and potassium fluoride; the waxed paper was soaked in this for about an hour, then dried. The paper was sensitised by floating it for about five minutes on an acid solution of silver nitrate; it was then dried and exposed. The latent image was developed by immersion in a gallic acid solution for up to three hours. It was then fixed and washed as usual with other salt prints.

Prints from negatives by Le Gray's process could be on salted paper or albumen during the 1850s, and unless documentation about the negative existed it would be impossible to be conclusive about the negative process from the appearance of the print. An improvement on post-waxed calotypes, with the sensitive emulsion lying on top of a continuous, smooth, waxed surface, this process had the advantage of

being as detailed as if on glass. However, the superior speed of the wet collodion method, combined with the robustness of glass plates for printing any number of prints from a single negative, caused the paper negative to become virtually obsolete by the 1860s.

Albumen Print

The albumen print was introduced by Louis Désiré Blanquart-Evrard in 1850, and for the next thirty years was virtually the only printing method used. Thin, good-quality writing paper was coated with albumen (made from fresh egg-white), and then sensitised with a solution of acidified silver nitrate. The prints were fixed in plain 'hypo' (sodium thiosulphate), and gold chloride was often used in the fixing bath to obtain a deeper, more purplish tone. The emulsion, and therefore the image, lay on the surface of the paper (as was not the case with the salt print) and produced a smooth, slightly glossy surface, which, uninterrupted by the surface of the paper, enhanced the richness of the tones and the very fine detail in the image.

Wet Collodion Process

The wet collodion process on glass revolutionised photography from 1851. Collodion, made from pyroxyline (a kind of guncotton) dissolved in a mixture of alcohol and ether, was introduced in England in 1847. R. J. Bingham, one of Faraday's assistants, was the first to suggest its use in photography, as was Gustave Le Gray, independently, in France. But the first wet collodion on glass negatives were demonstrated by Frederick Scott Archer late in 1848, and his perfected process was published in March 1851.

A perfectly clean glass plate was coated with prepared collodion in which were dissolved bromide and iodide salts. As soon as the film had set, the plate was immersed in a solution of silver nitrate, thus forming silver iodide or silver bromo-iodide in the collodion. It was then exposed in the camera and developed while still wet, normally with a proto-sulphate of iron developer, but a pyrogallic acid developer was sometimes used. The negative was usually intensified, fixed in a saturated solution of sodium thiosulphate ('hypo'), and washed. Finally, in order to prevent decomposition of the pyroxyline film by contact with air and moisture, the negative was varnished with a spirit varnish, which also helped to protect it from scratching.

The method was clearly not without its practical disadvantages. Glass was heavy and breakable; the manipulation involved in coating the plates with collodion was an art in itself; and, most of all, the entire operation had to be performed in the dark 'on site,' while the plates were still wet. This made it necessary to transport dark tents, apparatus, glass plates and chemicals to every location. The advantages of the glass negative were, however, so great that they far outweighed these hardships. Its speed was faster than the salt paper processes. Also, having a structureless film, very fine grain and clear whites, this process afforded incredible detail and tonal range which have never been bettered. It became virtually the only negative process in use between the mid-1850s and the 1880s, when dry plates became available.

Stereo-photography

A term referring to the format, not the process, using two slightly different views of the same subject taken side by side. The system depended on the binocular vision of the human eye. When the viewer looked through a stereoscope, each eye saw only one of the images, and these two were fused into one seemingly three-dimensional image by the brain.

Sir Charles Wheatstone's reflecting stereoscope was the first practical method. Two photographs, taken separately from slightly different viewpoints and each up to 8 by 5 inches, were positioned vertically at either end of a horizontal bar, and two plain mirrors, set mid-way between them and at an angle of 45°, reflected the pictures, one into each eye.

Later in the 1850s, Sir David Brewster's refracting or lenticular stereoscope provided a more portable method of viewing two pictures side by side on a card about 3½ by 7 inches. The card was placed in a hand-held Holmes stereoscope and was a popular form of domestic entertainment in Victorian drawing rooms up to the twentieth century. With Brewster's method, the two images were usually taken on one negative in a camera with twin lenses, about three inches apart, corresponding to the width between human eyes, and, like human eyes, having equal foci.

List of Works in the Exhibition

Russia

1. **Moscow, Domes of the Cathedral of the Resurrection in the Kremlin**, 1852
Matt silver print
179 × 217 mm
Gilman Paper Company Collection PH.78.458

2. **Scaffolding for the Repair of a Church at Moscow**, 1852
Matt silver print
172 × 215 mm
The Royal Photographic Society, Bath 3282

3. **Andreiski Church, Kiev**, 1852
Matt silver print
283 × 268 mm
Rubel Collection, Courtesy Thackrey & Robertson, San Francisco

4. **The Floating Bridge across the Dneiper, Kiev,** 1852
Matt silver print
240 × 355 mm
The Royal Photographic Society, Bath 3294

5. **The Great Lavra Monastery from the North Side of the Dneiper, Kiev,** 1852
Matt silver print
240 × 340 mm
The Royal Photographic Society, Bath 3287

6. **The Post House, Kiev,** 1852
Matt silver print
355 × 279 mm
Collection Centre Canadien d'Architecture/Canadian Centre for Architecture, Montreal PH.1985.0693

Portraits

7. **Prince Alfred, Duke of Edinburgh,** 1856
Matt silver print
331 × 260 mm
The Royal Photographic Society, Bath 12876

8. **Princesses Helena and Louise,** 1856
Matt silver print
381 × 342 mm
The Royal Photographic Society, Bath 3320/2

9. **Princess Royal and Princess Alice,** 1856
Matt silver print
313 × 315 mm
The Royal Photographic Society, Bath 3298/2

10. **Highland Ghillies at Balmoral,** 1856
Albumen print

298 × 414 mm
The Royal Photographic Society, Bath 3316

11. **A Ghillie at Balmoral,** 1856
Matt silver print
380 × 315 mm
The Royal Photographic Society, Bath 3325

12. **Mr. Ross Jnr, the winner of the Queen's Prize, Wimbledon, July 1860**
Albumen print
254 × 219 mm
Photograph from the Royal Archives, lent and reproduced by Gracious Permission of Her Majesty the Queen

13. **Horatio Ross and Son, the teacher and pupil, Wimbledon, July 1860**
Albumen print
264 × 250 mm
Photograph from the Royal Archives, lent and reproduced by Gracious Permission of Her Majesty the Queen

14. **Caption Ross, 57 points in the 3 periods, Wimbledon, July 1860**
Albumen print
240 × 250 mm
Photograph from the Royal Archives, lent and reproduced by Gracious Permission of Her Majesty the Queen

15. **Horatio Ross and his Son, the winner of the Queen's Prize, Wimbledon, July 1860**
[from left: Charles Lucy, Horatio Ross, J. H. Parker, Mr Ross, Jnr.]
Albumen print
238 × 279 mm
Photograph from the Royal Archives, lent and reproduced by Gracious Permission of Her Majesty the Queen

16. **Roger Fenton [possibly self-portrait],** c.1852
Albumen print
120 × 92 mm
Gilman Paper Company Collection PH.83.901

17. **Summer Meeting of the Photographic Club at Hampton Court, July 1856**
Matt silver print
189 × 330 mm
Exeter Camera Club

18. **Roger Fenton in Volunteer's Uniform,** 1860
Albumen print

266 × 226 mm
Royal Photographic Society, Bath 8005

The British Museum

19. **The British Museum, facade,** 1857
Albumen print
331 × 421 mm
Trustees of the British Museum 1857-7-11-77

20. **Discobolus,** c.1857
Albumen print
251 × 295 mm
The Royal Photographic Society, Bath 3020

21. **British Museum, Gallery of Antiquities,** c.1857
Albumen print
262 × 293 mm
The Royal Photographic Society, Bath 3024

22. **Head from the Tomb of Mausolus,** c.1857
Matt silver print
273 × 226 mm
The Royal Photographic Society, Bath 2921

23. **Greek Hero,** c.1857
Albumen print
347 × 247 mm
The Royal Photographic Society, Bath 2920

24. **Roman Portrait,** c.1857
Matt silver print
356 × 267 mm
Trustees of the British Museum T.108 (63)

25. **Laughing Satyr,** c.1857
Matt silver print
267 × 203 mm
Trustees of the British Museum T.82; II (53a)

26. **The Gold Dish by Benvenuto Cellini,** c.1857
Albumen print
388 × 389 mm (trimmed to circle)
The Royal Photographic Society, Bath 3090

27. **A Portion of the Crucifixion; after Memling, from a drawing in the British Museum,** 1858
Matt silver print
251 × 286 mm
Trustees of the British Museum 1858-10-9-32

28. **Study of Drapery and Three Hands; after Raphael Sanzio, from a drawing in the British Museum (Payne Knight Collection),** 1858
Matt silver print
332 × 228 mm
Trustees of the British Museum 1858-10-9-8

29. Man and Male Gorilla Skeletons (profile), c.1857
Albumen print
363 × 277 mm
The Board of Trustees of the Victoria and Albert
 Museum 40.850

30. Man and Male Gorilla Skeletons (front view),
 c.1857
Albumen print
350 × 276 mm
The Board of Trustees of the Victoria and Albert
 Museum 40.849

The Crimean War

31. Zouave, 2nd Division [Roger Fenton], 1855
Matt silver print
172 × 148 mm
Jeremy Fry

32. Field Marshal Lord Raglan, 1855
Matt silver print
199 × 153 mm
The J. Paul Getty Museum 84.XM.504.12

33. General Sir Colin Campbell, 1855
Matt silver print
248 × 210 mm
The Trustees of the National Portrait Gallery,
 London P.20

**34. Major General James Bucknell Estcourt and
 Staff**, 1855
Matt silver print
166 × 162 mm
Harry Ransom Humanities Research Center,
 Gernsheim Collection, Photography Department,
 the University of Texas at Austin

35. Lieutenant General Sir George de Lacy Evans,
 1855
Matt silver print
192 × 161 mm
Harry Ransom Humanities Research Center,
 Gernsheim Collection, Photography Department,
 the University of Texas at Austin

36. Captain Burnaby, Grenadier Guards, 1855
Matt silver print
181 × 137 mm
Harry Ransom Humanities Research Center,
 Gernsheim Collection, Photography Department,
 the University of Texas at Austin

37. Captain Turner, Coldstream Guards, 1855
Albumen print
182 × 149 mm (irregular)
The Board of Trustees of the Victoria and Albert
 Museum 283-1979

38. Omar Pasha, 1855
Matt silver print
179 × 134 mm
Gilman Paper Company Collection PH.78.449

39. Marshal Pélissier, 1855
Matt silver print
205 × 153 mm
Harry Ransom Humanities Research Center,
 Gernsheim Collection, Photography Department,
 the University of Texas at Austin

40. Discussion between Two Croats, 1855
Matt silver print
189 × 163 mm
Jeremy Fry

41. Sanitary Inspector, Crimea, 1855
Matt silver print
238 × 216 mm
The J. Paul Getty Museum 85.XP.355.6

42. Vivandière (Cantonière), 1855
Albumen print
186 × 134 mm (irregular)
The Board of Trustees of the Victoria and Albert
 Museum 271-1979

43. William Simpson—War Artist, 1855
Matt silver print
138 × 167 mm
Harry Ransom Humanities Research Center,
 Gernsheim Collection, Photography Department,
 the University of Texas at Austin

44. William Russell of The Times, 1855
Albumen print
187 × 160 mm
The Board of Trustees of the Victoria and Albert
 Museum 64.843

**45. Hardships in the Camp (Colonel and Captains
 Brown and George)**, 1855
Albumen print
174 × 157 mm
The Board of Trustees of the Victoria and Albert
 Museum 275-1984-75

46. General Bosquet and Staff, 1855
Matt silver print
173 × 164 mm
Collection, The Museum of Modern Art, New
 York, Gift of John C. Waddell (74.86)

47. The Council of War, 1855
Matt silver print
192 × 166 mm
Harry Ransom Humanities Research Center,
 Gernsheim Collection, Photography Department,
 the University of Texas at Austin

**48. General Sir Henry Barnard (with four men and
 a barrel outside the stores)**, 1855
Matt silver print
169 × 167 mm
Harry Ransom Humanities Research Center,
 Gernsheim Collection, Photography Department,
 the University of Texas at Austin

49. Ismael Pasha receiving his Chibuque, 1855
Matt silver print
175 × 145 mm
Harry Ransom Humanities Research Center,
 Gernsheim Collection, Photography Department,
 the University of Texas at Austin

50. Cattle and Carts leaving Balaclava Harbour,
 1855
Matt silver print
207 × 255 mm
Harry Ransom Humanities Research Center,
 Gernsheim Collection, Photography Department,
 the University of Texas at Austin

**51. Panorama of the Plateau of Sebastopol in eleven
 parts**, 1855
Matt silver prints

a.	84.XM.1028.69	233 × 342 mm
b.	84.XM.1028.70	214 × 327 mm
c.	84.XM.1028.71	243 × 348 mm
d.	84.XM.1028.72	216 × 327 mm
e.	84.XM.1028.73	235 × 371 mm
f.	84.XM.1028.74	219 × 357 mm
g.	84.XM.1028.75	222 × 359 mm
h.	84.XM.1028.76	235 × 334 mm
i.	84.XM.1028.77	222 × 346 mm
j.	84.XM.1028.78	245 × 351 mm
k.	84.XM.1028.79	222 × 345 mm

The J. Paul Getty Museum 84.XM.1028.69 to 79
inclusive

**52. Key to accompany the large panorama of the
 Plateau of Sebastapol**
Printed line diagram
416 × 1162 mm
The J. Paul Getty Museum 84.XM.1028.80

53. Cossack Bay, Balaclava, 1855
Matt silver print
286 × 362 mm
Gilman Paper Company Collection PH.78.446

54. The Ordnance Wharf, Balaclava, 1855
Matt silver print
212 × 255 mm
The Royal Photographic Society, Bath 3358

55. Landing Place, Ordnance Wharf, Balaclava, 1855
Matt silver print
260 × 349 mm
Gilman Paper Company Collection PH.78.445

56. Landing Place, Railway Stores, Balaclava, 1855
Matt silver print
279 × 363 mm
Gilman Paper Company Collection PH.78.447

57. A Quiet Day in the Mortar Battery, 1855
Matt silver print
248 × 337 mm
Collection, The Museum of Modern Art, New
 York, Gift of John C. Waddell (75.86)

58. The Valley of the Shadow of Death, 1855
Matt silver print
263 × 352 mm
Harry Ransom Humanities Research Center,
 Gernsheim Collection, Photography Department,
 the University of Texas at Austin

**59. Remains of the Light Infantry Company, 38th
 Regiment**, 1855
Matt silver print
148 × 237 mm
Harry Ransom Humanities Research Center,
 Gernsheim Collection, Photography Department,
 the University of Texas at Austin

60. The Tombs on Cathcart's Hill, 1855
Matt silver print
176 × 243 mm
Harry Ransom Humanities Research Center,
 Gernsheim Collection, Photography Department,
 the University of Texas at Austin

61. Cooking House of the 8th Hussars, 1855
Matt silver print
159 × 202 mm
Gilman Paper Company Collection PH.74.560

Landscape

62. **The Wharfe**, 1854
Matt silver print
193 × 233 mm (irregular)
The Board of Trustees of the Victoria and Albert
 Museum 478-1981

63. **Landscape near Edinburgh**, 1856
Matt silver print
270 × 435 mm
Rubel Collection, Courtesy Thackrey & Robertson,
 San Francisco

64. **Foulden near Berwick**, 1856
Albumen print
310 × 423 mm
The Royal Photographic Society, Bath 3141

65. **Fors Nevin on the Conway**, 1857
Albumen print
409 × 337 mm
The Royal Photographic Society, Bath 3203

66. **Pont-y-Garth, near Capel Curig**, 1857
Albumen print
343 × 435 mm
The J. Paul Getty Museum 85.XM.169.9

67. **On the Llugwy near Bettws y Coed**, 1857
Albumen print
356 × 422 mm
The J. Paul Getty Museum 85.XM.169.15

68. **Moel-siabod from the Lledr Valley**, 1857
Albumen print
349 × 432 mm
The J. Paul Getty Museum 85.XM.169.14

69. **Pont-y-Pant on the Lledr, from above**, 1857
Albumen print
361 × 438 mm
The J. Paul Getty Museum 85.XM.169.6

70. **Junction of the Lledr and Conway**, 1857
Albumen print
350 × 435 mm
The Royal Photographic Society, Bath 3210/2

71. **View from Ogwen Falls into Nant Ffrancon**,
 1857
Albumen print
424 × 365 mm
The J. Paul Getty Museum 85.XM.169.22

72. **The Nant Ffrancon Pass**, 1857
Albumen print
347 × 390 mm
The Royal Photographic Society, Bath 3220

73. **Rocks at the Head of Glyn Ffrancon**, 1857
Albumen print
361 × 434 mm
The J. Paul Getty Museum 85.XM.169.19

74. **The Double Bridge of the Machno**, 1857
Albumen print
403 × 336 mm
The Royal Photographic Society, Bath 3217

75. **Summer Seas, Llandudno**, 1857
Albumen print
241 × 334 mm
The Royal Photographic Society, Bath 3209

76. **The Keeper's Rest, Ribbleside**, 1858/9
Albumen print
351 × 427 mm
The Board of Trustees of the Victoria and Albert
 Museum 355-1935

77. **The Sale Wheel, River Ribble, a fresh**, 1858/9
Albumen print
324 × 420 mm
The Trustees of Stonyhurst College D43.47

78. **The Cheddar Cliff**, 1858
Albumen print
352 × 437 mm
The Royal Photographic Society, Bath 8167

79. **Down the Ribble, the Through's Ferry**, 1858/9
Albumen print
340 × 426 mm
The Royal Photographic Society, Bath 2969/1

80. **The Reed Deep, River Ribble**, 1858/9
Albumen print
282 × 398 mm
The Royal Photographic Society, Bath 2973

81. **Valley of the Ribble**, 1858/9
Albumen print
325 × 426 mm
The Royal Photographic Society, Bath 2967

82. **Reed Deep with Pendle Hill in the Background**,
 1858/9
Albumen print
209 × 287 mm
The Trustees of Stonyhurst College D48.111

83. **Down the Ribble near Ribchester**, 1858/9
Albumen print
284 × 434 mm
The Royal Photographic Society, Bath 2972

84. **Mill at Hurst Green**, 1859
Albumen print
352 × 436 mm
Royal Photographic Society, Bath 8168

85. **Cottages at Hurst Green**, 1859
Albumen print
307 × 324 mm
The Royal Photographic Society, Bath 3140

86. **September Clouds (I)**, 1859
Matt silver print
240 × 430 mm
Rubel Collection, Courtesy Thackrey & Robertson,
 San Francisco

87. **September Clouds (II)**, 1859
Matt silver print
320 × 440 mm
Rubel Collection, Courtesy Thackrey & Robertson,
 San Francisco

88. **Borrowdale from the Bowder Stone**, 1860
Albumen print
333 × 430 mm
The Royal Photographic Society, Bath 3197

89. **The Bowder Stone, Borrowdale**, 1860.
Albumen print
327 × 440 mm
The Royal Photographic Society, Bath 3202

90. **Derwentwater, looking to Borrowdale**, 1860
Albumen print
242 × 294 mm
The Royal Photographic Society, Bath 3218

91. **Aira Force, Ullswater**, 1860
Albumen print
265 × 267 mm
The Royal Photographic Society, Bath 3213

92. **On the Beach, Hythe**, 1860
Albumen print
330 × 432 mm
The Royal Photographic Society, Bath 3011

93. **Kensington Gardens, the water head**, n.d.
Albumen print
318 × 436 mm
Royal Photographic Society, Bath 3271

94. **Hyde Park**, n.d.
Albumen print
297 × 436 mm
Royal Photographic Society, Bath 3270

Architecture

95. **Rievaulx Abbey**, 1854
Albumen print
344 × 289 mm
The Board of Trustees of the Victoria and Albert
 Museum 318-1935

96. **Rievaulx Abbey, the high altar**, c.1854
Albumen print
295 × 366 mm
Gilman Paper Company Collection PH.85.1162

97. **Fountains Abbey, the nave**, 1854
Matt silver print
194 × 224 mm
The Royal Photographic Society, Bath 3049

98. **Fountains Abbey, north side of the choir**, 1854
Albumen print
289 × 356 mm
Private Collection

99. **Bolton Abbey, the west window**, 1854
Albumen print
251 × 345 mm
The Royal Photographic Society, Bath 3054

100. **Lindisfarne Abbey, Holy Isle**, 1856
Matt silver print
304 × 372 mm
The J. Paul Getty Museum 84.XP.219.8

101. **Interior of Lindisfarne, west end**, 1856
Matt silver print
340 × 289 mm
The J. Paul Getty Museum 84.XM.504.29

102. **Glastonbury Abbey**, 1858
Matt silver print
237 × 295 mm
Collection, The Museum of Modern Art, New
 York, Gift of John C. Waddell

103. **A Vista, Furness Abbey**, 1860
Albumen print
281 × 262 mm
The Royal Photographic Society, Bath 3026

104. **A Memento of Furness Abbey**, 1860
Albumen print
283 × 275 mm
The Royal Photographic Society, Bath 3027

105. Interior of Chapel, Westminster, n.d.
Albumen print
248 × 197 mm
Robert Hershkowitz

106. The Cloisters, Westminster, n.d.
Albumen print
214 × 186 mm
Collection Centre Canadien d'Architecture/Canadian
Centre for Architecture, Montreal PH.1982.0135

107. Tewkesbury Abbey, west front, n.d.
Albumen print
352 × 436 mm
The Royal Photographic Society, Bath 3029

108. Roslin Chapel, south porch, 1856
Matt silver print
359 × 433 mm
Private Collection

109. Dunkeld Cathedral, 1856
Albumen print
324 × 425 mm
Private Collection

110. York Minster from Lendall, 1856
Albumen print
314 × 267 mm
The Royal Photographic Society, Bath 3193

111. Lincoln Cathedral, Galilee Porch, 1857
Albumen print
436 × 365 mm
Private Collection

112. Lincoln Cathedral, south porch, 1857
Albumen print
361 × 422 mm
Private Collection

113. Lincoln, west front, 1857
Albumen print
430 × 352 mm
The Royal Photographic Society, Bath 3160/1

114. Ely Cathedral, from the west, 1857
Albumen print
347 × 436 mm
Private Collection

115. Ely Cathedral, west front, 1857
Albumen print
352 × 428 mm
Private Collection

116. Ely Cathedral, from the grammar school, c.1857
Albumen print
353 × 444 mm
Private Collection

117. Peterborough Cathedral, south transept, c.1857
Albumen print
353 × 435 mm
Private Collection

118. Lichfield Cathedral, west front, 1858
Albumen print
353 × 428 mm
The Royal Photographic Society, Bath 3182/2

119. Lichfield Cathedral, porch of the south transept,
1858
Albumen print
348 × 428 mm
Private Collection

120. Lichfield Cathedral, portal of the south transept,
1858

Matt silver print
282 × 291 mm
Collection Centre Canadien d'Architecture/Canadian
Centre for Architecture, Montreal PH.1980.0243

121. Lichfield Cathedral, porch, 1858
Albumen print
421 × 370 mm
Private Collection

122. Wells Cathedral, west front, 1858
Albumen print
335 × 438 mm
Private Collection

123. Wells Cathedral, window in the south aisle, 1858
Albumen print
238 × 285 mm (arched top)
The Royal Photographic Society, Bath 3184

124. Salisbury Cathedral, view in the Bishop's
garden, 1858
Albumen print
344 × 440 mm
Collection Centre Canadien d'Architecture/Canadian
Centre for Architecture, Montreal PH.1979.0445

125. Interior, Westminster, n.d.
Albumen print
300 × 310 mm
Gilman Paper Company Collection PH.81.753

126. Lambeth Palace, 1857
Albumen print
339 × 420 mm
Private Collection

127. Houses of Parliament from Lambeth Palace,
1857
Matt silver print
323 × 417 mm
The Royal Photographic Society, Bath 3266

128. House of Lords, Peers' Entrance, 1857
Matt silver print
339 × 423 mm
Collection Centre Canadien d'Architecture/Canadian
Centre for Architecture, Montreal PH.1985.0920

129. Slate Pier at Trefiw, looking towards Llanrwst,
1857
Matt silver print
322 × 434 mm
The Royal Photographic Society, Bath 2998/2

130. Saltash Bridge, under construction, 1858
Albumen print
280 × 370 mm
The Royal Photographic Society, Bath 2995

131. Stonyhurst from across the Water, 1858/9
Albumen print
299 × 323 mm
The Trustees of Stonyhurst College A6 32a

132. Boys in the Refectory, Stonyhurst, 1858/9
Albumen print
278 × 282 mm
The Trustees of Stonyhurst College B12 99

133. Haddon Hall, the garden front [Roger Fenton in
the foreground], 1858
Albumen print
341 × 438 mm
Private Collection

134. Hardwick Hall, 1858
Albumen print
368 × 430 mm
The Royal Photographic Society, Bath 3237

135. Harewood House and Park, Grandfather
Maynard on horseback, 1860
Albumen print
292 × 435 mm
The Royal Photographic Society, Bath 3258

136. Harewood House, the upper terrace, 1860
Albumen print
373 × 435 mm
The Royal Photographic Society, Bath 3262

137. Terrace and Park at Harewood, 1860
Albumen print
340 × 425 mm
The Royal Photographic Society, Bath 3263

138. Windsor Castle from the Town Park, 1860
Albumen print
223 × 428 mm
The Royal Photographic Society, Bath 3128

139. The Long Walk, 1860
Albumen print
306 × 433 mm
The Royal Photographic Society, Bath 3125

140. Museum, Oxford [Pitt Rivers Museum], 1859
Albumen print
273 × 296 mm
The Royal Photographic Society, Bath 3248

141. Magdalen Tower and Bridge, 1859
Albumen print
359 × 437 mm
The Royal Photographic Society, Bath 3246/2

142. Hyde Park Corner, n.d.
Albumen print
296 × 423 mm
The Royal Photographic Society, Bath 3267

143. The Colosseum, Regent's Park, n.d.
Albumen print
320 × 434 mm
The Royal Photographic Society, Bath 3265

Costumes and Still Lifes

144. Untitled (reclining odalisque), 1858
Albumen print
285 × 390 mm
Rubel Collection, Courtesy Thackrey & Robertson,
San Francisco

145. Nubian Water Carrier, 1858
Albumen print
261 × 206 mm
The Royal Photographic Society, Bath 3009

146. Nubian Water Carrier, 1858
Albumen print
278 × 228 mm
Collection Kenneth and Jenny Jacobson

147. Girl in Eastern Costume, 1858
Albumen print
264 × 181 mm (asymetrical)
Gilman Paper Company Collection PH.82.855

148. Eastern Costume Study, 1858
Albumen print

450 × 362 mm
The J. Paul Getty Museum 84.XP.219.32

149. **Semi-nude Study**, n.d.
Matt silver print
257 × 174 mm (irregular)
The Board of Trustees of the Victoria and Albert
Museum 486-1979

150. **Spoils of Wood and Stream**, 1858/9
Albumen print
342 × 427 mm
The Royal Photographic Society, Bath 2895/1

151. **Game**, c.1859
Albumen print
363 × 329 mm
The Royal Photographic Society, Bath 10,006

152. **Fur and Feathers**, c.1859
Albumen print
340 × 419 mm
The Royal Photographic Society, Bath 2894/1

153. **Decanter and Fruit**, 1860
Albumen print
418 × 353 mm
The Royal Photographic Society, Bath 3110/1

154. **Grapes and Jar**, 1860
Albumen print
353 × 419 mm
The Royal Photographic Society, Bath 3099

155. **Fruit**, 1860
Albumen print

353 × 430 mm
The Royal Photographic Society, Bath 3100

156. **Flowers and Fruit**, 1860
Albumen print
353 × 429 mm
The Royal Photographic Society, Bath 3104/1

157. **Ivory Tankard and Fruit**, 1860
Albumen print
358 × 431 mm
The Royal Photographic Society, Bath 3097

158. **Fruit**, 1860
Albumen print
379 × 426 mm
The Royal Photographic Society, Bath 3091